CelticArt

CelticArt

In Pagan and Christian Times

J. ROMILLY ALLEN

SENATE

Celtic Art

First published in 1904 by Methuen & Co, London

This edition first published in 1997 by Senate,
an imprint of Random House UK Ltd,
Random House, 20 Vauxhall Bridge Road,
London SW1V 2SA

ISBN 1 85958 501 9

Printed and bound in Guernsey by
The Guernsey Press Co Ltd

CONTENTS

CELTIC ART IN PAGAN AND CHRISTIAN TIMES

CHAPTER I

THE CONTINENTAL CELTS AND HOW THEY CAME TO BRITAIN

THE CELTS A BRANCH OF THE ARYAN FAMILY OF NATIONS

ALL the nations at present inhabiting Europe, with the exception of the Turks, the Finns, the Magyars, and the Basques, speak Aryan languages, and are to a large extent of Aryan descent,[1] although their blood has been mixed from time to time with that of the Neolithic non-Aryan aborigines. The Celts, therefore, belong to the Aryan group of nations, and came from the same cradle of the race in Central Asia as did the ancestors of the Greeks, Italians, Teutons, Slavs, Armenians, Persians, and the chief peoples of Hindustan.

It has been the fashion amongst persons holding what they suppose to be advanced views to dispute the fact that the cradle of the Aryans was in Central Asia, but this is neither the time nor the place to discuss

[1] The fallacy that identity of language or of culture necessarily implies identity of race must be carefully guarded against.

the question. It is sufficient for our purpose to note that the successive waves of Aryan conquest entered Europe from the east, and that their general direction was towards the west.

THE CELT AS DESCRIBED BY GREEK
AND ROMAN AUTHORS

The Celts make their first appearance in history at the end of the sixth century B.C., when, however, they are referred to not by their name as a people but by the name of the country they occupied. Thus, Hecatæus of Miletus, writing about 509 B.C., mentions Marseilles as being a Ligurian city near the Celtic region.[1]

Herodotus, writing half a century later, is the first historian who uses the word κελτός (Celt) as distinguished from κελτική (the Celtic region). In the two passages[2] in which the Celts are mentioned, Herodotus says that they inhabited the part of Europe where the Danube has its source, and that the only other people to the westward were the Cynetes or Dog-Men. Both Herodotus and Aristotle erroneously supposed that the source of the Danube was situated in the Pyrenees.

Aristotle[3] describes the country of the Celts as being so cold that the ass is unable to reproduce his species there.

Plato, who lived sixty years after the time of Herodotus, classes the Celts with the Scythians, Persians, Carthaginians, Iberians, and Thracians, as being warlike nations who like wine, and drink it to excess.[4]

[1] Μασσαλία πόλις τῆς Διγμστικῆς κατὰ τὴν κελτικήν (C. and T. Muellerus, *Fragmenta Historicorum Græcorum*, Paris, 1841, vol. i., p. 2, fragm. 22).

[2] Bk. ii., chap. xxxiii.; and Bk. iv., chap. xlix

[3] *De Generatione Animalium.*

[4] *De Legibus.*

Pytheas (*circa* B.C. 300) is the first author who includes the part of Europe which was afterwards the Gaul of Cæsar within the Celtic territory.[1]

According to the earlier historians, the parts of Europe occupied by the Celts at the end of the fourth century B.C. were the coast of the Adriatic from Rimini to Venice, Istria and the neighbourhood of the Ionian Gulf, and the left bank of the Rhone from the Lake of Geneva to the source of the Danube.[2]

Polybius (B.C. 205-123) gives more definite and satisfactory information about the Celts than the somewhat vague references made to them by previous writers. From him we learn[3]

(1) That the Celts of upper Italy did not come from the Gaul of Cæsar, but from the valley of the Danube, and more particularly from the countries which border upon the northern slopes of the Julian Alps of Noricum.

(2) That these peoples were primarily divided into Cisalpine Celts and Transalpine Celts, that is to say, into the Celts of the Alps and of the north of the Alps. In the third century B.C. these latter were already called, more particularly by Polybius, by the name of Galati.

(3) That the Cisalpine Celts, who from a remote period long before the fourth century B.C. inhabited the wide plains of Lombardy from the Alps to the river Pô, were, for the most part, an agricultural and sedentary race living in luxury and in a state of civilisation without any doubt greatly superior to that which could have existed in Gaul at that time.

(4) That the Galati, on the contrary, the Transalpine Celts, although kinsmen to the former mountaineers, still half nomads, shepherds and warriors chiefly, always ready to run the risk of a raid, armed from the fourth century with

[1] C. Elton's *Origins of English History*, p. 25.
[2] A. Bertrand and S. Reinach's *Les Celtes*, p. 19.
[3] *Ibid.*, p. 27.

an iron sword, an iron-headed spear and a shield, lived under the régime of a sort of military aristocracy, as proud as they were poor, such as the inhabitants of the Caucasus were not half a century ago.

The people who were called *Celtæ* by the earlier historians, and *Galatæ* by the more recent writers, were also known to the Romans as *Galli;* but these three separate appellations do not seem to indicate any difference of race, and indeed they all have the same meaning, viz. a warrior. The Gauls of Cæsar's time preferred to call themselves by the name which he wrote, *Celtæ*.[1]

All the Classical authorities are agreed as to the physical characteristics of the Celts with whom they were acquainted. The Celts are invariably described as being tall, muscular men, with a fair skin, blue eyes, and blonde hair tending towards red.[2] Such were the Gauls who conquered the Etruscans of northern Italy in B.C. 396, took Rome under Brennus six years later, sacked Delphi in B.C. 279, and gave their name to Galatia in Asia Minor.

It may well be asked what has become of the tall, fair-haired Celts who in the fourth century B.C. were the terror of Europe? The answer seems to be that being numerically inferior to the races which they conquered, but did not exterminate, they after a time became absorbed by the small, dark Iberians, who were the aborigines of France and Spain in the later Stone Age. In Great Britain the once warlike Celt at last became so effete that he fell an easy prey to the Picts, the Scots, the Angles, and the Saxons.

[1] Prof. J. Rhys' *Celtic Britain*, p. 2.
[2] C. Elton's *Origins of English History*, p. 113.

THE CELTS AS REPRESENTED IN GREEK AND ROMAN ART

The physical type of the Celt in Classical Sculpture was fixed by the artists of Pergamos, who were commissioned to perpetuate the victories of Attalus I. (B.C. 241–197) and Eumenes II. (B.C. 197–159) over the Galatians of Asia Minor.[1] The originals of the statues executed at this period to decorate the acropolis at Pergamon and at Athens have since been popularised by means of numerous copies. The statue most familiar to everyone is that wrongly called the Dying Gladiator,[2] but which is really a Gaulish warrior mortally wounded, as may be seen by the twisted torque round his neck, and the shape of his shield and trumpet. The other statues of the same class are the group formerly known as Arria and Paetus[3] (representing a Gaul committing suicide after having killed his wife) and the figures of an old man with a young man dead[4] and a young man wounded[5] from the defeat of the Gauls by Attalus.

In all these works of art the Gaulish type is the same, the men being tall and muscular, with abundant unkempt locks, and an energetic, almost brutal, physiognomy, the very opposite of the intellectual beauty of the ideal Greek. The type thus fixed by eminent artists was handed down from generation to generation, until the last years of the Roman empire. It may be recognised on the Triumphal Arch at Orange[6]

[1] *Les Celtes*, p. 37 ; H. B. Walters' *Greek Art*, p. 91 ; and Dr. A. S. Murray's *History of Greek Sculpture*, vol. ii., p. 376.

[2] In the Museum of the Capitol at Rome; cast in the South Kensington Museum.

[3] Prof. Ernest Gardner's *Handbook of Greek Sculpture*, pt. ii., p. 456 ; and A. Baumeister's *Denkmäler*, p. 1237.

[4] At Venice. [5] In the Louvre.

[6] A. de Caumont's *Abécédaire d'Archéologie* (Ère Gallo-Romaine), Second edition, p. 194.

(Vaucluse), in the south of France, and at the sarco-
phagus of Ammendola[1] in the museum of the Capitol
at Rome, both of which have derived their inspiration
from the works of art of the time of the kings of
Pergamon. Latterly the Gaulish type became that of
barbarians generally.[2]

THE CELT AS REVEALED BY ARCHÆOLOGICAL RESEARCH

From an archæological point of view the Celtic
civilisation which existed in Central Europe, certainly
as far back as 400 B.C., and very probably three or four
centuries earlier, was that of the Iron Age. The
Continental antiquaries divide the Iron Age in this
part of Europe into two periods marked by differences
in culture. The culture of the Early Iron Age is pre-
historic, and is called that of "Hallstatt," after the
great Alpine cemetery near Salzburg in Austria.

The culture of the Later Iron Age comes after the
time when the Celts first make their appearance in
history, and is known to Swiss and German archæ-
ologists as that of "La Tène," from the Gaulish
Oppidum at the north end of the Lake of Neuchâtel
in Switzerland. The La Tène culture in the form it
occurs in France is called "Marnian," and corresponds
with the "Late-Celtic" culture of Great Britain.

Hallstatt, from which the Celtic civilisation of the
earlier Iron Age takes its name, is situated thirty miles
S.E. of Salzburg in Austria, amongst the mountains
forming the southern boundary of the valley of the
Danube. It was a place of great commercial importance
in ancient times, in consequence of the salt mines in
the neighbourhood, and because it lay on the great

[1] S. Reinach's *Les Gaulois dans l'art antique.*
[2] S. Reinach's *Les Celtes*, p. 38.

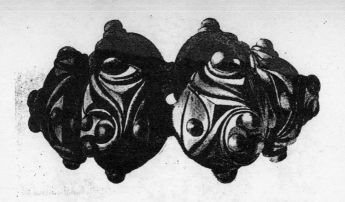

BRONZE ARMLET OF THE LA TÈNE PERIOD FROM GERMANY

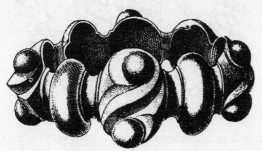

BRONZE ARMLET OF THE LA TÈNE PERIOD
FROM LONGIROD (VAUD)

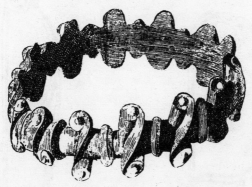

BRONZE ARMLET OF THE LA TÈNE PERIOD
FROM THE CEMETERIES OF THE MARNE

GRAVE OF A GAULISH WARRIOR AT SESTO CALENDE, ITALY

BRONZE FIBULA OF LA TÈNE TYPE,
FROM THE CEMETERIES OF
THE MARNE

BRONZE FIBULA OF LA TÈNE TYPE,
FROM THE CEMETERIES OF
THE MARNE

trade route by which amber was brought from the mouth of the Elbe to Hatria, at the head of the Adriatic.[1]

The pre-Roman necropolis of Hallstatt was discovered in 1846, and excavations have been going on there at intervals ever since. In 1864 M. de Sacken, curator of the collection of antiquities in the Vienna Museum, published a monograph on the subject, which still remains the best book of reference. M. de Sacken did not superintend the excavations personally, that task having fallen to the lot of George Ramsauer. Copies in MS. of Ramsauer's notes on the contents of the tombs, and sketches of the antiquities discovered in them exist in the Ashmolean Museum at Oxford, and in the national museums at Saint-Germain and at Vienna.

The Hallstatt finds show very clearly the transition from the Bronze to the Iron Age in Central Europe.

M. Salomon Reinach thus summarises, in his *Les Celtes dans les Vallées du Pô et du Danube* (p. 129), the conclusions arrived at by M. de Sacken :—

(1) Two distinct races have been buried at Hallstatt ; one of which cremated the bodies and the other which practised inhumation ; the former showing themselves to have been much richer than the latter.

(2) The people, as represented by their grave-goods, must have supported themselves, besides working the salt mines (their chief industry), by breeding cattle. The number of bones and teeth of animals found in the tombs show that they possessed herds. Their agricultural pursuits are proved by the presence of numerous scythes and sickles in the graves. Slag and moulds from founderies indicate that they were metallurgists.

[1] C. Elton's *Origins of English History,* pp. 46 and 62, and Prof. W. Boyd Dawkins' *Early Man in Britain,* pp. 417, 466, and 473.

(3) Amongst the individuals who had been burnt the greater part of the men and women displayed a relative luxuriousness of toilet appliances, a luxuriousness which was ministered to by foreign commerce supplying amber from the Baltic, Phœnician glass, ivory, embroidery in gold thread and stamped gold-leaf of oriental workmanship, used in the decoration of the sword-hilts and scabbards.

(4) On the bronze vessels, side by side with the old geometrical ornament, common to them and to the Cisalpine vases, are to be seen new combinations of symbolical designs which recur on the Celtic coinage of Gaul.

Amongst the objects most characteristic of the Hallstatt culture are :—

(1) Daggers, or short swords, with a pointed blade of iron and a bronze handle having two little projections at the top terminating in round knobs and resembling the antennæ of an insect.

(2) Long double-edged swords with an iron blade made in imitation of the leaf-shaped swords of the Bronze Age, having the edges slightly curved outwards in the middle, but not having so sharp a point as the Bronze Age sword, and being much longer. The hilts have a massive pommel encrusted with ivory and amber, and ornamented with gold-leaf.

(3) Pails, or situlæ, of thin bronze plates ornamented with figure subjects executed in repoussé work, and exhibiting a peculiar style of art which Dr. Arthur Evans thinks the Celts borrowed from the Veneti, the ancient Illyrian inhabitants of the north of the Adriatic, who, in their turn, had come under Hellenic influence whilst the amber trade route between Greece and the Baltic passed through Hatria.

The Hallstatt Sword

Dr. Arthur Evans[1] divides the Hallstatt remains into an earlier and a later group, the former dating from about 750 to 550 B.C. During the later period, from 550 B.C., he thinks there was a tendency for the typically Gaulish or Late-Celtic culture to overlap that of the Early Iron Age. The Gallo-Italian tomb of a Celtic chieftain, found in 1867 at Sesto-Calende,[2] at the south end of Lago Maggiore, illustrates the transition from the Hallstatt to the La Tène culture. Amongst the grave-goods were a situla with figure subjects in repoussé metalwork and a short pointed iron sword having a handle furnished with antennæ, like those from Hallstatt.

In addition, there were the remains of a chariot, horse-trappings, a bronze war-trumpet, helmet and greaves, and iron lancehead, such as we should expect to find buried with a Celtic warrior in the Iron Age in Gaul or Britain.

La Tène (which gives its name to the modified and later form of Hallstatt culture as it existed in Central Europe from about 400 B.C., when the name of the Gaul superseded that of the Celt, to the time of Cæsar's conquest) is a military stronghold, or oppidum, situated at the N.E. end of the Lake of Neuchâtel, commanding an important pass between the upper Rhone and the Rhine. The remains at La Tène were first explored by Colonel Schwab in 1858, and subsequently by E. Vouga in 1880. The objects derived from this remarkable site are to be seen in the public museums at Bienne, Neuchâtel, and Berne ; and in the private collections of Colonel Schwab,

[1] Rhind Lectures on the "Origins of Celtic Art," Lecture II., as reported in the *Scotsman* for December 12th, 1895.

[2] S. Reinach's *Les Celtes,* p. 49.

Professor Desor, E. Vouga, Dardel Thorens, and Dr. Gross.[1]

According to Dr. Arthur Evans, the date of the culminating epoch of Gaulish civilisation, as represented by the antiquities from La Tène, is probably the third century B.C. It was at this period that the earlier foreign elements derived from Hallstatt, and even from countries further afield, became thoroughly assimilated, and the style of art called Late-Celtic began to take definite shape.

The typical arms found at La Tène are :—

(1) A long sword with a double-edged iron blade having a blunt point. The length and flexibility of the blade made it useless for thrusting in the way which was possible with the shorter and more rigid leaf-shaped sword of the Bronze Age, so the pointed end was abandoned.

(2) Lances with an iron point often of a peculiar curved form.[2]

(3) An oval shield of thin bronze plates ornamented with bosses.

(4) A horned helmet of bronze.

The characteristic La Tène ornament is found chiefly on the sword-sheaths, the helmets, and the shields. The La Tène fibulæ are derivatives of the "safety-pin," and usually have the tail-end bent backwards, as in the Marnian fibulæ in France and the Late-Celtic fibulæ in England.

The Gaulish culture in France corresponding with that of La Tène in Switzerland has been called

[1] The remains are fully described in Dr. F. Keller's *Lake Dwellings ;* Dr. R. Munro's *Lake Dwellings of Europe;* E. Vouga's *Les Helvètes à la Tène ;* and Dr. Gross' *La Tène un Oppidum Helvète.*

[2] With flame-like undulating edges "so as to break the flesh all in pieces" (C. Elton's *Origins of English History,* p. 116).

"Marnian" by the French archæologists because the principal remains of this period have been found in the cemeteries of the Department of the Marne. A list of seventy-two such Marnian cemeteries (some of which contained as many as 450 graves) is given by A. Bertrand in his *Archéologie Celtique et Gauloise*, p. 358. The objects obtained from these cemeteries are fully illustrated in the *Dictionnaire Archéologique de la Gaule*, and in Leon Morel's *La Champagne*

Ornament on Bronze Sword-sheath from La Tène

souterraine (*Album*). The best collections are those in the Museum of Saint-Germain and the British Museum. M. Bertrand fixes the date of the Marnian cemeteries at from 350 to 200 B.C., the period between the time when bronze weapons ceased to be used, and the introduction of a national coinage into Gaul.

From the point of view of art, two of the most interesting burials discovered in the Departement du Marne are those at Berru[1] and Gorge-Meillet[2] of

[1] A. Bertrand's *Archéologie Celtique et Gauloise*, p. 356.
[2] E. Fourdriguier's *Double Sépulture Gauloise de la Gorge-Meillet*.

warriors interred with their chariots, horses, and complete military equipment, including two bronze helmets, which show the kind of decoration prevalent at the period, and afford a link between the Marnian style in Gaul and the Late-Celtic style in Britain. The

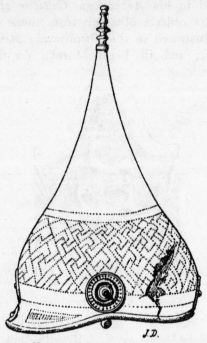

Gaulish Helmet of Bronze from Gorge-Meillet

burials at Berru and Gorge-Meillet correspond very nearly with those at Arras, Danes' Graves, and elsewhere, in the portion of Yorkshire occupied by the Celtic tribe of the Parisi.

The Marnian cemeteries belong to the second Iron Age of Central Europe after 400 B.C., but in the commune of Magny Lambert (Côte-d'or), near the source

of the river Seine, tumuli have been opened containing
long iron swords and bronze situlæ of distinctly Hall-
statt type.

Dr. Arthur Evans thinks that the older, or Hallstatt,
culture of Central Europe was gradually modified and
transformed into the La Tène, Marnian, and Late-Celtic
stages of culture, in consequence of the foreign in-
fluence exercised by the continual flow of Greek
commerce into eastern Gaul from the sixth century B.C.
onwards. Ample evidence of this commercial inter-
course is afforded by the discovery of tripods, hydrias,
œnochœs, and painted vases of Greek workmanship
associated with Gaulish burials,[1] as at Grækwyl, near
Berne in Switzerland, at Somme-Bionne (Marne), at
Rodenbach in Bavaria, and at Courcelles-et-Montagne
(Haute-Marne).

The great difficulty in understanding the evolution of
Celtic art lies in the fact that although the Celts never
seem to have invented any new ideas, they professed
an extraordinary aptitude for picking up ideas from the
different peoples with whom war or commerce brought
them into contact. And once the Celt had borrowed
an idea from his neighbour, he was able to give it such
a strong Celtic tinge that it soon became something so
different from what it was originally as to be almost
unrecognisable.

Polybius gives the following picture of the Cisalpine
Gauls :—

"These people camp out in villages without walls, and
are absolutely ignorant of the thousand things that make
life worth living. Knowing no other bed than straw, only
eating flesh, they live in a half-wild state. Strangers to

[1] A. Bertrand's *Archéologie Celtique et Gauloise,* pp. 328 to 347 ; see
also L. Lindenschmit's *Die Alterthümer unserer heidnischen Vorzeit,*
Mainz, 1858, etc.

everything which is not connected with war or agricultural labour, they possess neither art nor science of any description."

The tendency of the Celt to copy rather than invent is brought out most clearly in their coinage. M. A. Bertrand[1] says :—

"Were they settled in Macedonia they imitated with more or less success the tetradrachms of Philip and of Audoleon, king of Paeonia ; did they advance towards Thrace, they copied the tetradrachms of Thasos. The Senones of Rimini took for their model the Roman and Italian *aes grave ;* in the north of Italy, finding themselves in contact with nations who used the monetary system of the drachm and its multiples and divisions, the Gauls copied them until the time they were driven back on the Danube. In Liguria they copied the drachms of Massalia. Were they encamped on the banks of the Danube in Noricum, or in Rhaetia, they again copied the monetary systems of their neighbours. The tetradrachms of the Boii on which are inscribed the name of 'BIATEC,' one of their chiefs, reproduced the type of the last Roman of the family of Fufia struck between the years 62 and 59 B.C. In a word, the same habit of imitation is found everywhere in the cradle of Gaulish numismatics properly so-called ; on the left bank of the Rhine, it was the gold staters of Philip which served as the model for gold pieces and sometimes for silver ; in Aquitaine, it was the coins of Emporia, Rhoda, and Massalia. Armorica and the frontier countries were the first who adopted for their coinage types which can be called national, although still reflecting those imitated from the Macedonian staters. Let it be noticed that we are in one of the most Celtic parts of Gaul : it is therefore natural that the difference in genius between the two races of Celts and Gauls should manifest itself most clearly."

[1] *Archéologie Celtique et Gauloise,* p. 387.

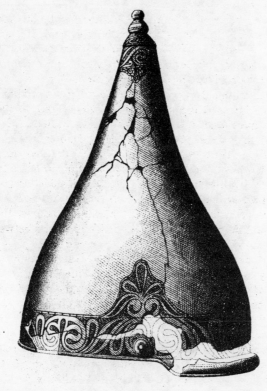

CASQUE DE BERRU. (MARNE.) decouvert dans un Cimetière Gaulois.

GAULISH HELMET OF BRONZE FROM BERRU (MARNE)

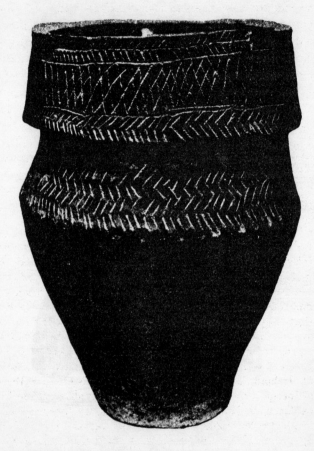

CINERARY URN OF BRONZE AGE FROM LAKE, WILTS;
NOW IN THE BRITISH MUSEUM

HEIGHT 1 FT. 3¼ INS.

INVASION OF BRITAIN BY GOIDELIC CELTS IN
THE BRONZE AGE

The aborigines of Europe, who were driven west-ward by the successive waves of Aryan conquest, appear to have been in the Neolithic stage of culture, and they are identified by Prof. W. Boyd Dawkins with the Iberians mentioned by Strabo. Prof. W. Boyd Dawkins gives a map in his *Early Man in Britain* (p. 318) showing the relative distribution of the Iberic, Celtic, and Belgic races in the historic period. In this map the Iberians occupy the north of Africa, the west of Spain and France, the country round Marseilles, the whole of Wales, and the south-west of Ireland. The Celts follow behind to the eastward, pressing the Iberians towards the Atlantic.

In the opening address of the Antiquarian Section at the meeting of the Royal Archæological Institute at Scarborough in 1895, Prof. Dawkins said :—[1]

" The theory that the Neolithic inhabitants of the British Isles are represented by the Basques and small, dark Iberic population of Europe generally, has stood the test of twenty-five years' criticism, and still holds the field. From the side of philology it is supported by the fact pointed out by Inchauspé that the Basque word *aitz* for stone is the root from which the present names of pick, knife, and scissors made of iron are derived. This of itself shows that the ancestors of the Basques were in the Neolithic stage of culture. The name of Ireland, according to Rhys,[2] is derived from Iber-land (Hibernia), the land of the Iberians, or sons of Iber. The evidence seems to be clear : 1. That the Iberians were the original inhabitants of France and Spain in the Neolithic age, and the only inhabitants of the British Isles ; 2. That

[1] *Archæological Journal*, vol. lii., p. 342.
[2] *Celtic Britain*, p. 262.

they were driven out of the south-eastern parts of France and Spain in the Neolithic age; (3) That they are now amply represented by the small dark peoples in the Iberian Peninsula, and in the island which bears their name, and in various other places in Western Europe, where they constitute, as Broca happily phrases it, 'ethnological islands.' The small, dark, long-headed Yorkshiremen form one of these islands."

Let us pause for a moment to consider the stage of culture attained by the Neolithic aborigines of Britain whom the Celts found here on their first arrival. The houses in which Neolithic man lived are of two kinds : (1) pit dwellings dug to a depth of from seven to ten feet deep in the chalk, like those at Highfield,[1] near Salisbury, explored by Mr. Adlam in 1866; and (2) hut circles like those at Carn Brê near Camborne,[2] in Cornwall, excavated by Mr. Thurstan C. Peter, and on Dartmoor,[3] excavated by the Rev. S. Baring-Gould and Mr. R. Burnard. In many cases the villages are fortified by a wall of rubble stone, as at Grimspound, on Dartmoor. Neolithic dwellings have also been explored by Mr. George Clinch, at Keston, in Kent.[4]

Neolithic man supported himself by the chase and by fishing, and also was a farmer in a small way, growing wheat and cultivating flax. He had domesticated the sheep, goat, ox, hog, and dog. He could spin, weave, mine flint, chip and polish stone implements and make rude pottery.

[1] W. Boyd Dawkins' *Early Man in Britain,* p. 267; and E. T. Stevens' *Flint Chips,* p. 57.

[2] R. Burnard in *Trans. of Plymouth Inst.,* 1895-6 ; and T. C. Peter in *Jour. R. Inst. of Cornwall,* No. 42.

[3] Reports of Dartmoor Exploration Committee in the *Trans. of Devonshire Assoc. for Advancement of Science.*

[4] *Proc. Soc. Ant. Lond.,* ser 2, vol. xii., p. 258, and vol. xvii., p. 216.

He buried his dead in long barrows, chambered cairns, and dolmens. Cremation was not practised, and it was usual to inter a large number of bodies in a chamber constructed of huge stones.

Such was the aboriginal inhabitant with whom the first Celtic invader had to contend. I say *first* Celtic invader advisedly, for there was a second Celtic invasion at a later period. The vanguard of the Celtic conquerors are called by Prof. J. Rhys, in his *Celtic Britain* (p. 3), "Goidels," to distinguish them from the "Brythons," who constituted the second set of invaders. The modern representatives of the Goidels are the Gaelic-speaking population of the Highlands of Scotland, Ireland, and the Isle of Man; whilst the descendants of the Brythons now inhabit Wales, Cornwall, and Brittany. At the time of the Roman occupation the Brythonic tribes inhabited the whole of England with the exception of the districts now occupied by Cumberland, Westmoreland, Devon, and Cornwall. The most important of these Brythonic tribes were the Brigantes and Parisi of Yorkshire, the Catuvelauni of the Midland Counties, the Eceni of the eastern counties, the Attrebates of the Thames Valley, and the Belgæ, Regni, and Cantion in the south. The south of Scotland was in possession of the Dumnoni and Otadini, who were Brythons, as were also the Ordovices of Central Wales. The Ivernians still held their own in the north of Scotland. The remainder of Great Britain was inhabited either by pure Goidels or by Goidels who had mixed their blood with the Ivernian aborigines.

As Prof. J. Rhys has pointed out in his *Celtic Britain* (p. 211), the soundest distinction between the Goidels and the Brythons rests on a peculiarity of

pronunciation in their respective languages. In the corresponding words in each language where the Brythons use the letter P, the Goidels use Qv. Hence they have been termed the "P and Q Celts." The most familiar instance of this is where the Welsh use the word *ap* to mean *son of*, and the Gaels use *mac*. The older form of *mac* found on the Ogam-inscribed monuments of Ireland, Scotland, Wales, and the West of England is *maqvi*, as in the bi-literal and bi-lingual inscribed stone at St. Dogmael's, in Pembrokeshire, where the Latin "SAGRANI FILI CVNOTAMI" has as an equivalent in Ogams "SAGRAMNI MAQVI CYNATAMI." In modern Welsh *map*, or *mab*, has been shortened by dropping the *m*, and in Gaelic the *v* of *maqvi* has been dropped, and the *q* made into *c*.

So much for the philological differences between the Goidel and the Brython. They can also be distinguished archæologically, the former as being in the Bronze Age stage of culture, and the latter in the Early Iron Age when he arrived in Britain. In a subsequent chapter we shall have to deal with the Brythonic Celt, but at present we are concerned exclusively with the Goidel.

The Neolithic inhabitants of this country, whom the Goidelic Celts found here on their arrival, were ethnologically a small dark-haired, black-eyed race, with long skulls of a type which is still to be seen amongst the Silurians of South Wales.[1] The ethnological characteristics of the Goidels were entirely different: they were tall, fair-haired, round-headed, with high cheek-bones, a large mouth, and aquiline nose. In studying the past much must necessarily be more or less conjectural, and we can never hope to see otherwise than "as in a glass darkly." As far, however, as it is

[1] Boyd Dawkins' *Early Man in Britain*, chapter ix.

possible to ascertain the facts, it appears probable that the advancing wave of Goidelic Celts did not entirely overwhelm the aborigines or drive them before it. Most likely the big Goidels made the small Iberians "hewers of wood and drawers of water," and in time either absorbed them or themselves became absorbed.

THE CHRONOLOGY OF THE BRONZE AGE IN EUROPE

Actual dates in years can only be ascertained by means of historical documents, and therefore no chronology of the ages of Stone, Bronze, and Iron is possible except where contact can be established between the prehistoric (or non-historic) races living in those stages of culture in Northern and Central Europe, and the more advanced civilisations on the shores of the Mediterranean and in Asia. Long before direct contact took place between the northern barbarians and the Egyptians, Assyrians, Phœnicians, Greeks, Romans, and other great nations of antiquity, through invasions or immigrations, a more indirect contact must have existed for centuries, owing to the trade in such things as amber, gold, bronze, and tin. Dates have been fixed approximately by the finding of imported objects in different countries, and by studying their geographical distribution. Other almost untouched fields of investigation which would help to solve many of the problems of prehistoric chronology, are the migration of symbols and patterns and comparative ornament.

The attempts that have been made to fix the duration of the Ages of Stone and Bronze in actual years are at the best mere guesses, but it may be worth while stating the conclusions arrived at by some of the leading European archæologists, so as to give a rough idea of

the time at which bronze was in use for the manufacture of implements and weapons in different countries.

Egypt during the greater part of its existence as a civilised nation was in the Bronze Age. The copper mines of the Sinaitic peninsula were worked as early as the Fourth Dynasty, as is proved by the rock inscriptions of Sneferu (B.C. 3998-3969) at Wady Maghera.[1] Bronze was certainly used by the ancient Egyptians in the fourteenth century B.C., and in the tomb of Queen Aah Hotep, although bronze weapons were found, iron was conspicuous by its absence, indicating that the latter metal had not come into general use in the fifteenth century B.C.

The Mycenæan civilisation in the Ægean was of the Bronze Age, and Prof. Flinders Petrie places its flourishing period at about 1400 B.C.[2] Bronze continued in use in Greece until the time of the Dorian invasion, B.C. 800.

In dealing with the local centres of the bronze industry, Prof. Boyd Dawkins[3] recognises three distinct local centres in Europe.

(1) The Uralian, or Eastern—Russia.

(2) The Danubian, or Northern and Central—Scandinavia, Hungary.

(3) The Mediterranean, or Southern—Greece, Italy, France, Switzerland.

Dr. Oscar Montelius[4] gives the following tentative dates for the duration of the Bronze Age in these areas :—

[1] Petrie's *Hist. of Egypt*, vol. i., p. 31. Article on "The Age of Bronze in Egypt," in *L'Anthropologie* for January, 1890, translated in the *Smithsonian Report* for 1890, p. 499.

[2] *Jour. of Hellenic Studies*, vol. xii., p. 203.

[3] *Early Man in Britain*, p. 414.

[4] *Matériaux pour l'histoire primitive de l'homme*, pp. 108-113.

The Caucasus.—The Massagete were, according to Herodotus, still using bronze in the sixth century B.C.

Greece.—Bronze Age civilisation of Mycenæ, 1400 to 1000 B.C.

Italy.—Terramare of Bronze Age, twelfth century B.C. Iron introduced in ninth or eighth century B.C.

Scandinavia and Germany.—Bronze Age begun in fifteenth century B.C., and ended in fifth century B.C.

Worsaae[1] places the beginning of the Bronze Age in Scandinavia five centuries later than Montelius, *i.e.* 1000 B.C.

Dr. Naue[2] dates the Bronze Age in Upper Bavaria from 1400 B.C. to 900 B.C.

As regards Great Britain, there is no reason for supposing that the Brythonic Celts of the Early Iron Age arrived in this country much before B.C. 300, which date would terminate the Bronze Age, at all events in southern England. The date of the beginning of the Bronze Age in Britain can only be surmised. If, as we hope to be able to prove, much of the art of that period here can be traced to a Mycenæan origin there is no reason why the Bronze Age in Britain should not have commenced shortly after the spiral-motive patterns were transferred from ancient Egypt to the Ægean, say, about 1400 B.C., and thence to Hungary, Scandinavia, and other parts of Europe. It is not impossible, nay, it is even probable, that the Bronze Age may have lasted a thousand years in Britain, beginning B.C. 1300, and ending B.C. 300.

[1] *The Industrial Arts of Denmark*, p. 41.

[2] Dr. Arthur Evans' review of Dr. Julius Naue's *Die Bronzezeit in Obayern* in the *Academy* for April 27th, 1895.

CHAPTER II

PAGAN CELTIC ART IN THE BRONZE AGE

GENERAL NATURE OF THE MATERIALS AVAILABLE FOR THE STUDY OF THE ART OF THE BRONZE AGE IN BRITAIN, AND THE DECORATIVE MOTIVES EMPLOYED

A S we have already observed, the Goidelic Celts were in the Bronze Age stage of culture when they landed in Britain. Let us now inquire into the nature of the materials available for the study of the Pagan Celtic art in the Bronze Age.

The remains of this period may be classified, according to the nature of the finds, as follows :—

(1) Sepulchral remains.

(2) Remains on inhabited and fortified sites.

(3) Merchants' and founders' hoards.

(4) Personal hoards, that is to say, finds of objects purposely concealed, either in times of danger, or buried as *ex voto* deposits.

(5) Finds of objects accidentally lost.

(6) Sculptured rocks and stones.

The art of the Bronze Age in Europe is both of a symbolical and decorative character. The principal symbols employed are :—

The Swastika.	The Ship.
The Triskele.	The Axe.
The Cup and Ring.	The Wheel.

It is probable that most of these were connected with sun-worship.[1]

The chief decorative art motives which were prevalent during the Bronze Age are as follows:—

> The Chevron.
> The Concentric Circle.
> The Spiral.
> The Winding Band.

With the introduction of bronze into Britain an entire change took place in the burial customs of the people. The long barrows with their megalithic chambers and entrance passages gave place to round barrows containing cists constructed of comparatively small slabs of stone, and having no approach from the exterior.

Although burial by inhumation still continued to be practised, cremation was adopted for the first time. The proportions of unburnt to burnt bodies found in opening barrows in different parts of England vary according to Thurnam[2] thus:—

	Unburnt.		Burnt.
Wilts . . .	82	...	272
Dorset . . .	21	...	91
Derbyshire . .			
Staffordshire . .	150	...	121
Yorkshire . .			
Yorkshire . .	58	...	53

The survival of the practice of inhumation to so large an extent would seem to indicate that the bronze-using Goidels amalgamated with the Neolithic aborigines rather than exterminated them.

The unburnt bodies were usually buried in a doubled-

[1] See J. J. A. Worsaae's *Danish Arts*, p. 68.
[2] *Archæologia*, vol. xliii., p. 310.

up position, and sometimes an urn was placed near the deceased. When the body was cremated the ashes were placed in a cinerary urn, and the grave-goods most commonly consisted of smaller pottery vessels, a bronze dagger or razor, and a stone wrist-guard. Occasionally flint implements and polished stone axe-hammers have been found with burials of this type, but it does not necessarily follow, in consequence, that bronze was unknown at the time.

The sepulchral pottery derived from the round barrows of the Bronze Age supplies us with ample material for studying the art of the period.

The principal collections are to be seen in the British Museum and the museums at Devizes, Sheffield, Edinburgh, and Dublin. These have been derived from the barrows opened by Sir R. Colt Hoare in Wiltshire, T. Bateman in Derbyshire and Staffordshire, Rev. Canon Greenwell and the Rev. J. C. Atkinson in Yorkshire, C. Warne in Dorsetshire, and W. C. Borlase in Cornwall.

The pottery from the round barrows exhibits an endless variety of form, but as regards their suggested use, they may be divided into four classes, namely :—

(1) Cinerary urns.
(2) Food-vessels.
(3) Drinking-cups.
(4) Incense-cups.

There is no doubt as to the use for which the cinerary urns[1] were intended, because they are found filled with burnt human bones, sometimes placed in an inverted position upon a flat stone, and sometimes mouth upwards. The cinerary urns vary in height from 6 inches to 3 feet, and the most common shape resembles that

[1] Greenwell's *British Barrows*, p. 66.

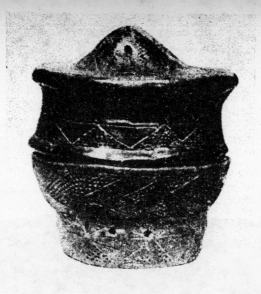

BRONZE AGE URN OF "INCENSE-CUP" TYPE
FROM ALDBOURNE, WILTS; NOW IN
THE BRITISH MUSEUM

HEIGHT 3½ INS.

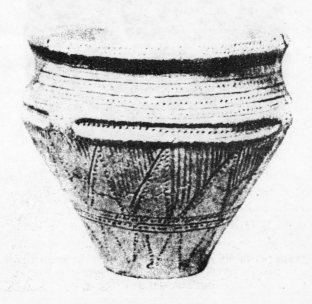

BRONZE AGE URN OF "FOOD-VESSEL" TYPE FROM
ALWINTON, NORTHUMBERLAND; NOW IN
THE BRITISH MUSEUM

HEIGHT 5 INS.

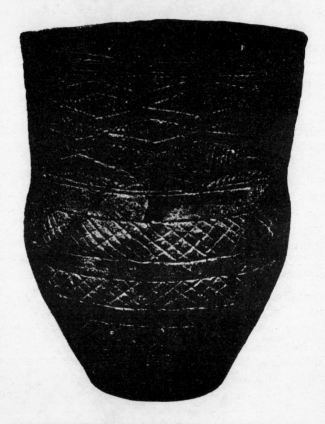

BRONZE AGE URN OF "DRINKING-CUP" TYPE FROM LAKEN-
HEATH, SUFFOLK; NOW IN THE BRITISH MUSEUM

HEIGHT 7½ INS.

of an ordinary garden flower-pot, with a deep rim round
the top, probably to give the vessel greater strength.

The so-called food-vessels[1] have received this name
because they are believed to have contained food for
the deceased in the next world. In support of this
theory it may be mentioned that remains of substances
resembling decayed food have been found in some of
the vessels in question. Urns of the food-vessel type
are shaped like a shallow bowl, and they vary in height
from 3 to 8 inches. They are usually found placed
beside the deceased.

The use of the so-called drinking-cups[2] is suggested
more by the form, which resembles that of a mug, or
beaker, slightly contracted in the middle, than by any
actual facts connected with their discovery. They are
generally placed near the deceased. The height of
the drinking-cups varies from 5 to 9 inches. The
Hon. J. Abercromby, F.S.A. (Scot.), has recently
published an elaborate monograph on the drinking-
cups of the Bronze Age entitled "The Oldest Bronze
Age Ceramic Type in Britain ; its close Analogies on
the Rhine ; its Probable Origin in Central Europe."[3]

Incense-cups were conjectured by Sir R. Colt Hoare
and the earlier archæologists to have been used for
burning some aromatic substance during the funeral
rites. The view taken by the late Mr. Albert Way,
and supported by Canon Greenwell,[4] is that they were
for carrying burning wood to light the funeral pile.
The incense-cups are the smallest of the sepulchral
vessels of the Bronze Age, being only from 1 to 3 inches
high. The shape is like that of a little cup. The sides

[1] *British Barrows,* p. 84. [2] *Ibid.,* p. 94.
[3] *Jour. Anthropolog. Inst.,* vol. xxxii., p. 373.
[4] *British Barrows,* p. 81.

are sometimes perforated. The incense-cups are often found inside the cinerary urns.

Canon Greenwell states that the urns of the four different types were found associated with unburnt and burnt bodies in the barrows opened by him on the Yorkshire wolds in the following proportions :—

	Unburnt.		Burnt.
Cinerary urns	12	...	9
	(of cinerary urn type, but without ashes)		(containing burnt bones)
Food-vessels .	57	...	16
Drinking-cups .	22	...	2
Incense-cups .	none	...	6

The geographical distribution of the different types of sepulchral urns, as far as at present ascertained, is as follows: Food-vessels are most common in Yorkshire, and most rare in Wiltshire and the south of England generally. Drinking-cups are found all over Great Britain,[1] and it is the type of urn which varies least. Incense-cups are found with greater frequency in the south of England than in the north.

Now as to the decorative features of the sepulchral pottery of the Bronze Age in Great Britain.

The sepulchral urns are made of coarse clay moulded by hand—not turned on a lathe—and imperfectly baked by means of fire. The decoration was executed whilst the clay was moist, either by

 (1) The finger-nail.
 (2) An impressed cord.
 (3) A pointed implement.
 (4) Stamps of wood or bone.

Besides incised patterns produced by these methods, the ornament was sometimes moulded in relief and

[1] See map given by the Hon. J. Abercromby in the *Jour. Anthropolog. Inst.*, vol. xxxii., pl. 24.

sometimes sunk, and the incense-cups often have orna-
mental perforations.

With the exception of the circles found on the
bottoms of some of the incense-cups the decoration
consists entirely of straight lines running more often
diagonally than either horizontally or vertically. The
same preference for diagonal lines will be observed
in the key patterns in the Irish MSS. of the Christian

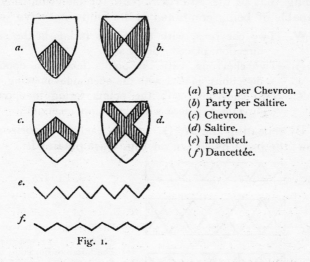

(*a*) Party per Chevron.
(*b*) Party per Saltire.
(*c*) Chevron.
(*d*) Saltire.
(*e*) Indented.
(*f*) Dancettée.

Fig. 1.

period, and led, as we shall see in a subsequent chapter,
to those modifications of the Greek fret which are
characteristically Celtic.

Of the hundreds and hundreds of sepulchral urns of
the Bronze Age that have been found in Great Britain
no two are exactly the same either in size, form, or
decoration. The fertility of imagination exhibited in
the production of so many beautiful patterns by com-
bining diagonal straight lines in every conceivable way
is really amazing. On examination it will be found

that, complicated as the patterns appear to be, the chevron or zigzag is at the base of the whole of them. We use the heraldic terms for the sake of convenience; their meaning will be understood by a reference to Fig. 1.

It will be seen that the chevron consists of two straight lines or narrow bars inclined towards each other so as to meet in a point, the form thus produced being that of the letter **V**. Now the chevron, or **V**, is capable of being combined in the following ways :—

W.—Two chevrons, with the points facing in the same direction, placed side by side.

◊.—Two chevrons, with the points facing in opposite directions, placed with the open sides meeting.

X.—Two chevrons, with the points facing in opposite directions, placed with the points meeting.

By repeating the **W**, **◊**, and **X**, each in a horizontal row, the patterns shown on Fig. 2 are obtained.

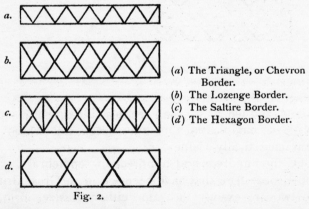

(*a*) The Triangle, or Chevron Border.
(*b*) The Lozenge Border.
(*c*) The Saltire Border.
(*d*) The Hexagon Border.

Fig. 2.

It will be noticed that the same pattern results from repeating a series of **◊**'s in a horizontal line as from repeating a series of **X**'s, so that in order to distinguish the lozenge border from the saltire border, it is necessary

to introduce a vertical line between each pair of **X**s. The hexagon border is derived from the lozenge by omitting every other **X**.

It is a principle in geometrical ornament that for each pattern composed of lines there is a corresponding pattern in which bars of uniform width are substituted for lines. Another way of stating the same proposition is, that for each pattern composed of geometrical

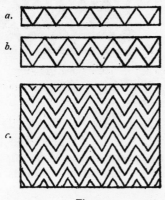

a.

b.

(a) Line Chevron Border.
(b) Bar Chevron Border.
(c) Surface Pattern, produced
 by repeating either of
 the preceding.

c.

Fig. 3.

figures (squares or hexagons, for instance) there is a corresponding pattern produced by moving the figures apart in a symmetrical manner so as to leave an equal interspace between them. This principle is illustrated by Fig. 3, where a zigzag bar is substituted for the zigzag line of the triangle or chevron border.

Then, again, another set of patterns may be derived from those composed of lines or plain bars, by shading alternate portions of the design as in chequer-work. Thus on Fig. 4 are shown three different ways of shading the chevron border, and on Fig. 5 the method of shading the patterns on Fig. 3.

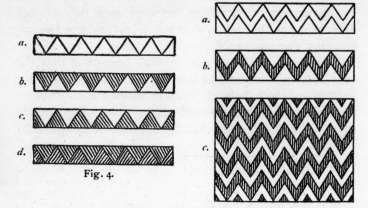

Fig. 5.

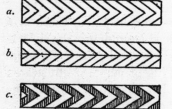

Fig. 4.

Fig. 4.—(a) Line Chevron Border.
 (b, c, and d) Different Methods of Shading (a).
Fig. 5.—(a) Bar Chevron Border.
 (b) The same as (a), but shaded.
 (c) Surface Pattern, produced by repeating (b).

A few new patterns (see Fig. 6) may be produced by placing the chevron with the point of the V facing to the right or left, thus, < or >, instead of upwards or downwards, thus, ∧ or V.

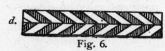

(a) Chevron Border, with V's placed thus, > >.
(b) The same as (a), but with a horizontal line through the points of the V's.
(c) The same as (a), but shaded.
(d) The same as (b), but shaded.

Fig. 6.

Figs. 7 to 10 give the triangular patterns, plain and shaded, produced by repeating the chevron border (see Fig. 2, a).

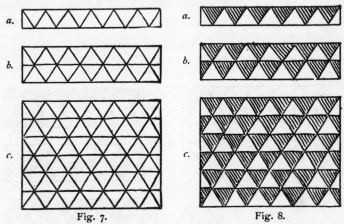

<div align="center">Fig. 7. Fig. 8.</div>

Fig. 7.—(*a*) Single Border, composed of Triangles.
 (*b*) Double Border, composed of Triangles, with the points of all the Triangles meeting.
 (*c*) Surface Pattern, composed of Triangles, with the points of all the Triangles meeting.

Fig. 8.—(*a*, *b*, and *c*) The Patterns shown on Fig. 7, shaded.

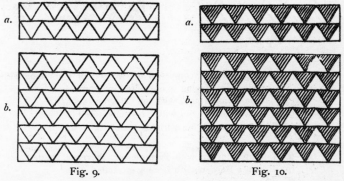

<div align="center">Fig. 9. Fig. 10.</div>

Fig. 9.—(*a*) Double Border, composed of Triangles, with the points of the Triangles in one row falling in the centres of the bases of Triangles in the row above.
 (*b*) Surface Pattern, composed of Triangles, arranged in the same way as in the preceding.

Fig. 10.—(*a* and *b*) The Patterns shown on Fig. 9, shaded.

The patterns derived from the lozenge are shown on Figs. 11 to 18.

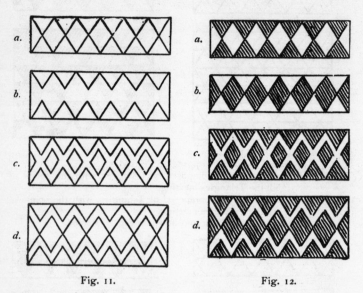

Fig. 11. Fig. 12.

Fig. 11.—(*a*) Lozenge Border, composed of two sets of Chevrons, with their points facing in opposite directions.

 (*b*) The same as (*a*), but with the Chevrons set apart.

 (*c*) The same as (*a*), but with bars substituted for lines.

 (*d*) The same as (*b*), but with bars substituted for lines.

Fig. 12.—(*a*) Lozenge Border, with Triangles or Chevrons, shaded.

 (*b*) Lozenge Border, with Lozenges shaded.

 (*c*) The same as Fig. 11 (*c*), but shaded.

 (*d*) The same as Fig. 11 (*d*), but shaded.

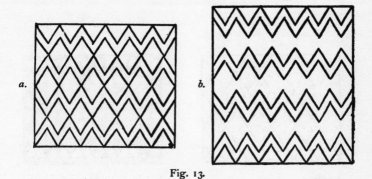

Fig. 13.

Fig. 13.—(a) Surface Pattern, produced by repeating the Bar-Chevron
Border, so that the points of all the Chevrons meet.
(b) The same as (a), but with the Chevrons set apart.

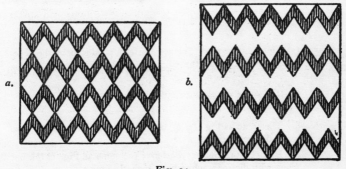

Fig. 14.

Fig. 14.—(a) The same as Fig. 13 (a), but shaded.
(b) The same as Fig. 13 (a), but shaded.

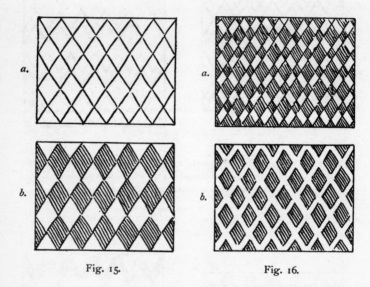

Fig. 15. Fig. 16.

Fig. 15.—(*a*) Line Lattice-work Surface Pattern, produced by the repetition of either the Chevron Border, Fig. 2 (*a*), or the Lozenge Border, Fig. 2 (*b*).

 (*b*) The same as (*a*), but shaded.

Fig. 16.—(*a*) The same as Fig. 15 (*b*), but with shaded Lozenges of two different sizes.

 (*b*) Lattice-work Surface Pattern; the same as Fig. 15 (*b*), but with diagonal white bars instead of lines.

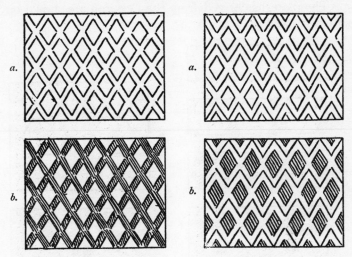

Fig. 17. Fig. 18.

Fig. 17.—(a) Bar Lattice-work-Surface Pattern; the same as Fig. 15 (a),
but with diagonal bars instead of lines.

 (b) The same as (a), but shaded.

Fig. 18.—(a) Surface Pattern, produced by repeating Fig. 11 (c).

 (b) The same as (a), but shaded.

The patterns derived from the saltire are shown on
Fig. 19.

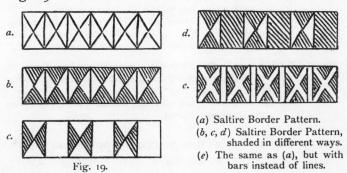

Fig. 19.

(a) Saltire Border Pattern.

(b, c, d) Saltire Border Pattern,
shaded in different ways.

(e) The same as (a), but with
bars instead of lines.

The patterns derived from the hexagon are shown on Figs. 20 and 21.

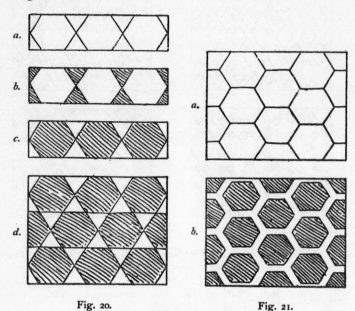

Fig. 20. Fig. 21.

Fig. 20.—(a) Hexagon Border Pattern, derived from the Lozenge Border, Fig. 2 (b), by leaving out every other **X**.

 (b) The same as (a), but with the Triangles shaded.

 (c) The same as (a), but with the Hexagons shaded.

 (d) Surface Pattern, composed of Hexagons and Triangles; produced by repeating (c), so that the Hexagons in one horizontal row adjoin the Triangles in the next.

Fig. 21.—(a) Hexagon Surface Pattern, probably derived from Fig. 11 (b), by drawing straight lines between the points of each of the Chevrons.

 (b) The same as (a), but with bars instead of lines, and having the Hexagons shaded.

The variations in the practical application of the chevron patterns, which have been described above,

to the decoration of the sepulchral pottery of the Bronze Age, are produced in the following ways :—

(1) By placing the chevrons (*a*) horizontally, or (*b*) vertically.

(2) By making the chevrons of different sizes.

(3) By altering the angle of the chevrons, *i.e.* making the points more acute or more obtuse.

(4) By shading some parts of the pattern whilst other parts are left plain.

(5) By using different methods of shading, such as plain hatching, cross-hatching, dotting, etc.

(6) By combining the chevrons with horizontal and vertical lines.

(7) By arranging the patterns in horizontal bands of different widths.

In a few cases[1] hexagonal figures occur in the decoration of the urns, but the patterns do not belong to the true hexagonal system of ornament. The hexagons were arrived at by leaving a space between the triangles of the chevrons, as on a drinking-cup found at Rhosheirio,[2] Anglesey.

The decoration of the urns is generally confined to the exterior, the only exceptions being the interiors of the lips of some of the examples and the crosses in relief found on the bottoms inside of cinerary urns from Wilts, Dorset, and Sussex.

The incense-cups have occasionally ornament on the bottoms of them which, like the crosses just mentioned, may have a symbolical significance.

Some of the urns from Ireland, Scotland, and the Isle of Man, are very beautifully decorated with sunk triangles and ovals.

[1] Ll. Jewitt's *Grave Mounds and their Contents*, p. 108. Folkton, Yorkshire.

[2] *Archæologia Cambrensis*, 3rd ser., vol. xiv., p. 271; *British Barrows*, p. 70.

The different types of urns are not all equally highly ornamented. The large flower-pot-shaped cinerary urns have least decoration, being sometimes quite plain, but in the majority of cases having a broad band of ornament round the top. The drinking-cups are more elaborately decorated than any other class of sepulchral pottery, although the food-vessels are also nearly as ornate.

The artistic quality of the decoration varies in different parts of Great Britain. Some of the most beautiful examples come from localities where there was a great mixture of aboriginal blood with that of the Celtic invaders, and it is not unlikely that the infusion of new blood may have had something to do with the excellence of the art.

The chevron, although it was more highly developed as a decorative art-motive in the Bronze Age than at any other period, was not unknown to the Neolithic inhabitants of Great Britain, and it is more than probable that the Goidelic Celts got the idea from them. Several shallow vessels with a band of chevron ornament round the rim were found in the chambered cairn at Unstan,[1] Orkney, which is of the later Stone Age. This particular chevron pattern occurs frequently in the Bronze Age. Each of the triangles formed by the chevron is filled in with hatched lines running diagonally, but alternately in directions at right angles to each other (Fig. 4, *d*, p. 30). The pattern had no doubt a structural origin, and was suggested by lashing of the description used for the hafting of stone axes, or by some similar bandaging of cords.[2]

[1] Dr. J. Anderson's *Scotland in Pagan Times : Bronze and Stone Ages,* p. 294.
[2] Prof. A. C. Haddon's *Evolution in Art,* p. 87.

A similar chevron pattern is to be seen on a bowl from the Dolmen du Port-Blanc, Saint Pierre, Quiberon, Morbihan, Brittany.[1] Possibly this may be the survival of a strengthening band of basketwork round the vessel.

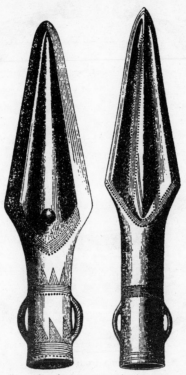

Bronze Spear-heads ornamented with rows of dots
In the Museum of the Royal Irish Academy, Dublin

The decoration of the bronze implements, gold lunulæ, and jet necklaces of the Bronze Age corresponds very nearly with that of the sepulchral pottery. All the

[1] Paul du Chatellier's *La Poterie aux Époques préhistorique et Gauloise*, pl. 12, fig. 12.

designs are founded upon the chevron, and the only differences are in the methods of execution. On the objects of metal the patterns are produced by the

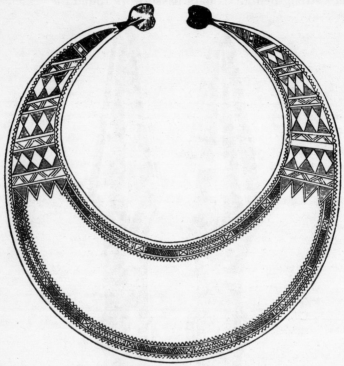

Gold Lunula from Killarney

Now in the Museum of the Royal Irish Academy, Dublin

hammer, punch, and graver,[1] and on the flat jet beads of the necklaces by a borer.

The bronze implements most frequently decorated are celts and razors, and more rarely dagger-blades and spear-heads.

[1] Sir W. Wylde's *Catal. Mus. R. I. A.*, p. 388.

Of the three classes of bronze celts, namely,[1]

 (1) Flat celts,
 (2) Winged and flanged celts,
 (3) Socketed celts,

it is only the first two that are decorated with chevron patterns in the same way as the sepulchral pottery. The socketed celts, which are later than the others, are ornamented with concentric circles resembling those on certain Gaulish terra-cotta figures.[2]

On some of the bronze spear-heads in the Museum of the Royal Irish Academy the ornament consists of lines of small dots. The dotted patterns in the Irish MSS. of the Christian period may possibly be traced to this source.

The greatest number of gold lunulæ, most of which exhibit the characteristic chevron-motive decoration of the Bronze Age, have been found in Ireland. Dr. W. Frazer has compiled a list of known examples, which will be found in the *Journal of the Royal Society of Antiquaries of Ireland.*[3] The numbers are as follows :—

Museum of the Royal Irish Academy	32
British Museum	11
Edinburgh Museum	4
Belfast Museum	1
Private Collections	3
Present owners unknown	9
Found in France	2

The decoration consists of very fine lines executed with chisel-edged punches,[4] and it is concentrated on the edges and the two horns of the crescent, the broad

[1] *Early Man in Britain*, p. 350; and *British Museum Bronze Age Guide*, p. 40.

[2] *Archæologia Cambrensis*, ser. 3, vol. xiv., p. 308.

[3] 5th ser., vol. vii., p. 41.

[4] Sir W. Wilde's *Catal. of Antiquities of Gold in Mus. R. I. A.,* p. 10.

part of the crescent in the middle being quite plain, as will be seen in the specimen illustrated on page 40 from Killarney, now in the Museum of the Royal Irish Academy in Dublin.

The lunulæ were probably worn as head-dresses or else round the neck, and the contrast between the large expanse of burnished gold and the delicately engraved patterns must have been very effective when seen flashing in the bright sunlight.

Some of the finest examples of jet necklaces have been found with Bronze Age burials in Scotland, as at Balcalk, Forfarshire; Tayfield, Fife; Torrish, Sutherlandshire;[1] Assynt, Ross-shire;[2] Melfort, and Argyllshire. They have also been found occasionally in England, as at Middleton Moor,[3] Derbyshire.

The beads of which the necklaces are composed are of three different shapes, ovoid, flat triangular plates, and four-sided flat plates. The flat beads are decorated with chevrons, triangles, and lozenges produced by rows of dots. Here again we have an instance of a kind of decoration which survived in Christian times.

The last class of remains exhibiting Bronze Age decoration are the sculptured rocks and stones. Some of the carvings are found on natural rock surfaces and boulders; others on such megalithic monuments as stone circles, dolmens, and chambered cairns; whilst numerous examples are on the slabs forming the covers or sides of sepulchral cists.

Although the megalithic structures called by the late Mr. James Ferguson "rude stone monuments" un-

[1] Dr. J. Anderson's *Scotland in Pagan Times: Bronze and Stone Ages*, pp. 53, 55, and 56.

[2] Daniel Wilson's *Prehistoric Annals of Scotland.*

[3] Bateman's *Ten Years' Diggings*, p. 25.

doubtedly belong as a class to the Neolithic period, yet some of them exhibit decorative forms which are characteristic of the Bronze Age. This suggests the interesting speculation whether the ornamental patterns used by the Celts in the Bronze Age may not have been to a large extent borrowed from the Neolithic aborigines, and also whether the absorption of the Iberian peoples by the conquering Goidels may not have had a stimulating effect on decorative art.

However this may be, it is a curious fact that the best specimens of Bronze Age ornament sculptured on stone exist in the Co. Meath, in Ireland, where such an admixture of race would be most likely to occur, and the type of monument on which the carvings are found belongs to the Neolithic period. In Ireland, therefore, either the erection of dolmens, chambered cairns, and other similar structures must have survived during the Bronze Age, or else the characteristic patterns of the Bronze Age must have been derived from a Neolithic source.

The wonderful series of chambered cairns at Newgrange, near Drogheda, and at Sliabh na Calliaghe, near Oldcastle, both in the Co. Meath, have been well known to archæologists for many years, but it is only quite recently that their decorative sculpture has been studied scientifically by Mr. George Coffey, M.R.I.A., the Curator of the Museum of the Royal Irish Academy in Dublin. The following account has been compiled chiefly from Mr. Coffey's admirable monographs on the subject, published in the *Transactions of the Royal Irish Academy*.[1]

The great prehistoric cemetery, which has been identified with the Brugh na Boinne mentioned in the

[1] Vol. xxx., p. 1.

Leabhar-na-h-Uidhri and in the Book of Ballymote, is situated five miles west of Drogheda, extending thence about three miles along the northern bank of the Boyne towards Slane. Amongst the most important of the sepulchral remains are the three great tumuli of Dowth, Newgrange, and Knowth, taking them in order from east to west. Two of the tumuli certainly contain chambers, access to which is gained by a passage leading from the exterior, and the third, judging from analogy, probably is also chambered. The Boyne tumuli are recorded in the *Annals of Ulster* to have been plundered by the Danes in A.D. 862. The chamber of the Dowth tumulus has been open since 1847; that of Newgrange since 1699, when it was first entered in modern times by Edward Lhuyd, the keeper of the Ashmolean Museum at Oxford; and that of Knowth still remains to be explored.

The sculptures at Newgrange are of such exceptional interest that it is desirable to give a brief description of the structure upon which they are found. The tumulus stands less than a quarter of a mile north-east of Newgrange House, the Dowth tumulus being 1¼ to the north-east, and the Knowth tumulus three-quarters of a mile to the north-west. The Newgrange tumulus is surrounded by a circle of stones originally consisting of thirty-five upright monoliths, twelve of which may still be traced. Four of the standing stones near the entrance are from 6 to 7 feet in height, but the remainder are of smaller size. Between the circle and the base of the mound is a ditch and a rampart of loose stones. The tumulus is also of loose stones, surrounded at the base by a continuous curb of great slabs of stone from 8 to 10 feet long, laid on edge, above which is a retaining wall of dry rubble 5 or 6 feet high. The tumulus is

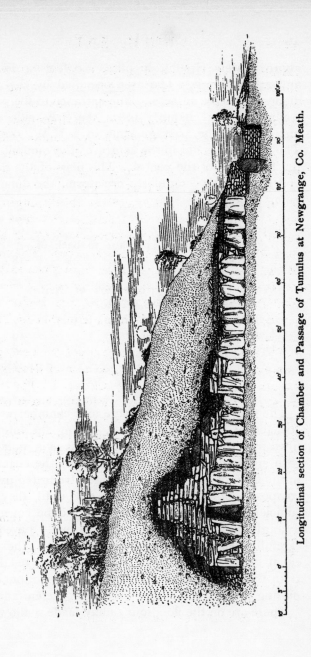

Longitudinal section of Chamber and Passage of Tumulus at Newgrange, Co. Meath.

approximately circular in plan, 280 feet in diameter, and 44 feet high. The area occupied by the mound alone is at least an acre. The entrance to the passage leading to the chamber is on the S.E. side of the mound, and the passage runs in a N.W. direction. The chamber is not in the centre of the mound, but to the S.E. side of the centre. The plan of the passage and chamber is irregularly cruciform, the dimensions being as follows :—

	Feet.	Inches.
Length of passage	62	0
Length from end of passage to back of N.W. recess	18	0
Average width of passage . . .	3	0
Width of chamber from back of N.E. recess to back of S.W. recess . .	21	0
Height of passage varies from 4 ft. 9 in. to	7	10
Height of chamber . . .	19	6
Depth of N.E. recess . . .	8	8
,, N.W. ,, . . .	7	6
,, S.W. ,, . . .	3	4

The side walls of the passage and chamber are constructed of tall upright stones, having the interstices filled in with rubble work. The passage is roofed over with single lintel stones. The roof of the chamber is in the form of an irregular six-sided truncated pyramid composed of stones corbelled out until they meet sufficiently near together at the top to be covered by a single slab. The floor was originally paved with carefully selected, water-rounded pebbles. These with equal originality and care have been removed by the Irish Board of Works, and placed in the bottom of the pit dug in front of the carved stone at the entrance.

There are on the floor four rudely made shallow stone

basins, one in each of the three recesses, and the fourth in the centre of the chamber. The one in the middle of the chamber was taken from the position it formerly occupied on the top of the basin in the N.E. recess (where it was seen by Edward Lhuyd in 1699), and placed where it now is by the over-officious zeal of the Irish Board of Works. The large stones used in the construction of the chamber are of the lower silurian grit of the district.

The following stones of the Newgrange Tumulus are sculptured :—

On exterior of Mound at Base.

No. 1.—Above entrance of passage leading to chamber.

No. 2.—Front of entrance.

No. 3.—Nearly in a line with axis of passage prolonged to cut circumference of mound on N.W. side.

No. 4.—N. side of monud.

In Passage.

N.E. side—twenty-one uprights—Nos. 3, 12, 18, and 21 sculptured, counting from entrance inwards.

S.W. side—twenty uprights—Nos. 10, 11, 17, and 20 sculptured, counting from entrance inwards.

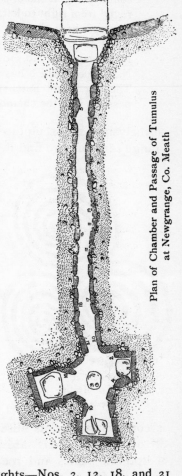

Plan of Chamber and Passage of Tumulus at Newgrange, Co. Meath

In Chamber.

Seventeen uprights—Nos. 2, 3, 4, 10, and 16 sculptured,
 commencing at end of passage S.W. side, and counting
 round from right to left. Nos. 2, 3, and 4 are in S.W.
 recess, where there is also a horizontal stone above
 No. 3 sculptured. No. 10 forms the N.E. jamb of the
 N.W. recess. No. 16 forms the S.E. jamb of the
 N.E. recess, which has also a sculptured roofing-stone.
 The horizontal lintel-stone over the opening of the
 passage into the chamber is sculptured.

Analysing the sculptured decoration of the New-
grange tumulus, we find it to consist partly of chevron
patterns and chevron deri-
vatives (such as combina-
tions of the triangle and
lozenge), and partly of
spiral ornament, together
with a few designs formed
of circles grouped round
a lozenge, and some cups
and rings. The chevron
patterns have already been
noticed on sepulchral urns,
bronze implements, and
jet necklaces of Great
Britain, and concentric
circles on socketed bronze
celts, but spiral ornament

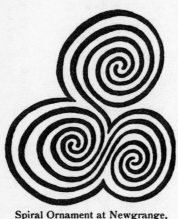

Spiral Ornament at Newgrange,
Co. Meath.
Scale ⅛ linear

is conspicuous by its absence on any of these classes
of objects. Spirals are only known to occur on
sculptured stones and rock-surfaces in Great Britain,
and on a few of the remarkable stone balls with knobs
found in Scotland. The following examples have been
recorded :—

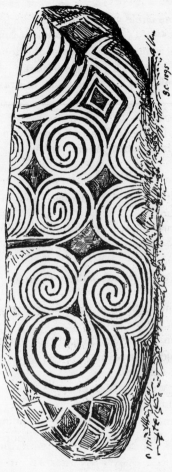

Slab with Spiral Ornament outside entrance to passage of Tumulus
at Newgrange, Co. Meath

From a drawing by George Coffey, M.R.I.A.

ENGLAND

CUMBERLAND.
Maughanby (Stone circle surrounding cist under tumulus).
Old Parks, Kirkoswald (Upright slab under tumulus).

LANCASHIRE. Calderstones, near Liverpool (Stone Circle).

NORTHUMBERLAND. Morwick (Rock surface).
Lilburn Hill Farm (Slabs of stone found in grave).

WALES

MERIONETHSHIRE. Llanbedr (Slab of stone found near hut-circles, now in Llanbedr churchyard).

SCOTLAND

ORKNEY. Eday (Stone in Pict's House, now in the Edinburgh Museum).
Firth (Slab of stone, now in the Edinburgh Museum).

ELGINSHIRE. Strypes (Standing stone).
Elgin (Stone ball).

ABERDEENSHIRE. Towie (Stone ball, now in the Edinburgh Museum).
Lumphanan (Stone ball, now in collection of Hugh W. Young, Esq., F.S.A., Scot.).

ARGYLLSHIRE. Achnabreac (Sculptured rock-surface).

AYRSHIRE. Coilsfield (Cist-cover).
Blackshaw (Rock-surface).

PEEBLESSHIRE. La Mancha (Slab of stone, now in the Edinburgh Museum).

WIGTONSHIRE. Camerot Muir, Kirkdale (Standing stone).

DUMFRIESSHIRE. Hollows Tower, Eskdale (Door-sill).

IRELAND

CO. MEATH. Newgrange (Chambered Cairn).
Dowth (Chambered Cairn).
Loughcrew (Chambered Cairn).
King's Mountain (Chambered Cairn).

Co. LOUTH. Killing Hill, Dundalk (Sepulchral Chamber).
Co. TYRONE. Knockmany (Chambered Cairn).
Co. FERMANAGH. Castle Archdall (Sepulchral Chamber).
Co. DONEGAL. Glencolumbkille (Sepulchral Chamber).

Spiral ornament is as conspicuously absent on the implements and objects of the Bronze Age in Gaul as in Britain. It is, then, to Scandinavia that we must look for the origin of the Bronze Age spirals found in this country.

In the museums at Copenhagen, Stockholm, and Christiania, may be seen splendid specimens of bronze axes, sword-hilts, and personal ornaments exhibiting spiral decoration in the greatest perfection. These are fully illustrated in A. P. Madsen's monograph on the Bronze Age, in the works of O. Montelius and J. H. A. Worsaae, and in the *Transactions* of the various archæological societies in Sweden and Denmark.

Spiral Ornament on Bronze Axe-head from Denmark

The spirals with which the objects of the Bronze Age in Scandinavia are decorated are generally arranged with their centres at equal distances apart, and connected together by S- or C-shaped curves, the former being the most common.

When spirals are arranged in a single row, the problem of how to connect the whole together so as to form a continuous running pattern does not present much difficulty, but if it is required to cover a large surface with spirals in groups of three or of four, all properly connected, the solution is not so easy as it appears at first sight. Both the metal-workers who made the Scandinavian bronze implements, and the artist who designed the sculptured decoration of the Newgrange tumulus, seem to have been unable to

master the method of arranging the S- and C-shaped connections of the spirals in proper order,[1] so as to be capable of extension in every direction over a surface of any required size. The difficulty was got over by a most ingenious artifice, as Mr. George Coffey was

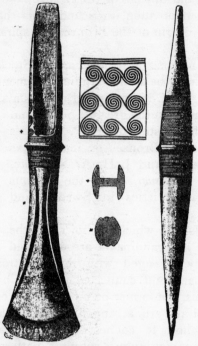

Bronze Axe-head with Spiral Ornament from Sweden

the first to point out in his monograph on "Newgrange, Dowth, and Knowth" in the *Transactions of the Royal Irish Academy* (vol. xxx., p. 25). When the spirals

[1] That is to say, the way of placing the centres of the spirals in relation to each other, and of determining how many S- or C-shaped curves should run to each centre.

are not arranged and connected together in accordance with the requirements of geometry, some of the bands which compose the ornament have loose ends, *i.e.* run to nowhere. The question was how to dispose of the loose ends so as to deceive the eye and give the appearance of a continuous pattern. It was effected very simply by carrying the loose ends right round one or more of the other spirals so as to enclose them. Good instances of this occur on the sculptured slabs at Newgrange (p. 48), and on the carved stone ball from Towie, Aberdeenshire, now in the Edinburgh Museum of Antiquities.

Mr. G. Coffey's theory, in which we feel inclined to agree, is that the spiral motive came to Ireland from Scandinavia across Scotland and the north of England. Both the geographical distribution of spirals sculptured on stone in Great Britain, and the fact that the same imperfect method of connecting the spirals together for all-over surface treatment is found in Ireland, Scotland, and Scandinavia certainly lend support to this view.

It is now generally admitted by archæologists that the spiral decoration of the Bronze Age in Scandinavia is of Mycenæan origin; and the clearest possible proof is furnished by an associated spiral and lotus motive design upon a bronze celt from Aarhöj,[1] near Aalborg, Jutland, which finds an exact parallel in the ornament upon a gold pectoral from Mycenæ.[2]

The Mycenæan spiral decoration has furthermore been clearly proved by Mr. Goodyear in his *Grammar of the Lotus* to have been borrowed from ancient Egypt; the best instance of the transference of a spiral and lotus motive pattern from Egypt to the

[1] *Mémoires de la Société Royale des Antiquaires du Nord*, 1887, p. 259.
[2] Perrot and Chipiez's *Art in Primitive Greece*, vol. i., p. 323.

Ægean being the sculptured ceiling of the beehive tomb at Orchomenos. In Egypt, the spiral is found by itself forming a continuous running border on the scarabs of Usertesen I.[1] (Twelfth Dynasty, B.C. 2758–2714), and combined with the lotus on a scarab at Turin[2] of the same period. The best examples of the use of the spiral as continuous surface ornament are to be seen on the ceilings of Egyptian tombs of the Eighteenth Dynasty (B.C. 1633–1500).[3]

The spiral motive thus was most flourishing in Egypt from the Twelfth Dynasty to the Eighteenth, say from B.C. 2758–1700.[4] After that it found its way to the Ægean, perhaps as early as 1400 B.C.,[5] and thence to Hungary, Scandinavia, and Great Britain.

The chambered tumuli at Dowth, on the Boyne, and Loughcrew, near Oldcastle, Co. Meath, resemble the Newgrange tumulus in plan and construction, but the sculptures upon the stones of the chambers and passages are not so obviously of Bronze Age type as those at Newgrange. The designs seem to be more symbolical than ornamental, and from the frequent occurrence of star- and wheel-shaped designs may have to do with sun-worship. The Loughcrew tumuli and their sculptures have been very fully described by Mr. E. A. Conwell, in the *Proceedings of the Royal Irish Academy* (vol. ix., p. 355 ; and 2nd ser., vol. ii., p. 72); by Mr. George Coffey, in the *Transactions* of the same society (vol. xxxi., p. 23) ; and by Dr. W. Frazer, in the *Proceedings of the Society of Antiquaries of Scotland* (vol. xxvi., p. 294).

[1] Flinders Petrie, *Egyptian Decorative Art*, p. 21.
[2] *Ibid.*, p. 22.
[3] *Prisse d'Avennes, Histoire de l'Art Egyptien après les Monuments.*
[4] Flinders Petrie, *Decorative Art in Egypt*, p. 28.
[5] *Journal of Hellenic Studies*, vol. xii., p. 203.

A certain proportion of the sepulchral cists of the Bronze Age in Great Britain exhibit symbolical or decorative designs. The following is a list of the examples which have been recorded :—

Ross-shire. Bakerhill.

Argyllshire. Kilmartin.
 Carnbân.

Clackmannan. Tillycoultry.

Linlithgowshire. Caerlowrie.
 Craigie Wood.

Lanarkshire. Carnwath.

Ayrshire. Coilsfield.

Cumberland. Aspatria.
 Redlands, near Penrith.

Northumberland. Ford West Field.

Yorkshire. Bernaldby Moor.

Co. Tyrone. Seskin.

The sculpture is usually on the cover-stone of the cist, but in the case of the examples at Kilmartin and at Carnbân it is on the vertical end slabs.

The sculptured designs consist of cups and rings, concentric circles, lozenges, triangles, axe-heads, curved meandering lines, and a few patterns composed of straight lines. The carvings show the same pick-marks that were observed at Newgrange.

The axe-heads on the end slab of the cist at Kilmartin[1] are of the wedge shape common in the early Bronze Age. Like the stone axes and axe-heads sculptured on the dolmens of Brittany, they probably have a symbolical meaning connected with the worship of some axe-bearing deity such as Zeus.

[1] *Jour. Brit. Archæol. Assoc.*, vol. 36, p. 146.

The designs, composed of triangles alternately covered with dots and left plain, which occur on the cist-cover from Carnwath,[1] we have already seen sculptured at Newgrange and engraved on bronze axes and jet necklaces. The grouped circles on the cist-cover from Craigie Wood[2] may also be compared with those on the slabs in the Newgrange tumulus, on the stone ball from Towie in the Edinburgh Museum, and on the chalk drums from Folkton in the British Museum.

In three cases (viz. at Coilsfield,[3] Carnwath, and Tillycoultry)[4] elaborately ornamented urns of the food-vessel type have been found in the sculptured cists, thus clearly proving the period to which the cists belong.

Sometimes slabs of stone sculptured with cup-marks, cups and rings, and spirals, have been found associated with Bronze Age burials, although not forming parts of a cist. One of the most remarkable discoveries of this kind was made at Old Parks,[5] near Kirk Oswald, Cumberland. In 1894 a barrow composed of loose stones, 80 feet in diameter and 4 feet high, was opened by the late Chancellor R. S. Ferguson, F.S.A., and when the mound was removed a row of five slabs fixed upright in the ground was disclosed. The stones were in a line pointing north and south, cutting the site of the mound into two halves, and three of them are sculptured with spirals. As many as thirty-two deposits of burnt bones were found in holes scooped out of the natural surface of the ground, together with two orna-

[1] *Proc. Soc. Ant. Scot.*, vol. x., p. 62.
[2] *Ibid.*, vol. vi., *Appendix*, p. 28.
[3] *Ibid.*, vol. vi., *Appendix*, p. 27.
[4] *Ibid.*, vol. xxix., p. 190.
[5] *Cumb. and West. Ant. Soc. Trans.*, vol. xiii., p. 389.

mented urns of incense-cup form, fragments of several other urns, and a necklace of cannel-coal beads.

A slab of stone sculptured with spirals and concentric circles was found in 1883 on Lilburn Hill[1] Farm near Wooler, Northumberland, associated with seven deposits of burnt bones buried in small circular pits.

Stones sculptured with cups, or cups and rings, have been found either as cover-stones of urns or associated with burials in round barrows at the following places:—

NORTHUMBERLAND. Ingoe.
 Black Hedon.
 Kirk Whelpington.
CUMBERLAND. Maughanby.
YORKSHIRE. Kilburn.
 Ayton Moor.
 Claughton Moor.
 Wykeham Moor.
DERBYSHIRE. Elkstone.
 Sheen.
STAFFORDSHIRE. Stanton.
DORSETSHIRE. Came Down.
SUTHERLANDSHIRE. Dornoch Links.
ABERDEENSHIRE. Greenloan, Cabrach.

A link between the art of the Bronze Age in Britain and the art of Mycenæ is afforded by a rock-sculpture at Ilkley,[2] Yorkshire, which takes the form of a curved swastika. It belongs to a peculiar class of patterns composed of winding bands and small bosses or dots, of which there are numerous examples in the Scandinavian[3] and Mycenæan[4] metal-work. Perhaps some of

[1] *Archæol. Æliana*, ser. 2, vol. x., p. 220.
[2] *Jour. Brit. Archæol. Assoc.*, vol. xxxv., p. 18.
[3] A. P. Madsen's *Antiquités préhistoriques du Danemark*.
[4] Schlieman's *Mycenæ*, pp. 166, 167, 169, 264, and 265.

the Late-Celtic designs, in which the arrangement of the long sweeping S- and C-shaped curves is governed by the position of circular bosses they connect, may be descended from the winding-band patterns of the Mycenæan period. For instance, the designs on the enamelled handles of the bowl found at Barlaston,

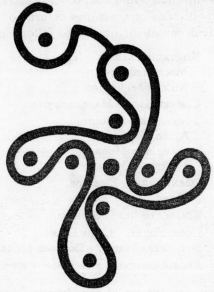

Winding Band (curved Swastika), sculptured in rock
near Ilkley, Yorkshire
Scale ⅛ linear

Staffordshire, and on the Ilkley rock-sculpture have obvious points in common, both being founded on the curved swastika.

There are in different parts of Great Britain a great number of rocks and boulders sculptured with cups, generally surrounded by concentric rings, and often having a radial groove leading from the cup outwards.

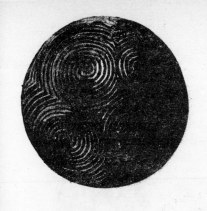

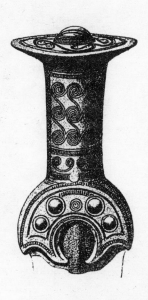

WINDING-BAND CURVED SWASTIKA
ON SWORD-HILT FROM DENMARK

PIRAL ORNAMENT ON STONE BALL FROM
TOWIE, ABERDEENSHIRE; NOW IN THE
EDINBURGH MUSEUM

SCALE $\frac{1}{1}$ LINEAR

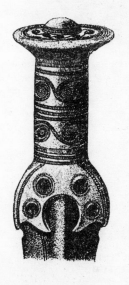

BRONZE SWORD-HILT WITH
WINDING-BAND PATTERN
FROM DENMARK

BRONZE SWORD-HILT WITH
SPIRAL ORNAMENT
FROM DENMARK

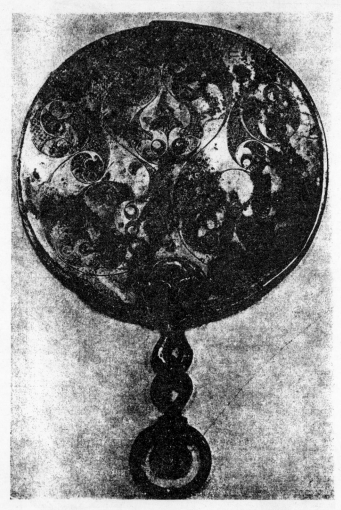

BRONZE MIRROR FROM BIRDLIP, GLOUCESTERSHIRE;
NOW IN THE GLOUCESTER MUSEUM

R. W. Dugdale photo.

The best-known instances are at Ilkley in Yorkshire, Wooler in Northumberland, the district on the east side of Kirkcudbright Bay between Kirkcudbright and the Solway Firth, and Lochgilphead and Kilmartin in

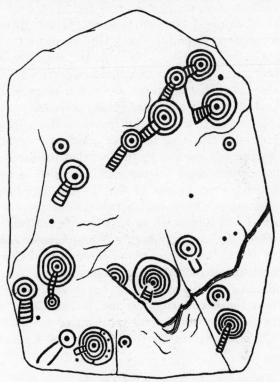

Cup-and-ring Sculptures on rock at Ilkley, Yorkshire
Scale ₁/₁₂ linear

Argyllshire. In a few cases the cup-and-ring sculptures are associated with the wheel-symbol, as at Mevagh, Co. Donegal, and at Cochno, Dumbartonshire. Such sculptures are more likely to be symbolical than decorative, but it would take us too far afield to

discuss their meaning here. Those who wish to pursue
the subject further may with advantage consult Sir
James Simpson's valuable paper on "Ancient Sculp-
turings of Cups and Concentric Rings," forming the
Appendix to vol. vi. of the *Proc. Soc. Ant. Scot.*

The sculptured rock-surfaces of Great Britain in
some respects resemble the "Hällristninger" on the
west coast of Sweden. The cup and ring, the wheel-
symbol, and the curved swastika are common to both,
but the Swedish sculptures are much more elaborate
and include figure-subjects, ships, animals, etc. The
age of some of the sculptures is indicated by the
characteristic shape of the axes (evidently of bronze)
held by the figures, and by the fact that the same set of
symbols which occur on the rocks are also to be seen
on the engraved knives of the Bronze Age found in
Scandinavia. The Swedish rock-sculptures are fully
described and illustrated in L. Baltzer's *Hällristningar
fran Bohuslan*, A. Holmberg's *Skandinaviens Hällrist-
ninger,* and the *Mémoires* of the International Congress
of Prehistoric Archæology at Stockholm.

Summing up the results of our investigations, we
find that the peculiarities in the Pagan Celtic art of
the Bronze Age which were transmitted to the Pagan
and Christian styles of the Early Iron Age are as
follows :—

(1) The use of the closely coiled spiral.
(2) The use of rows of dots.
(3) The use of diagonal lines in preference to those run-
ning horizontally or vertically.
(4) The use of designs founded on the curved swastika.

Of all these the spiral decorative motive is by far the
most important, as we shall see in a subsequent chapter.

CHAPTER III

PAGAN CELTIC ART IN THE EARLY IRON AGE

INTRODUCTION OF THE USE OF IRON INTO BRITAIN BY THE BRYTHONIC CELTS, CIRCA B.C. 300

IN a previous chapter we pointed out the difference between the Q and the P Celts, the former being Goidels in the Bronze Age, and the latter Brythons in the Iron Age, when they first arrived in Britain. We will now proceed to consider the nature of the culture introduced with the use of iron into this country from Gaul by the Belgic or Brythonic Celts.

NATURE OF THE CIRCUMSTANCES WHICH HAVE LED TO THE FINDS OF OBJECTS OF THE EARLY IRON AGE IN GREAT BRITAIN

A great variety of circumstances have led to the discovery of objects of the Early Iron Age. Where they have not been buried at any great depth beneath the surface of the ground, the plough[1] has frequently been the means of bringing them to light. The making of roads[2] and railways,[3] drainage of land for agricultural purposes,[4] military fortifications,[5] quarrying[6] and

[1] As at Polden Hill, Somersetshire.
[2] As at Birdlip, Gloucestershire.
[3] As at cuttings near Bedford and between Denbigh and Corwen.
[4] As at Westhall, Suffolk.
[5] As at Mount Batten, near Plymouth.
[6] As at Hamdon Hill, Somersetshire.

61

mining,[1] have also had their share in helping the
archæologist. A considerable number of antiquities
which have found their way into the beds of rivers
have been recovered in the course of dredging opera-
tions for the improvement of inland navigation[2] and
building of bridge foundations.[3] Tumuli,[4] camps,[5]
caves,[6] sites of towns[7] and villages,[8] crannogs,[9] etc.,
have yielded a plentiful harvest to the scientific ex-
plorer. In some cases the denudation of the wind[10] or
the erosion of the sea[11] has removed the covering of sand
by which the traces of the ancient inhabitants have
been concealed for centuries. The rabbit,[12] although
the enemy of the farmer, sometimes becomes the friend
of the antiquary by throwing up priceless relics of the
past out of his burrow. Lastly, pure accident[13] is now

[1] As at Hunsbury, near Northampton.
[2] As in deepening the Shannon, Thames, and Witham.
[3] As at Kirkby Thore, on the Eden, Westmoreland.
[4] As at Arras, Yorkshire.
[5] As at Mount Caburn, near Lewes.
[6] As at Settle, Yorkshire; Deepdale, Derbyshire; and Kent's Cavern
near Torquay.
[7] As at Great Chesters and Silchester.
[8] As at Glastonbury, Somersetshire.
[9] As at Lisnacroghera, Co. Antrim; Strokestown, Co. Roscommon;
and Lochlee, Ayrshire.
[10] As on the Culbin Sands, Elginshire, where in 1827 a sportsman
having lost his gunflint, found a splendid Late-Celtic bronze armlet,
whilst seeking for another flint on the site of a Neolithic settlement covered
with blown sand, except where denuded by the wind.
[11] As at Hoylake, in Cheshire, where the encroachment of the sea on
the portion of the coast lying between the estuaries of the Dee and the
Mersey washes out antiquities of every period from the submarine forest
and the sandhills above it.
[12] A beautiful Late-Celtic bronze armlet was found at Stanhope,
Peeblesshire, by the tenant of the farm, whilst searching for a rabbit,
under a large flat stone on the hillside.
[13] As in the case of the hoard of gold objects of bullion value, amount-
ing to £110, found at Shaw Hill, Peeblesshire, by a herd-boy who saw
something glitter in the ground, and scraped out the torques and other
relics with his foot.

and then the agent by which the position of a long-forgotten hiding-place for valuables is made known.

GENERAL CHARACTER OF THE FINDS OF OBJECTS OF THE EARLY IRON AGE

The general character of the finds of objects of the Early Iron Age is almost as varied as the circumstances which have led to their recovery from oblivion, and they may be classified according to their nature, as follows :—

(1) Sepulchral remains.
(2) Remains found on inhabited or fortified sites.
(3) Hoards of objects purposely concealed.
(4) Objects accidentally lost.

Sepulchral Remains.—The sepulchral deposits of the Early Iron Age differ greatly, both as regards the methods of burial adopted in each case, and the kind of grave-goods placed with the deceased. This is to be accounted for by a difference of time rather than area ; and it is only natural to find the Bronze and Iron Ages merging into one another, whilst towards the close of the Late-Celtic Roman and even Saxon influence began to be felt.

Possibly the earliest sepulchral remains of the Late-Celtic period that have been found in England are the burials under mounds at Arras, on the Yorkshire Wolds, which were explored by the Rev. E. W. Stilling-fleet, D.D.,[1] in 1815-17, and the Rev. Canon W. Greenwell[2] in 1876. The bodies were not cremated, as was generally the case in the Bronze Age, and also subsequently during the Romano-British period ; but were

[1] *Memoirs of the Meeting of the British Archæological Institute held at York in* 1846, p. 26.
[2] Greenwell's *British Barrows*, p. 454.

buried in excavations in the chalk, and the place of sepulture marked by a tumulus. The so-called Queen's Barrow at Arras, when opened by the Rev. W. Stillingfleet, was found to contain the skeleton of a female, with the feet gathered up, and the head to the north. The grave-goods consisted of one hundred glass beads, two bracelets, rings of gold and amber, and a pair of tweezers.

In another barrow at Arras, the Rev. W. Stillingfleet discovered the remains of a warrior resting on the smooth pavement of a circular excavation in the chalk, 8 to 9 yards in diameter, and 1 foot 6 inches deep, lying on his back, with his arms crossed over the breast. He had been interred with his chariot, a pair of horses completely harnessed, and two wild boars.

A third barrow explored by the Rev. W. Stillingfleet also covered the skeleton of a warrior with the remains of his martial equipment, consisting of the bosses of his shield, one wheel of his chariot, two of his horses' bridle-bits. Two wild boars' tusks (one of which was perforated with a square hole, and enclosed in a case of thin brass) were associated with this burial; indicating, perhaps, some religious or superstitious belief connected with this animal.[1]

A portion of the antiquities mentioned are now in York Museum, and the Rev. W. Stillingfleet's manu-

[1] A Late-Celtic boar's head of bronze was found at Liecheston, in Banffshire, in 1816 (see Dr. J. Anderson's *Scotland in Pagan Times: Iron Age*, p. 117). Three little bronze figures of boars, from Hounslow, now in the British Museum, are illustrated in the *Proc. Soc. Ant. Lond.* (2nd ser., vol. iii., p. 90); and the splendid bronze shield from the Thames at Battersea, in the same collection, has a boar represented upon it (see Kemble's *Horæ Ferales*, pl. 14). The boar also occurs on one of the Scotch symbol-bearing slabs at Knock-na-Gael, near Inverness (see Stuart's *Sculptured Stones of Scotland*, vol. i., pl. 38). For a boar on a helmet, see account of Benty Grange tumulus on p. 67.

script notes on his diggings in 1815-17 are preserved in the Library of the York Philosophical Institute.

The barrow at Arras, opened by the Rev. Canon W. Greenwell, covered a circular grave, 12 feet in diameter, sunk in the chalk to a depth of 3 feet, on the floor of which was laid the skeleton of a woman, resting on the left side, with her left hand up to the face, and the head to the west. Two tame pigs were buried with the deceased, and the grave-goods comprised an iron mirror, a bronze harness-ring, a pair of iron chariot-wheels, two snaffle-bits, and what may have been a whip-shank.

In 1875 Canon Greenwell explored a tumulus near Beverley, in Yorkshire, which yielded two chariot-wheels and a bridle-bit, but no human or other bones.

In July, 1897, Mr. J. R. Mortimer, of Driffield, opened 16 out of a group of 178 barrows, called "Danes' Graves," near Pockthorpe Hall, two miles west of Kilham, E. R. Yorkshire.[1] The burial-mounds were from 10 to 33 feet in diameter, and from 1 foot 3 inches to 3 feet 6 inches high, covering graves, either oval or oblong with rounded corners, about 7 feet long by 5 feet wide by 2 feet deep. All the bodies were unburnt and buried in the doubled-up attitude characteristic of the Neolithic period. A beautiful bronze pin, inlaid with shell, was associated with the skeleton of a female in a grave beneath the largest of the mounds, and in another were found two male skeletons buried with a chariot, the iron tyres of the wheels and the iron hoops of the naves of which still remained together with the two iron snaffle bridle-bits of the horses. The antiquities derived from the "Danes' Graves" are now in the

[1] *Reliquary* for 1897, p. 224 ; *Proc. Soc. Ant. Lond.*, 2nd ser., vol. xvii., p. 119.

Museum of the York Philosophical Society. The average breadth index of the skulls was ·735.

The burials just described bear a marked resemblance to those of Gaulish warriors at Berru[1] and at Gorge-Meillet,[2] both in the Department of the Marne in France, and may have belonged to the Celtic tribe of the Parisi, who gave their name to Paris in Gaul, and who colonised or conquered parts of Yorkshire.

Canon Greenwell describes the result of opening four barrows of the Early Iron Age in the parish of Cowlam,[3] in Yorkshire, in all of which were found the skeletons of females, laid on the natural surface of the ground, resting on the left side, with the hands up to the face, and the head to the north-east. The grave-goods from the first barrow consisted of a bronze armlet, a bronze fibula with an iron pin, and seventy exquisite blue glass beads; and from the second, of an ornamental armlet. From the remaining two barrows only fragments of pottery were obtained.

Mr. J. R. Mortimer explored a grave dug in the chalk, but without any mound above it, in 1868, a quarter of a mile north-east of Grimthorpe[4] House, near Pocklington, in Yorkshire. It measured 4 feet 6 inches long, by 2 feet 9 inches wide, by 4 feet deep, and contained the skeleton of a young man, placed on the floor of the grave, resting partly on the back, with the knees and head inclined to the left side, the lower extremities drawn up, the hands on the breast, and the head to the

[1] A. Bertrand, *Archéologie Celtique et Gauloise*, 2nd ed., 1889, p. 356.

[2] E. Fourdrignier, *Double Sépulture Gauloise de la Gorge-Meillet.*

[3] *British Barrows*, p. 208, Nos. li. to liv. The results of the exploration are now in the British Museum. The bronze objects are engraved in Sir J. Evans' *Ancient Bronze Implements*, pp. 387, 388, and 400.

[4] *Reliquary*, vol. ix., p. 180, and Ll. Jewitt's *Grave-Mounds and their Contents*, pp. 237 and 263.

south. Associated with the burial were sixteen bone implements, a sword-sheath, the umbo of a shield, a disc of bronze with repoussé ornament, and bits of rude pottery.

The number of burials of the Early Iron Age that have been found in Great Britain is extremely small as compared with those of the Ages of Stone and Bronze. This would seem to indicate that the period between the introduction of iron into this country and the commencement of the Roman occupation cannot have been very long; and that if the new metal was brought in by a foreign invasion rather than by peaceful commercial intercourse, nothing like the extermination of the native inhabitants, who used bronze and cremated their dead, can have taken place.

As we have seen, a large proportion of the sepulchral remains of the Early Iron Age have been derived from Yorkshire; but other instances have come to light in Derbyshire, Staffordshire, Kent, Gloucestershire, Devon, and Cornwall.

The Rev. Mr. Pegge has given an account in the *Archæologia*[1] of the opening of a tumulus on Garratt's Piece, Middleton Common, Derbyshire, a mile and a half south-east of Arbelows, and ten miles south-east of Buxton. The body had been laid on the surface of the ground, lying east and west. With it were found one of the circular enamelled discs to which reference will be made subsequently; a shallow basin of thin brass, much broken and crushed; and part of the iron umbo of a shield.

At Benty Grange, in Derbyshire, eight miles south-east of Buxton, on the road to Ashbourne, and one mile

[1] Vol. ix., p. 189: letter read May 8th, 1788; and T. Bateman's *Vestiges of the Antiquities of Derbyshire*, p. 24.

north-west of Arbelows, Mr. Thomas Bateman[1] excavated a barrow, about 2 feet high, surrounded by a fosse. The body had all decayed, except the hair; but in the spot where it had been deposited was a remarkable assemblage of relics, consisting of a leathern cup mounted with silver round the edge, and having wheel- or cross-shaped silver ornaments round the bowl; three circular enamelled discs of the same class as those from the Middleton Common tumulus previously described; an iron helmet surmounted by the figure of a hog of iron with bronze eyes, having a small silver cross inlaid on the nasal; a buckle; fragments of chains, etc. This burial, presenting some Celtic characteristics, belongs to a late period, possibly even after the Roman occupation.

Two Early Iron Age burials are recorded as having been discovered in Staffordshire, one at Alstonfield, the other at Barlaston. The barrow near Alstonfield, called Steep Lowe,[2] was composed of loose stones, and was 50 feet in diameter, and 15 feet high. The Iron Age interment was a secondary one, the tumulus having been made originally in the Bronze or Stone Age. The body was laid on its back; and amongst the grave-goods were a spear-head, a lance-head, and a knife (all of iron), some fragments of a highly ornamented drinking-cup, a stud of amber, and Roman coins of Constantine and Tetricus.

The burial at Barlaston,[3] unlike the one just described, was not in a mound, but in a grave, 7 feet long by 2 feet wide, by 1 foot 3 inches deep, cut in the solid red sandstone rock. With the body were associated a

[1] *Ten Years' Diggings*, p. 28.
[2] Bateman's *Vestiges of the Antiquities of Derbyshire*, p. 76.
[3] Ll. Jewitt's *Grave-Mounds and their Contents*, p. 258; and *Archæologia*, vol. lvi., p. 44.

beautifully ornamented flat bronze ring of Late-Celtic character; three circular, enamelled discs of the type found in the barrow on Middleton Moor; some fragments of a bronze bowl, which Mr. Ll. Jewitt erroneously conjectured to have formed portions of a helmet; and blades of an iron sword and knife.

No discovery of sepulchral remains belonging to the Late-Celtic period surpasses in interest that made in 1879, between Birdlip[1] and Crickley, on the Cotteswold Hills, seven miles south-east of Gloucester, both on account of the completeness of the series of objects buried with the deceased, and the extreme beauty of some of them as works of art.

Whilst repairing the road, Joseph Barnfield unearthed three skeletons interred with the feet to the south, in graves protected by thin slabs of stone placed on edge. The central skeleton was that of a female, and those on each side males. The following grave-goods were associated with the female: a bronze bowl (laid on the face of the deceased); a silver fibula plated with gold; a necklace consisting of thirteen amber beads, two jet beads, and one marble bead; a tubular brass armlet; a brass key-handle; a bronze knife-handle ornamented with a beast's head, having small knobs at the ends of the horns; and last, but not least, a superb bronze mirror.

Another very similar find of skeletons in graves formed of stones placed on edge was made in 1833 at Trelan Bahow,[2] in the parish of St. Keverne, in Cornwall, ten miles south-east of Helston. With one of

[1] See John Bellows, in *Trans. of Bristol and Gloucestershire Archæol. Soc.*, vol. v., p. 137. The objects found are now in the Gloucester Museum.

[2] See J. Jope Rodgers in *Archæol. Journ.*, vol. xxx., p. 267.

the skeletons was a beautiful bronze mirror, now in the British Museum.

Sepulchral deposits of the same period, which have also yielded mirrors, were brought to light in the course of military works at Mount Batten,[1] near Plymouth, in the spring of 1865. The burials, however, in this case were not in stone-lined graves near the surface, but in pits from 4 feet to 4 feet 6 inches deep, excavated in the disintegrated rock. In addition to a bronze mirror and the handles of two others, the following objects were obtained : two jointed bronze armlets, two plain bronze armlets, four fibulæ, three bronze rings, a bronze cup, an iron dagger, and a pair of shears, black pottery, and fragments of glass. Ancient British coins had been found previously at Mount Batten,[3] indicating a settlement here, perhaps in the first century B.C.

The exploration of the Late-Celtic urn-field at Aylesford,[3] in Kent, three miles north-west of Maidstone, by Dr. Arthur Evans, has been the means of extending our knowledge of the art of this period in a most unexpected manner, and has supplied the missing links between the culture of Britain in the first three or four centuries B.C., and that of La Tène on the Continent, which in its turn can be shown to have been strongly influenced by the civilisation of the ancient Venetian country at the head of the Adriatic.[4] The shape of the tall, cordoned, pedestalled vases, and other peculiarities of the pottery from Aylesford, were

[1] See J. Spence Bate in *Archæologia*, vol. xl., p. 500.
[2] Sir J. Evans' *Ancient British Coins*, pp. 72 and 106.
[3] *Archæologia*, vol. lii., p. 315.
[4] Dr. Arthur J. Evans' third Rhind Lecture on the "Origins of Celtic Art," as reported in the *Scotsman*, December 14th, 1895.

things entirely unknown to archæologists previously, and enable a distinction now to be drawn between the fictile ware of the Late-Celtic period and that of the Romano-British period. The discovery also of bronze objects of Italo-Greek manufacture of the second century B.C., associated with Late-Celtic burials, clearly indicates that there must have been a much more intimate trade-intercourse between Britain and the southern parts of Europe, in pre-Roman times, than has hitherto been suspected.

The Late-Celtic urn-field at Aylesford was uncovered in 1886, at Messrs. Silas Wagon and Son's gravel-pit, in the course of removing the surface earth which here overlies the old river-deposits to a depth of 3 feet or so. One of the first burial-pits which attracted attention was circular, and about 3 feet 6 inches deep, the sides and bottom being coated with a kind of chalky compound. In the pit were found a bronze *situla*, or pail, splendidly ornamented with repousse work in the Late-Celtic style, and containing calcined bones; an *œnochoe*, or wine-jug; and *patella*, or shallow pan, of imported Italo-Greek fabric; fragments of a second *situla*; a bronze fibula; and fragments of pottery.

From another grave, about 1 foot 6 inches deep, situated 200 yards north-west of Aylesford Church, was obtained a bronze-plated tankard with two handles, of the same class as the Trawsfynydd tankard, surrounded by a circle of five or six earthenware vases, one of these being the finest pedestalled urn collected from the site. All the antiquities from Aylesford are now in the British Museum.

Remains of the Early Iron Age found on Inhabited or Fortified Sites.—Next in importance to the sepulchral remains, as affording indications of the culture of the

Early Iron Age, come the remains derived from inhabited or from fortified sites. And it may be remarked in passing that it is impossible to separate the inhabited from the fortified sites, because in these early times the state of the country was so unsettled that no isolated place of residence, village or town, could afford to do without some means of defence, either natural or artificial.

The inhabited site which bids fair to rival all others in the varied nature of the relics obtained from it, and the light they help to throw on the arts and industries of the Early Iron Age in Great Britain, is the Glastonbury Marsh Village. As the explorations begun by Mr. Arthur Bulleid, F.S.A., in 1892 are still in progress, it would be premature to pass an opinion upon the finds until they are completely exhausted. For an account of what has been already discovered there, the reader is referred to Mr. Bulleid's paper on the subject, which appeared recently in the *Proceedings of the Somersetshire Archæological Society*.[1] A bronze bowl is there illustrated which seems to be of the same kind as those derived from the graves, but it is ornamented with raised bosses instead of with circular plaques of enamel. The handle of a mirror, like those from the graves, was also found at the Glastonbury Marsh Village in 1896.

From the exploration of this settlement we have obtained a knowledge of the peaceful pursuits and methods of life of the Late-Celtic inhabitants, which could never have been derived from their sepulchral remains. We now know that they were expert potters, wood-carvers, coopers, and weavers,[2] applying the

[1] Vol. xl. (1893).

[2] Ornamental weaving was, no doubt, practised. Although we have no absolute proof of this, the La Tène helmet from Gorge-Meillet (Marne), previously mentioned, has a sort of swastika pattern upon it, suggestive of a textile origin.

same beautiful flamboyant forms of decoration that are characteristic of the metal-work of the period to earthenware and wooden vessels. The long-handled weaving-combs, which are so well known in the Pictish towers, or *brochs*, of the north of Scotland, have been found here also. Amongst the iron implements was a bill-hook for lopping the branches of trees—a most useful appliance for clearing away undergrowth in forests, procuring firewood, and building wattled structures. Unbaked ovoid clay pellets have been dug up in hundreds. These were probably sling-stones, indicating that the inhabitants must have been expert fowlers.

The dwellings appear to have been circular or oval wattled huts, the rudeness of which stands out in marked contrast to the high artistic taste and technical skill of the inhabitants.

A few of the crannogs of Scotland[1] and Ireland,[2] whose structure is somewhat analogous to the Glastonbury Marsh Village, have also yielded Late-Celtic objects, but not in such quantities as to give evidence of permanent occupation over a considerable period.

Hunsbury,[3] two miles south-west of Northampton, which has been called the English "La Tène," is a good example of a Late-Celtic *oppidum*. The camp is of oval shape in plan, measuring 560 feet by 445 feet, and defended by a single earthen rampart and ditch.

[1] At Lochlee and at Lochspouts, Ayrshire; Dowalton, Wigtownshire; and Hyndford, Lanarkshire (see Dr. R. Munro's *Lake-Dwellings of Scotland*).

[2] Lisnacroghera and Craigywarren, Co. Antrim; Strokestown and Ardakillen, Co. Roscommon; Lagore, Co. Meath; and Ballinderry, Co. Westmeath (see Wood Martin's *Lake-Dwellings of Ireland*).

[3] See Sir Henry Dryden in *Associated Architectural Societies' Reports*, vol. xviii. (1885), p. 53.

The area enclosed is about four acres. Between 1880 and 1886 the whole of the interior was excavated to obtain ironstone, which lay in a bed 12 feet thick, at a depth of 7 feet 6 inches below the natural surface of the ground.

In the course of the excavations about three hundred refuse-pits, averaging 5 feet in diameter, and dug in the soil overlying the ironstone, were discovered. Amongst the contents of the pits were two bronze sword-sheaths, one of them highly ornamented in the Late-Celtic style;[1] three fibulæ, bridle-bits and cheek-pieces of bone, a chariot-wheel, iron saws, knives, spear-heads, etc.; one hundred and fifty quernstones, reckoning the upper and lower stones separately; eight spindle-whorls, long-handled weaving-combs, and pottery with Late-Celtic decoration. All these antiquities are now in the Northampton Museum.

The camp on Mount Caburn, two miles south of Lewes, in Sussex, explored by General Pitt-Rivers[2] in 1878, seems to have been an *oppidum* of the same class as that at Hunsbury, and the relics indicated the same kind of culture. The pits found at Mount Caburn were some of them oval, and others oblong, 5 to 7 feet in diameter, and 5 feet deep. The objects obtained from the pits included ornamental pottery, long-handled weaving-combs, an iron billhook like the one from the Glastonbury Marsh Village, and three ancient British tin coins.

The fine collection of Late-Celtic horse-trappings, etc., now in the Duke of Northumberland's private Museum at Alnwick Castle, was found in 1844, in a pit about 5 feet deep, within an earthen entrenchment

[1] Engraved in the *Archæologia*, vol. lii., p. 762.
[2] *Archæologia*, vol. xlvi., p. 423.

at Stanwick, in Yorkshire, seven miles north of Rich-
mond.[1]

A few Late-Celtic objects have been derived from
Roman towns[2] and stations[3] in England; and also from
the *weems*,[4] or underground houses, and the *brochs*,[5] or
Pictish towers of Scotland.

The bone-caves which were the permanent habita-
tions of Palæolithic and Neolithic man in Britain served
as temporary places of refuge for the Brit-Welsh popu-
lation during the troublous times immediately succeed-
ing the Roman evacuation of this country. Gildas'
account of the Britons leaving their houses and lands,
and taking shelter in the mountains, forests and caves,
whence they were able successfully to repel the inroads
of the Picts and Scots,[6] is fully borne out by archæolo-
gical research.[7]

The principal caves which have yielded relics of this
period are Kirkhead[8] Cave in Lancashire; the Victoria,[9]

[1] *Memoirs of the Meeting of the Archæological Institute of Great
Britain and Ireland at York in* 1846, p. 88; Dr. J. C. Bruce's *Catalogue
of the Antiquities at Alnwick*, p. 38.

[2] As in Silchester. These have not been illustrated, but are to be seen
in the Reading Museum.

[3] As in Æsica (Great Chesters) (*Archæologia Æliana*, 2nd ser.,
vol. xvii., p. xxviii.).

[4] As at Castle Newe, Aberdeenshire, and Grange of Conan, Forfar-
shire (see Dr. J. Anderson's *Scotland in Pagan Times: Iron Age*, pp. 141
and 160).

[5] As at Okstrow and at Harray in Orkney (*Ibid.*, pp. 219, 236).

[6] Gildas, xvii.; Bede's *Eccl. Hist.*, bk. i., chap. xiv.

[7] Prof. W. Boyd Dawkins' *Cave-Hunting*, p. 106.

[8] Three miles south of Cartmel, on the shore of Morecambe Bay
(*Cave-Hunting*, p. 125).

[9] A mile and a half north-east of Settle (*Cave-Hunting*, p. 81; and
H. Eckroyd Smith in *Trans. of Hist. Soc. of Lancashire and Cheshire*,
vol. for 1866, p. 199; and Roach Smith's *Collectanea Antiqua*, vol. i.,
p. 67).

Kelko,[1] and Dowkerbottom[2] Caves in Yorkshire; Poole's[3] Hole and the Deepdale[4] Cave in Derbyshire; Thor's[5] Cave in Staffordshire; and Kent's[6] Cavern in Devonshire.

The character of the antiquities derived from the caves does not differ materially from that of the remains from the crannogs and the *oppida*, although a few things of peculiar form have been found in some of the caves, such as the spoon-shaped bone-pins from the Victoria and Dowkerbottom Caves, and the bone whistles from Thor's Cave. The fibulæ from the Victoria and the Deepdale Caves are of remarkable beauty. Evidence of spinning is afforded by the long-handled comb from Thor's Cave, and the numerous spindle-whorls from others. The discovery of Roman coins and Samian ware indicate the period at which the Brit-Welsh sought refuge in these recesses of the rock.

Hoards of Late-Celtic Objects purposely concealed.— The horse-trappings found in an excavation at the bottom of one of several oblong pits, 7 feet long by 3 feet wide by 4 feet deep, at Hagbourne Hill[7] in Berkshire, two miles south of Didcot, seem to have been purposely hidden; as also the horse-trappings which were discovered in the chink of the rock by quarrymen at Hamdon Hill[8] in Somersetshire, five

[1] Overlooking Giggleswick, one mile north-west of Settle.

[2] Between Kilnsey and Arncliffe, ten miles north-east of Settle (*Proc. Geol. and Polytech. Soc. of W. Riding of Yorksh.* for 1859, p. 45).

[3] A mile south-west of Buxton (*Cave-Hunting*, p. 126).

[4] Three miles south-east of Buxton (*Derbyshire Archæol. Soc. Trans.*, vol. xiii., p. 196).

[5] Near Grindon, eight miles north-west of Ashbourne (*Reliquary*, vol. vi., p. 201, and *Trans. Midland Sci. Assoc.*, 1864–5, p. 1).

[6] One mile north-west of Torquay. There is a fragment of pottery, with Late-Celtic ornament upon it, from Kent's Cavern, in the British Museum.

[7] *Archæologia*, vol. xvi., p. 348. [8] *Ibid.*, vol. xxi., p. 39.

miles west of Yeovil. Another instance of intentional
concealment is afforded by the beautiful bronze mirror
that was found, with other ornamental pieces of bronze,
wrapped in a cloth, and covered by the upper stone of
a quern, at Balmaclellan,[1] two miles north-east of New
Galloway, Kirkcudbrightshire.

Late-Celtic Objects accidentally lost.—Besides the
Late-Celtic objects which have been dropped by their
original owners on dry land, and got covered with the
soil and thus been preserved, it is remarkable in how
many cases they have been lost whilst crossing or navi-
gating rivers, especially the Thames,[2] Witham,[3] Tyne,[4]
and Tweed.[5]

FINDS OF CELTIC COINS IN BRITAIN

The earliest native coinage of Britain belongs to the
Iron Age, and dates from 200 to 150 B.C. Sir John
Evans has collected together all the known facts relating
to the numismatics of this period in his *Coins of the
Ancient Britons*, and gives excellent maps showing the
geographical distribution of the finds. Prof. John
Rhys, in his *Celtic Britain* (p. 19), says :—

"The coinage of Britain had been modelled in the first
instance after that of Gaul, which, in its turn, can be traced to
the Phocæan Greeks of Massilia or Marseilles, through
whom the continental Gauls became acquainted in the latter
part of the fourth century before Christ with the gold stater
of Philip II. of Macedon. This was a fine coin, weighing

[1] Dr. J. Anderson's *Scotland in Pagan Times: Iron Age*, p. 126.

[2] Shield (*Archæologia*, vol. xxiii., p. 96); helmet (in the British
Museum); fibula (*Proc. Soc. Ant. Scot.*, 2nd ser., vol. xv., p. 191).

[3] Shield (*Archæologia*, vol. xxiii., p. 96); sword-sheath (J. C. Bruce's
Catal. of Alnwick Mus.); daggers (Kemble's *Horæ Ferales*, pl. 17).

[4] Fibulæ (*Illustrated Archæologist*, vol. ii., p. 157).

[5] Sword-sheath (*Archæologia*, vol. xlv., p. 45).

133 grains, and having on one side the head of Apollo wreathed with laurel, while the other showed a charioteer in a biga, with Philip's name underneath. It was imitated by the Gauls fairly well at first, but as it got further removed from the original in time and place, the figures degenerated into very curious and fantastic forms."

Before the landing of Julius Cæsar in Britain in 55 B.C. the Cantii, the Dutoriges, the Catuvelauni, and the Trinovantes each had coinages of their own, but entirely devoid of lettering. The lettered coins begin with those of Commios, dating from a period some time before 30 B.C., after which come those of his three sons—Tincommios, Verica, and Eppillos. Prof. J. Rhys[1] says:—

"The coins of Commios, and some of the earlier ones of Tincommios, continued the degenerate imitations of the Macedonian stater without showing any Roman influence; but it was not long after Augustus became emperor, in the year 30, that Tincommios copied the Latin formula, in which the former styled himself *Augustus Divi Filius*, or the son of his adoptive father, Julius Cæsar, who had now got to be officially called *Divus*, or the god. So Tincommios had inscribed on his money the legend *Tinc. Commi F.*, or even shorter abbreviations, meaning Tincommios son of Commios; and the grotesque traits derived from the stater soon disappear in favour of classical designs of various kinds, proving very distinctly that the influence of Roman art was beginning to make itself felt in the south of Britain."

The coins which have been assigned to the Dobunni (although their exact date, place of issue, and sequence are somewhat doubtful) belong to the series of the Macedonian stater, and show hardly any trace of Roman influence. Their probable date[2] seems to be between A.D. 1 and 41.

[1] *Celtic Britain*, p. 25. [2] *Ibid.*, p. 35.

There was no native British coinage either in Scotland, Wales, or Ireland, and in England the finds do not extend further north than Newcastle-upon-Tyne. The greater part of the finds lie to the south of a line drawn from Wroxeter to the Wash, and east of a line drawn from the same place to Exeter. The geographical distribution of the finds is clearly shown on the map given in Sir John Evans' *Coins of the Ancient Britons.*

GEOGRAPHICAL DISTRIBUTION OF FINDS OF OBJECTS OF THE LATE-CELTIC PERIOD IN GREAT BRITAIN [1]

In the present state of our knowledge no very satisfactory deductions can be made from a study of the geographical distribution of the finds of this period, partly because the discoveries have been so imperfectly recorded (more especially in Ireland), and partly because a large number of sites which are probably Late-Celtic still remain unexplored. Another difficulty to be reckoned with is that it is only within the last few years that archæologists have been able to distinguish between what is purely Celtic and what is Romano-British. Indeed, in many cases, in the absence of coins or other evidence, it is quite impossible to determine whether particular finds are of pre-Roman, Roman, or even post-Roman, as the Late-Celtic style of decoration was in vogue throughout the whole of the Pagan Iron Age in Britain, and survived in remote districts after the introduction of Christianity. Then, again, the fact must not be lost sight of that the greater frequency of finds in some districts than others can be accounted for by their having been covered with lakes where crannogs could be easily constructed, or on the limestone

[1] A complete list of the finds as far as recorded is given in the *Archæologia Cambrensis*, 5th ser., vol. xiii., p. 321.

formation, where rock-shelters and caves suitable for temporary places of refuge already existed.

We will take the geographical distribution of the sepulchral remains first. It is most remarkable that up to the present no Late-Celtic burials have been recorded in Wales, Scotland, or Ireland, although finds of objects of the period have been frequent in all three of these countries. The earlier Bronze Age burial customs may, of course, have survived after the introduction of iron, or interments of the Iron Age may have passed unrecognised owing to the rapid decay of the metal implements accompanying the body.

In England the greatest number of Late-Celtic burials have been found in the south-east corner of Yorkshire, near Beverley and Driffield. In most cases the tumuli covering the graves are in large groups, those at " Danes' Graves," near Kilham, numbering 178; those at Arras, near Market Weighton, 200; and those in Scorborough Park, near Beverley, 170. The people to whom these extensive cemeteries belonged probably invaded Britain from the Continent some few centuries before the Roman occupation, and landing at the mouth of the Humber, settled permanently on the east coast of Yorkshire. The people in question had long skulls, and buried their dead in a doubled-up attitude without cremation, which has suggested another less probable theory that they were the direct descendants of the more ancient Neolithic inhabitants of Yorkshire.

In Derbyshire one undoubted Late-Celtic burial has been found[1] and there are a few others which seem to belong to the transition towards the end of the Roman occupation or the beginning of the Saxon Pagan period.[2]

[1] In Deepdale. [2] At Benty Grange, and on Middleton Moor.

In Kent[1] and Devonshire[2] cemeteries containing a large number of graves have been brought to light.

Isolated burials have been found in single localities in each of the counties of Stafford,[3] Gloucester,[4] Dorset,[5] and Cornwall.[6]

The following lists show the geographical distribution of the inhabited or fortified sites of the Late-Celtic period in Great Britain :—

CAVES

YORKSHIRE. Dowkerbottom Hole, Arncliffe.
Victoria Cave, Settle.
Kelko Cave, Settle.

LANCASHIRE. Kirkhead Cave.

DERBYSHIRE. Thirst House, Deepdale.
Poole's Hole, near Buxton.

STAFFORDSHIRE. Thor's Cave, Dovedale.

DEVONSHIRE. Kent's Cavern, Torquay.

LAKE-DWELLINGS AND CRANNOGS

SOMERSETSHIRE. Glastonbury Marsh Village.

LANARKSHIRE. Hyndford Crannog.

AYRSHIRE. Lochlee Crannog.
Lochspouts Crannog.

WIGTOWNSHIRE. Dowalton Crannog.

Co. ANTRIM. Lisnacroghera Crannog.
Craigywarren Crannog.

Co. ROSCOMMON. Strokestown Crannog.
Ardakillen Crannog.

Co. WESTMEATH. Ballinderry Crannog.

Co. MEATH. Lagore Crannog.

[1] At Aylesford.
[2] At Mount Batten.
[3] At Barlaston.
[4] At Birdlip.
[5] In the Isle of Portland.
[6] At Trelan Bahow.

PICTISH TOWERS

ORKNEY. Broch of Harray.
 Broch of Okstrow.
CAITHNESS. Broch of Kettleburn.
SELKIRKSHIRE. Broch of Torwoodlee.

UNDERGROUND HOUSES

ABERDEENSHIRE. Castle Newe.
FORFARSHIRE. Grange of Conan.

CELTIC *OPPIDA* AND FORTIFIED VILLAGES

YORKSHIRE. Stanwick.
NORTHAMPTONSHIRE. Hunsbury.
KENT. Bigbury Camp.
SUSSEX. Mount Caburn.
BERKSHIRE. Northfield Farm, Long Wittenham.
DORSETSHIRE. Hod Hill.
 Hambledown Hill.
 Maiden Castle.
 Rotherley.
SOMERSETSHIRE. Ham Hill.
NAIRNSHIRE. Burghead.
PERTHSHIRE. Abernethy.
AYRSHIRE. Seamill Fort.
CARDIGANSHIRE. Castell Nadolig.
CARNARVONSHIRE. Treceiri.

ROMANO-BRITISH STATIONS AND TOWNS

NORTHUMBERLAND. Great Chesters (Æsica).
 Risingham (Habitancum).
WESTMORELAND. Brough.
 Kirkby Thore.
LANCASHIRE. Ribchester.
YORKSHIRE. New Malton.
NORTHAMPTON. Wellingborough.
SURREY. Farley Heath.
HAMPSHIRE. Silchester.
PERTHSHIRE. Ardoch.
DUMFRIES. Birrenswark.

A study of the above lists discloses some interesting facts. It will be noticed that the caves are confined exclusively to the limestone districts of the counties of York, Lancaster, Derby, Stafford, and Devon. The lake-dwellings are found chiefly in the south-west of Scotland and the north-east and central part of Ireland, there being only one example in England and none in Wales. The *brochs* and *weems* (or underground houses) are Pictish structures, and therefore do not occur any-where except in Scotland, chiefly in its north-eastern counties. The Celtic *oppida* are most common in the south of England where the Belgic settlements pre-dominated, but there are a few examples in Scotland. Probably a more systematic examination of the hill-forts throughout Great Britain would show that those in which large areas are enclosed by double and triple ramparts of stone or earth[1] belong to the Late-Celtic period. At the present time practically nothing is known as to the age of the stone forts and earthen raths in Ireland or Wales.

Most of the Romano-British fortified sites which have yielded works of art of Late-Celtic type, although executed under Roman influence, are in the south of Scotland or in the north of England, on or near the Wall of Hadrian, or along the lines of the military roads leading to it.[2] At Farley Heath, near Guild-ford, Surrey, numerous specimens of Kelto-Roman enamelled bronze objects have been found, and this

[1] I refer here to defensive works in which the whole of the summit of the hill is enclosed. These forts are usually of approximately oval shape, and follow the conformation of the hill.

[2] As, for instance, at Risingham (Habitancum) on the road going north from the Wall into Scotland, and at Brough and Kirkby Thore on the road from York to Carlisle, which passes through upper Teesdale, and thence into the valley of the Eden.

site would no doubt produce a plentiful harvest of antiquities of a similar nature if properly explored. The great difficulty, however, as we have already pointed out in dealing with the Romano-British sites, is to determine to what extent the style of the art of the objects found there can be shown to be definitely Celtic. In our lists we have only included sites from which have been procured antiquities exhibiting Celtic enamel and flamboyant ornament, or fibulæ of known Celtic type.

If to the sepulchral deposits and inhabited sites just described be added all the miscellaneous finds of objects accidentally lost or purposely concealed, it will be observed that there is hardly a single county throughout England, Wales, Scotland, and Ireland which cannot show one or two such Late-Celtic finds at least. Some counties are nevertheless richer than others,[1] as, for instance, Aberdeen, Forfar, Perth, Ayr, Kirkcudbright, and Dumfries, in Scotland ; Antrim, Meath, and Roscommon, in Ireland; Denbighshire, in Wales; and Northumberland, Durham, Yorkshire, Derbyshire, Suffolk, Middlesex, Kent, Gloucestershire, Oxfordshire, Berks, Wilts, Dorset, Hants, and Somerset, in England.

EVIDENCE AS TO DATES OF FINDS OF OBJECTS OF THE EARLY IRON AGE IN GREAT BRITAIN

The finds of objects of the Early Iron Age to which an approximate date can be assigned are as follows :—

(1) Finds associated with burials of a particular kind.
(2) Finds associated with objects of the Bronze Age.
(3) Finds associated with objects of early Hallstatt type.

[1] *i.e.* have from four to ten localities where Late-Celtic finds have been made.

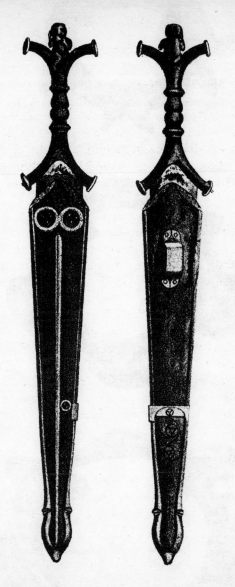

IRON DAGGER WITH BRONZE HILT AND SHEATH
FROM RIVER WITHAM

Reproduced from Kemble's "Horæ Ferales"

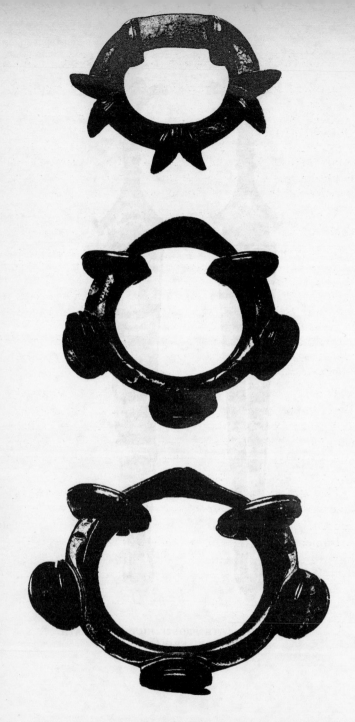

BRONZE HARNESS-RINGS FROM POLDEN HILL, SOMERSETSHIRE
NOW IN THE BRITISH MUSEUM
SCALE ⅔ LINEAR

(4) Finds associated with fibulæ or other objects of La Tène type.

(5) Finds of objects associated with imported articles of Græco-Italic fabric.

(6) Finds of objects associated with Ancient British coins.

(7) Finds of objects, (*a*) on Romano-British inhabited or fortified sites, (*b*) associated with Roman coins, and (*c*) associated with articles of Roman manufacture.

There are at least three different methods of burial characteristic of the Late-Celtic period in Great Britain.

(1) Uncremated burials in excavated graves beneath barrows in which the deceased is generally found with his chariot and horses, as at Arras, Yorkshire.

(2) Cremated burials in pits without any exterior mound, the ashes being contained in cinerary urns and the burials in groups, as at Aylesford, Kent.

(3) Uncremated burials in graves formed of slabs of stone placed on edge, without any exterior mound, as at Birdlip, Gloucestershire.

The first class of burials correspond with those at Berru and Gorge-Meillet, Department of the Marne, and probably belong to the same period as these earlier Gaulish interments which, from the associated Greek and Etruscan relics,[1] are known on the Continent to belong to the third, fourth, and fifth centuries B.C.[2]

The second, or Aylesford urn field type of burial, is dated by associated vessels of Italo-Greek fabric at from 200 to 150 B.C.[3]

Implements of the Bronze Age have been occasionally discovered with objects of Late-Celtic character, as at

[1] Such as the Græcwyl bronze vase now in the Berne Museum; the bronze *œnochoe* and Etruscan cup from Somme-Bionne (Marne); and the two-handled cup from Rodenbach, Bavaria (described and illustrated in A. Bertrand's *Archéologie Celtique et Gauloise*, pp. 328 to 347).

[2] Arthur Evans in *Archæologia*, vol. lii., p. 72.

[3] *Ibid.*, vol. lii., p. 66.

Hagbourn Hill,[1] Berks, where a Late-Celtic bridle-bit and harness-rings were associated with some small spear-heads and a socketed celt; and at Hounslow,[2] Middlesex, where three figures of boars and two of other animals were found with celts and gouges of the Bronze Age.

Up to the present time, no specimen has yet been found in this country of the great iron sword of Hallstatt type, with its massive ivory handle encrusted with amber.[3] Of the smaller Hallstatt sword with an iron blade and a bronze handle, having antennæ-like projections at the top,[4] one specimen from the Thames is to be seen in the British Museum, and there are about half a dozen others in the Museum of the Royal Irish Academy in Dublin.

Tall vessels made of thin sheets of bronze riveted together and furnished with two round ring-handles at the top have been found in Ireland (at Montiaghs,[5] Co. Armagh; and Dowris,[6] King's Co.) and in Scotland (at Cardross,[7] Dumbartonshire); the form of these vessels shows that they are akin to the situlæ of the late Hallstatt or early La Tène period on the Continent.

In the instances where other objects have been associated either with the swords à antennes or situlæ in Great Britain they have been of purely Bronze Age type, showing that the Hallstatt period on the Continent was earlier than the Late-Celtic period in this country.

The forms of the fibulæ associated with Late-Celtic

[1] *Archæologia,* vol. xvi., p. 348.

[2] *Proc. Soc. Ant. Lond.,* 2nd ser., vol. iii., p. 90.

[3] A. Bertrand and S. Reinach's *Les Celtes dans les Vallées du Pô et du Danube,* p. 125. [4] *Ibid.,* p. 85.

[5] *Jour. Royal Soc. Ant. Ireland,* ser. 5, vol. vii., p. 437. Another example found in Ireland is figured in Sir W. Wylde's *Catal. Mus. R.I.A.,* p. 531.

[6] Now in the British Museum. Evans' *Ancient Bronze Implements,* p. 410. [7] R. Munro's *Prehistoric Scotland,* p. 40.

finds afford specially valuable evidence as to date. The pre-Roman, or La Tène, type of fibula was made in one piece on the same principle as the modern safety-pin, and therefore differed from the Roman Provincial harp, or bow-shaped fibula, in which the pin was separate from the back and worked on a hinge. Fibulæ of the earlier kind have been found with Late-Celtic burials at Cowlam, Yorkshire; Aylesford, Kent; and Birdlip, Gloucestershire; and on inhabited and fortified sites at Hod Hill, and Rotherley, Dorset. The fibulæ from the Stamford Hill Cemetery, near Plymouth, and the Polden Hill hoard of horse-trappings belong to the later class. As the forms of the different fibulæ will be discussed subsequently, no more need be said on the subject here.

Ancient British coins have been found near the Late-Celtic cemeteries at Aylesford,[1] Kent, and Stamford Hill,[2] near Plymouth; also within the fortifications of the Late-Celtic *oppida* at Mount Caburn,[3] near Lewes, Sussex, and Hod Hill,[4] near Blandford, Dorset. General Pitt-Rivers came across ancient British coins during his excavations on the site of the Romano-British village at Rotherley[5] in Cranbourne Chase, Dorset, and numerous specimens (especially of the coins of Verica, one of the three sons of Commios) have turned up from time to time at Farley Heath,[6] near Guildford, Surrey.

The Romano-British inhabited or fortified sites from which objects of Late-Celtic character have been derived, have already been specified. The following lists show the instances where Late-Celtic finds have been associated with Roman coins or with objects of Roman manufacture :—

[1] *Archæologia*, vol. lii., p. 315. [2] *Ibid.*, vol. xl., p 500.
[3] *Ibid.*, vol. xlvi., p. 423. [4] *Archæol. Jour.*, vol. lvii., p. 52.
[5] *Excavations in Cranbourne Chase*, vol. ii., p. 188.
[6] F. Martin Tupper's *Farley Heath*, p. 10.

Late-Celtic Finds associated with Roman Coins.

Place.	Nature of Find.	Date of Coins.
Victoria Cave, Settle, Yorkshire	Inhabited Site	Trajan to Constans, A.D. 98–[353.
Kelko Cave, Giggleswick, Yorkshire	Inhabited Site	(?)
Dowkerbottom Cave, Arncliffe, Yorkshire	Inhabited Site	Claudius Gothicus to Tetricus, A.D. 268–273
Kirkhead Cave, Cartmel, Lancashire	Inhabited Site	Domitian, A.D. 81–96
Poole's Cavern, Buxton	Inhabited Site	(?)
Thirst House, Deepdale, Derbyshire	Inhabited Site	Antoninus Pius to Gallienus, A.D. 138–268
Thor's Cave, Staffordshire	Inhabited Site	(?)
Broch of Torwoodlee, Selkirkshire	Fortified Tower	Vespasian, A.D. 69–79
Rotherley, Dorset	British Village	Trajan to Gallienus, A.D. 98–268
Kirkby Thore, Westmoreland		Vespasian to Severus, A.D. 69–211
Hod Hill, Dorset	Fortified Site	Augustus to Trajan, B.C. 27—A.D. 117
Æsica, Northumberland	Romano-British Station	Mark Antony to Magnentius, B.C. 32–A.D. 353
Farley Heath	British Village	(?)
Alstonfield, Staffordshire	Burial	Tetricus and Constantine, A.D. 268–337
Ham Hill, Somerset	Fortified Site	Valerian to Theodosius I., A.D. 379–395
Westhall, Suffolk	Horse-trappings	Faustina
Chorley, Lancashire	Fibulæ	Hadrian, A.D. 117–138

Place.	Nature of Find.	Date of Coins.
Backworth, Northumberland	Fibulæ	Antoninus Pius, A.D. 138–161
Kingsholm, Gloucestershire	Horse-trappings	Claudius, A.D. 41–54
Castlethorpe, Bucks	Silver Armlet	Verus, A.D. 161-169

Late-Celtic Finds associated with Samian Ware.

Place.	Nature of Find.
Broch of Okstrow, Orkney .	Pictish Tower.
Lochlee	Crannog.
Lochspouts	Crannog.
Settle, Yorkshire . . .	Cave.
Deepdale, Derbyshire . .	Cave.
Thor's Cave, Staffordshire .	Cave.
Isle of Portland . . .	Burial.
Westhall, Suffolk . . .	Horse-trappings.

Late-Celtic Finds associated with Objects of Roman Manufacture.

Place.	Nature of Late-Celtic Find.	Class of Roman Object.
Dowalton, Wigtownshire	Crannog	Saucepan
Stanhope, Peeblesshire	Armlet	Saucepan
Polden Hill, Somersetshire	Horse-trappings	Fibulæ
Stamford Hill, near Plymouth	Cemetery	Fibulæ
Castlethorpe, Bucks	Armlet	
Æsica, Northumberland	Fibulæ	Silver necklace, etc.
Hay Hill, Cambridgeshire	Fire-dog	Amphora
Mount Bures, Essex	Fire-dog	Six amphoræ, glass, etc.
Stanfordbury, Bedfordshire	Fire-dog	Bronze jug, Samian ware, etc.

CHAPTER IV

PAGAN CELTIC ART IN THE EARLY IRON AGE

GENERAL NATURE OF THE MATERIALS AVAILABLE FOR THE STUDY OF THE DECORATIVE ART OF THE EARLY IRON AGE IN GREAT BRITAIN

THE materials available for the study of Late-Celtic art in this country may be classified as follows :—

METALWORK.
Arms of Offence and Defence.
Horse-trappings.
Chariot Fittings.
Personal Ornaments.
Toilet Appliances.
Domestic Appliances.
Musical Instruments.
Objects for Religious Use.
Objects of Unknown Use.

POTTERY AND GLASS.
Sepulchral Urns.
Vessels for Domestic Use.
Beads for Necklaces.

WOODWORK AND BONEWORK.
Vessels for Domestic Use.
Dress-fasteners.
Spatulæ.

STONEWORK.
Sculptured Monuments.

The arms of offence and defence of the Late-Celtic period are made of metal; the sword-blades, dagger-blades, and lance-heads being of iron; and the sword-sheaths, dagger-sheaths, shields, and helmets of bronze. In this country the bronze objects only are ornamented.[1]

Bronze sword- and dagger-sheaths have been found in considerable numbers in England, and also less frequently in Scotland and Ireland, as will be seen from the lists given below.

List of Localities in Great Britain where Bronze Sword-sheaths of the Late-Celtic Period have been found.

Carham	Northumberland.
Embleton	Cumberland.
Houghton le Skerne	Co. Durham.
Sadberge	Co. Durham.
Warton	Lancashire.
Stanwick	Yorkshire.
Catterdale	Yorkshire.
Flasby	Yorkshire.
Grimthorpe	Yorkshire.
Lincoln	Lincolnshire.
Hunsbury	Northamptonshire.
Amerden	Buckinghamshire.
Water Eaton	Oxfordshire.
Dorchester	Oxfordshire.
Boxmoor	Hertfordshire.
London	Middlesex.
Battersea	Middlesex.
Icklingham	Suffolk.
Hod Hill	Dorsetshire.
Moreton Hall	Midlothian.
Glencotho	Peeblesshire.
Bargany House	Ayrshire.
Lisnacroghera	Co. Antrim.

[1] A lance-head of iron from La Tène, in Switzerland, is ornamented with engraved patterns, but nothing of a similar kind has been found in Great Britain (E. Vouga, *Les Helvètes a La Tène,* pl. 5).

*List of Localities in Great Britain where Bronze Dagger-
sheaths of the Late-Celtic Period have been found.*

River Witham	. . .	Lincolnshire.
North Hinksey	. . .	Oxfordshire.
Wandsworth	. .	Surrey.
Southwark	. . .	Surrey.
Cookham	. . .	Berkshire.
Athenry	. . .	Co. Galway.

Some of these sheaths are elaborately ornamented,
more especially the specimens from Hunsbury, Lisna-
croghera, and the River Witham. The shape of the
sheaths was evidently derived from a foreign source,
as may be seen by comparing those found in Great
Britain with the examples from Hallstatt and La Tène.

Bronze shields of the Late-Celtic period are not by
any means common, but the British Museum is fortunate
enough to possess the only two perfect specimens now
in existence. One of these came out of the River
Thames at Battersea, and the other from the River
Witham, near Lincoln. The former is, perhaps, on the
whole, the most beautiful piece of Late-Celtic metal-
work that has survived to the present time. It is of
oblong shape with rounded corners like the Gaulish
shields,[1] and is made out of plates of thin hammered
bronze, strengthened all round the edge by a roll
moulding. The body of the shield consists of a plain
plate upon which are riveted three circular pieces of
ornamental repoussé work, the largest one in the centre,
and the other two smaller ones at the top and bottom.
In the middle of each of the circular pieces of ornament
is a raised boss, the annular space surrounding which

[1] See article on the Gaulish statue from Montdragon (Vaucluse) now
in the Musée Calvet at Avignon in the *Revue Archéologique*, N.S., vol. xvi.
(1867), p. 69; also *Diodorus*, bk. 5, ch. 30.

is filled in with gracefully flowing S- and C-shaped curves raised above the rest of the surface, and starting from and returning to small circular plaques of enamel with a swastika design on each. No written description can give any idea of the subtle decorative effect produced by the play of light on the surfaces of the flamboyant curves as they alternately expand and contract in width and rise and fall above the surrounding level background. The drawing of the curves is simply exquisite, and their beauty is greatly enhanced by the sharp line used in all cases to emphasise the highest part of the ridge. It will be observed that the design is set out with regard to small circular bits of enamel placed in definite positions symmetrically round a central boss. If closely coiled spirals like those of the Bronze Age were to be substituted for the enamelled discs, we should then have a style of decoration exactly similar to that of the Christian Celtic MSS. The metalworker who made this shield seems to have possessed the true artistic feeling which told him instinctively exactly how much plain surface of shining bronze should be left to set off the ornament to the greatest advantage. The other shield in the British Museum, from the River Witham, is very inferior to the one just described, and is probably of later date.

Late-Celtic bronze helmets are of great rarity. There are two in the British Museum, one from the Thames at London, and the other from an unknown locality. A third from Torrs, Kirkcudbrightshire, is now preserved at Abbotsford, near Melrose. The specimen from the Thames is furnished with two conical horns terminating in small turned knobs, all the different pieces of wrought metal being riveted together with extreme neatness. The front of the helmet is orna-

mented with small, round enamelled discs and repoussé
work in very low relief. The other helmet in the
British Museum is shaped like a jockey's cap, and is
particularly ugly in appearance.

The helmet at Abbotsford has been so fully described
by Dr. Joseph Anderson in his *Scotland in Pagan
Times : The Iron Age* (p. 113) that it will not be neces-
sary to say more about it here.

Decorated bronze helmets of the La Tène period
have been found in France at Berru[1] (Marne) and
Gorge-Meillet[2] (Marne).

It will be seen from the list given below how extremely
common finds of Late-Celtic horse-trappings have been.

*List of Localities in Great Britain where Late-Celtic
Horse-trappings have been found.*

South Shields . . .	Co. Durham.
Stanwick	Yorkshire.
Arras	Yorkshire.
Rise	Yorkshire.
Danes' Graves . .	Yorkshire.
Kirkby Thore . . .	Westmoreland.
Hunsbury	Northamptonshire.
Locality unknown . .	Lincolnshire.
Leicester	Leicestershire.
The Fens	Cambridgeshire.
Saham Toney . .	Norfolk.
Westhall	Suffolk.
Norton	Suffolk.
London	Middlesex.
Canterbury	Kent.
Bapchild	Kent.
Stouting	Kent.
Alfriston	Sussex.
Chessell Down . . .	Isle of Wight.

[1] A. Bertrand's *Archéologie Celtique et Gauloise*, 2nd ed., 1889, p. 356.
[2] E. Fourdrignier's *Double Sepulture Gauloise de la Gorge-Meillet.*

Hagbourn Hill . . .	Berkshire.
Polden Hill	Somersetshire.
Hamdon Hill . . .	Somersetshire.
Abergele	Denbighshire.
Neath	Glamorganshire.
Clova	Aberdeenshire.
Crichie	Aberdeenshire.
Ardoch	Perthshire.
Middleby	Dumfriesshire.
Kirriemuir	Forfarshire.
Henshole	Roxburghshire.
Torwoodlee	Selkirkshire.
Stanhope	Peeblesshire.
Lochlee	Ayrshire.
Dowalton	Wigtownshire.
Birrenswark . . .	Dumfriesshire.
Auchendolly . . .	Kirkcudbrightshire.
Ballycostello . . .	Co. Mayo.
Clooncunra	Co. Roscommon.
Emlagh	Co. Roscommon.
Tara	Co. Meath.
Ballynaminton . . .	King's Co.
Kilkeeran	Co. Monaghan.

Under the head of horse-trappings are included a large number of miscellaneous objects, such as bridle-bits, harness-rings, -buckles, and -mountings, pendants, head ornaments, etc. In fact, the term has been much abused by museum curators, who, when in doubt, say horse-trappings. Much the most important finds, consisting in each case of a large number of objects, have been those made at Polden Hill, Somersetshire, in 1801; Hagbourne Hill, Berks, in 1803; Westhall, Suffolk; Stanwick, Arras, and Rise, Yorkshire; all the objects being now in the British Museum. The specimens from the Saham Toney find, which was equally important, are to be seen in the Norwich Museum.

Other smaller finds are preserved in the museums at Edinburgh and Dublin.

Nearly all the big finds of horse-trappings have included several bridle-bits. These are usually quite plain, but there are, at least, four highly ornamented examples known (1) from Rise,[1] Yorkshire, now in the British Museum; (2) from Birrenswark,[2] Dumfriesshire, in the Edinburgh Museum; (3) found near Tara,[3] Co. Meath, now in the Dublin Museum; and (4) from Kilkeeran,[4] Co. Monaghan, also at Dublin. These bridle-bits are formed of three or four separate pieces linked together, as in a modern one, and the decoration, which is concentrated on the terminal rings, consists of the usual Late-Celtic trumpet-shaped expansions and coloured *champlevé* enamels.

In nearly all the finds of horse-trappings rings of various shapes and sizes are of frequent occurrence. They were probably used for passing the reins or other parts of the harness through, and perhaps also to act as strap buckles. Most of the rings are round in cross-section, except a segment separated from the rest by projecting flanges, the cross-section of which is made rectangular, apparently to enable the ring to be more rigidly fixed to the harness. The decoration of the rings usually consists of curious projections of various shapes, some resembling pairs of mushrooms placed with the convex tops together and the stems inclined at an angle; whilst others are more like segments of an orange. Many of the rings are ornamented with engraved patterns composed of lines

[1] *Magazine of Art* for 1885, p. 456.
[2] Dr. J. Anderson's *Scotland in Pagan Times: Iron Age*, p. 124.
[3] Sir W. Wilde's *Catal. of Mus. R. I. A.*, p. 605.
[4] *Journ. R. Hist. and Archæol. Assoc. of Ireland*, N.S., vol. i., p. 423.

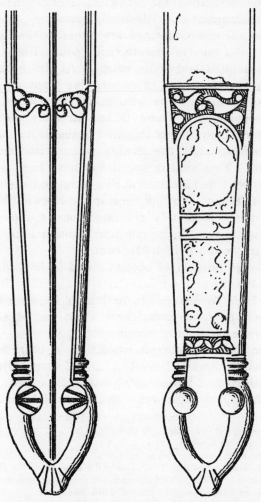

Lower ends of Bronze Sword-sheaths from Hunsbury

Now in the Northampton Museum

and dots, or are enamelled. The best specimens in the British Museum have been derived from the finds already described at Stanwick, Yorkshire; Polden Hill, Somerset; and Westhall, Suffolk.

The harness-mountings are either in the form of a cross or a sort of rosette, with petals like a flower, some pointed and some round. At the back of the mounting are a pair of rectangular loops for passing a strap through. The front is, in many cases, beautifully enamelled. There is an extremely pretty little cruciform mounting of this kind in the British Museum, but unfortunately the locality whence it came is unknown. Two similar specimens have been recorded, one in the Uffizi Museum at Florence,[1] and another from Saham Toney,[2] Norfolk, now in the Norwich Museum. The most elaborately decorated harness-mounting of the rosette type is the one from Polden Hill,[3] Somersetshire, in the British Museum.

A large number of objects found in Ireland, resembling a spur or the merry-bone of a chicken in shape, have been conjectured to be horses' head ornaments.[4] One of them was found near Tara, Co. Meath, with the bridle-bit already mentioned.

Iron tyres of chariot-wheels have been found at Stanwick, Arras, Beverley, and Danes' Graves in Yorkshire, and Hunsbury, Northamptonshire; but the bronze objects associated with them, which are believed

[1] Kemble's *Horæ Ferales*, pl. 19, fig. 5.
[2] *Norfolk Archæology*, vol. ii., p. 398.
[3] Kemble's *Horæ Ferales*, pl. 19, fig. 3.
[4] There are more than thirty-two in the Museum of the Royal Irish Academy (see Wilde's *Catal.*, p. 109). Others have been found in the counties of Roscommon, Sligo, and Cork (see *Proc. R. I. A.*, vol. vii., p. 161; Vallancey's *Coll. de Rebus Hibernicis*, vol. iv., p. 54; and Wood Martin's *Pagan Ireland*, p. 462).

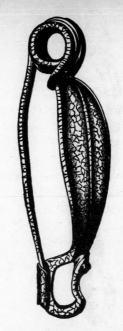

LATE CELTIC FIBULA FROM IRELAND;
NOW IN THE MUSEUM OF THE ROYAL
IRISH ACADEMY, DUBLIN

LATE CELTIC BRONZE FIBULA
FROM WALMER, KENT; NOW
IN THE BRITISH MUSEUM

SCALE ¾ LINEAR

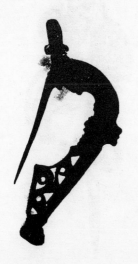

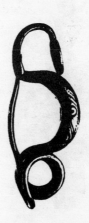

ENAMELLED BRONZE FIBULA FROM
RISINGHAM, NORTHUMBERLAND;
NOW IN THE NEWCASTLE MUSEUM

BRONZE FIBULA, WATER EATON,
OXON; NOW IN THE BRITISH
MUSEUM

SCALE $\frac{1}{1}$ LINEAR

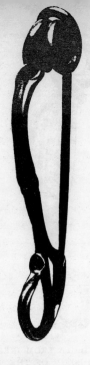

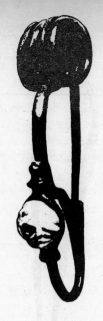

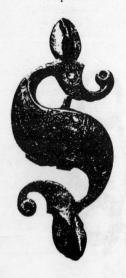

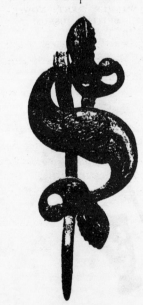

BRONZE FIBULA FROM CLOGHER.
CO. TYRONE; NOW IN THE
BRITISH MUSEUM

SCALE $\frac{1}{1}$ LINEAR

LATE-CELTIC BRONZE FIBULA
LOCALITY UNKNOWN; NOW IN
THE BRITISH MUSEUM

SCALE $\frac{1}{1}$ LINEAR

S-SHAPED ENAMELLED BRONZE
FIBULA, LOCALITY UNKNOWN;
NOW IN THE BRITISH MUSEUM

SCALE $\frac{1}{1}$ LINEAR

S-SHAPED FIBULA OF ENAMELLED
BRONZE, FROM NORTON, E. RIDING
OF YORKSHIRE; NOW IN THE
BRITISH MUSEUM

SCALE $\frac{1}{1}$ LINEAR

to be the fittings of the chariots, do not afford sufficiently characteristic decoration to need description here.

The personal ornaments of the Late-Celtic period consist chiefly of fibulæ, pins, collars, and armlets, usually of bronze, but in rare instances of gold or silver.

The evolution of the Roman Provincial type of fibula from earlier La Tène type can be nowhere better studied than in this country during the transition from the Late-Celtic to the Romano-British period.

To anyone who is acquainted with the elaborate studies[1] made by Scandinavian archæologists on the origin and development of the various forms of fibulæ found in northern Europe it must be a matter of surprise that up to the present no attempt has been made to do the same thing for our own country. With the exception of Dr. Arthur Evans' paper in the *Archæologia*,[2] absolutely nothing has been written on the subject in England, nor do the curators of our public museums make the faintest attempt to classify the different kinds of fibulæ of the Romano-British period according to their shapes.

Looked at from a purely mechanical point of view, a fibula, or brooch, belongs to the same class of appliances as an ordinary door-lock ; being, in fact, a device for fastening applied to dress. The fibula was probably in its earlier stages evolved from a simple pin by endeavouring to invent some way by which the pin might be prevented from slipping out once it had been

[1] Hans Hildebrand's *Industrial Arts of Scandinavia;* Oscar Montelius' "Spännen från bronsåldern" in the *Antiquarisk Tidskrift för Sverige ;* and O. Almagren's *Studien über norden europäische Fibelformen.*

[2] Vol. lv., p. 179.

inserted in the fabric of the dress. A sufficiently obvious plan for effecting this is to connect the head of the pin with the point by means of a rigid bar sufficiently bent into the shape of an arch to avoid pressing too closely upon the portion of the dress between it and the pin. When fixed in its place the brooch forms a complete ring, so that a locking and unlocking contrivance is necessary in order to enable it to be removed when not in use.

The modern safety-pin, which is also one of the most ancient inventions, is perhaps the simplest kind of dress-fastener, and yet it is the parent of the almost endless series of European fibulæ from the Bronze Age to the present time. It can be constructed in the easiest possible manner out of a single piece of metal wire of uniform thickness by making a coil in the middle of its length to act as a spring and a point at one end and a hook at the other. The pointed end is then bent round until it catches in the hook, and the thing is complete.

There are two other classes of brooches which do not belong to the safety-pin type or its descendants, namely, (1) the Celtic penannular brooch;[1] and (2) the Northern Bronze Age brooch,[2] which has a pin with a hole through the head enabling it to slide, turn, and move about loosely on the body of the brooch. With these we are not concerned at present.

Although the safety-pin type of fibula was, in its earlier stages, made out of a single piece of wire, it may be considered to consist of four different parts, each of which performs a function of its own, namely, (1) the head, containing the spring or hinge; (2) the tail, containing the catch, or locking apparatus; (3)

[1] Dr. J. Anderson's *Scotland in Early Christian Times,* 2nd ser., p. 7.
[2] J. J. A. Worsaae's *Industrial Arts of Denmark,* p. 92.

the body or framework, connecting the head with the tail; and (4) the pin, moving on a hinge or spring at one end and with the pointed end fitting into the catch. In all fibulæ derived from the safety-pin the pin is straight and the body bent into a more or less arched shape, like a bow. An infinite variety of forms were produced (1) by increasing the number of coils in the spring and their size; (2) by expanding the tail end into a thin triangular plate; and (3) by increasing the thickness of the body, or by making a coil in the middle of its length to act as a secondary spring. Much the most important modifications, however, in the safety-pin brooches were those which gradually led up to the harp-shaped, T-shaped, and cruciform fibulæ of the Romano-British period. Dr. Arthur J. Evans, in his paper in the *Archæologia* (vol. lv., p. 179) on "Two Fibulæ of Celtic Fabric from Æsica," has traced the evolution of the harp-shaped fibula from the bow-shaped fibula in a most interesting way. The different stages in the process appear to have been as follows:—

(1) The tail end of the fibula was extended and bent backwards so as to make an S-shaped curve with the bow; (2) the retroflected end of the tail was fixed to the middle of the convex side of the bow by means of a small collar, made in a separate piece; (3) the whole of the back was formed out of one piece of metal, with the collar surviving as a mere ornament; and (4) the triangular opening at the tail, bounded by the retro-flected end, part of the bow, and the catch for the point of the pin, was filled in solid with a thin plate. It will be noticed that during this process of evolution the extended and retroflected end of the tail has become part of the continuous curve of the convex side of the bow, whilst what was previously one half of the outside

of the bow is now on the inside of the triangular plate at the tail end. This, together with the expansion of the head to suit the increased number of coils in the spring, produced the characteristic harp-shape of the Romano-British fibula, in many of which the knob ornament in the middle of the back is the last survival of the collar for fixing the retroflected end of the tail in its place.

The cruciform and T-shaped fibulæ, which began in Roman times and continued to be used by the Anglo-Saxons, resulted from extending the coils of the spring at the head symmetrically on both sides of the pin. In this class of fibula the two outside ends of the coil were joined by a loop passing through the inside of the bow so as to give extra leverage to the spring, or sometimes serving merely as a loop for suspension by means of a chain.

A specimen of silver was found at the Warren,[1] near Folkestone, and is now in the British Museum. The lower portion is, unfortunately, broken off, but the retroflected end of the tail remains, with the little ornamental knob which is the survival of the practically useful collar for securing it to the back of the bow. The coils of the spring on each side of the pin and the connecting loop are clearly seen, together with the loose ring passing through the coils of the spring and a portion of the chain for suspension.

An exceedingly pretty pair of harp-shaped fibulæ of silver, with a well-wrought chain for suspension, were found near Chorley, Lancashire, with Roman coins dating from Galba to Hadrian, and are now in the British Museum. At the top of each fibula is a loop for attachment to the chain, and the bodies are beauti-

[1] *The Reliquary* for 1901, p. 197.

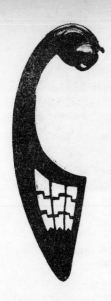

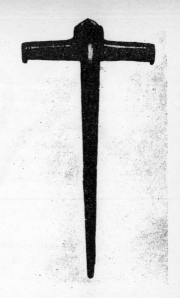

BRONZE FIBULA FROM POLDEN HILL,
SOMERSETSHIRE; NOW IN THE
BRITISH MUSEUM

SIDE VIEW, SCALE ¾ LINEAR

BRONZE FIBULA FROM POLDEN HILL,
SOMERSETSHIRE; NOW IN THE
BRITISH MUSEUM

FRONT VIEW, SCALE ¾ LINEAR

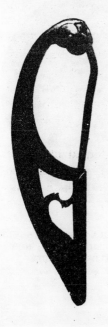

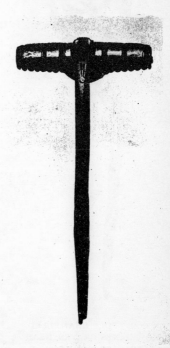

BRONZE FIBULA FROM RIVER CHURN,
NOW IN THE BRITISH MUSEUM

SIDE VIEW, SCALE ⅟₁ LINEAR

BRONZE FIBULA FROM RIVER CHURN;
NOW IN THE BRITISH MUSEUM

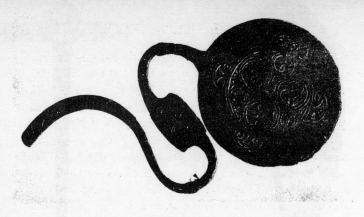

BRONZE HOOK-AND-DISK ORNAMENT FROM IRELAND;
NOW IN THE DUBLIN MUSEUM

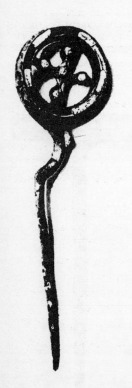

BRONZE DISC FIBULA WITH LATE-CELTIC
ORNAMENT, FROM SILCHESTER; NOW AT
STRATHFIELDSAYE HOUSE

S Victor White, of Reading, photo.

BRONZE PIN, ENAMELLED,
FROM DANES GRAVES, NEAR
DRIFFIELD, YORKSHIRE;
NOW IN THE YORK MUSEUM

fully ornamented with Late-Celtic flamboyant patterns. The knob, which is the survival of the collar already referred to, has here assumed a highly ornamental form resembling two floriated capitals of columns placed together.

The specimen represented on p. 104 is one of a pair of silver-gilt fibulæ, similar to the preceding, but larger and without the chain, although possessing the loops for suspension. They were purchased in Newcastle about the year 1811, and are now in the British Museum. It is stated in Hodgson's *History of Northumberland* (vol. iii., Appendix x., p. 440) that the locality from whence they came was somewhere in the county northeast of Backworth. The fibulæ were discovered in a silver patera bearing a dedicatory inscription to the Deæ Matres, and containing, in addition—

> 5 gold rings.
> 1 silver ring.
> 2 gold chains with wheel pendants.
> 1 gold bracelet.
> 3 silver spoons.
> 1 mirror.
> 280 denarii.
> 2 large brass coins of Antoninus Pius.

A full account of the find is given in E. Hawkins' "Notice of a remarkable collection of ornaments of the Roman period, connected with the worship of the Deæ Matres, and recently purchased for the British Museum" in the *Archæological Journal* (vol. viii., p. 35).

We may here call attention to the intensely Celtic character of the fibulæ just described. The wearing of brooches in pairs with a chain attachment was a Celtic and not a Roman custom, as has already been pointed

out in a previous volume of *The Reliquary* (for 1895, p. 157). A pair of bronze fibulæ, of the same kind as the one from the Warren, Folkestone, fastened together by a double chain, was found in one of the Gaulish cemeteries in the Department of Marne[1] in France, and

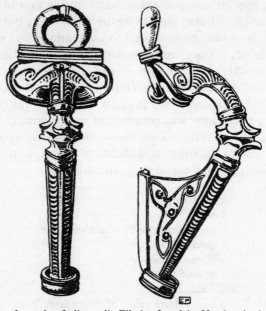

One of a pair of silver-gilt Fibulæ found in Northumberland, with Denarius of Antoninus Pius (A.D. 139)

Drawn by C. Praetorius

is now to be seen in the museum of St. Germain, near Paris. It may, therefore, be fairly assumed that all the fibulæ found in this country with chains attached to

[1] Engraved in the *Dictionnaire Archeologique de la Gaule.* Other examples from the cemeteries of Somme Bionne, Courtois, Bussy-le-Château, and Sommesous in the Department of the Marne, are given in the *Album* accompanying L. Morel's *La Champagne souterraine* (pls. 13, 29, 34, and 40).

them or with loops for a chain at the top are more Celtic than Roman.

Amongst the Late-Celtic antiquities in the British Museum are three specimens which illustrate the evolution of the harp-shaped fibula very well. One ornamented with a coral boss and gold stud, probably from the Marne district, was presented by the late Sir A. W. Franks; another came from a chalk pit near Walmer, Kent; and the third was found at Clogher, Co. Tyrone.

Broadly speaking, it may be said that the safety-pin type of fibula made in one piece is earlier in date than the Roman occupation of Britain, and the specimens found in this country are obviously either imported from abroad or copied from foreign originals, such as those found at La Tène, in Switzerland, and in the Champagne district of France. The fibula in use in Britain, after it became a province of the Roman Empire, has a massive harp or bow-shaped back made in a separate piece from the pin and spring. In the earlier, or La Tène type of the fibula, the catch for the end of the pin forms one side of a triangular opening, which, as we have already mentioned, is filled in with a thin plate in the later or Roman Provincial fibula. There is also a sort of transitional kind, with ornamental piercings in the plate.

There was yet another description of fibula belonging to the Romano-British period, having a flat plate for the body in the shape of a circular disc, or sometimes in the shape of a fish or animal.

The different classes of Late-Celtic fibulæ are given in the following lists.

List of Localities in Great Britain where Late-Celtic
Fibulæ have been found.

LA TÈNE AND MARNIAN TYPE, WITH TAIL BENT BACKWARDS.

Cowlam (Brit. Mus.)	Yorkshire.
Hammersmith (Brit. Mus.) . .	Middlesex.
Avebury (Brit. Mus.)	Wiltshire.
Water Eaton (Brit. Mus.) . . .	Oxfordshire.
Clogher (Brit. Mus.)	Co. Tyrone.

LA TÈNE AND MARNIAN TYPE, WITH TAIL BENT BACKWARDS AND ATTACHED TO BOW.

Aylesford (Brit. Mus.) . . .	Kent.
Folkestone (Brit. Mus.) . . .	Kent.
Walmer (Brit. Mus.)	Kent.
Locality not given (Liverpool Mus.) .	Kent.
Datchet	Oxfordshire.

LA TÈNE AND MARNIAN TYPE, WITH FLATTENED AND EXPANDED BOW.

Ringham Low	Derbyshire.
Hod Hill (Brit. Mus.) . . .	Dorsetshire.
London (Guildhall Mus.) . . .	Middlesex.
Bonville (Brit. Mus.) . . .	Co. Armagh.
Navan Rath (Mus. R.I.A.) . .	Co. Armagh.
Locality unknown (Mus. R.I.A.) .	Ireland.
Hunsbury (Northampton Mus.) . .	N'hamptonshire.

TRANSITIONAL TYPE, WITH ORNAMENTAL HEAD AND EITHER PLAIN OR PIERCED TAIL-PLATE.

Birdlip (Gloucester Mus.) . . .	Gloucestershire.
London (Guildhall Mus.) . . .	Middlesex.

ROMAN PROVINCIAL TYPE, WITH HARP-SHAPED PROFILE, T-SHAPED TOP, OR SPRING-CASE, AND PIERCED TAIL-PLATE.

Polden Hill (Brit. Mus.) . . .	Somersetshire.
Stamford Hill, Plymouth . . .	Devonshire.
Cricklade (Brit. Mus.) . . .	Wiltshire.

ROMAN PROVINCIAL TYPE, WITH HARP-SHAPED PROFILE, EXPANDED TRUMPET-SHAPED TOP, AND FLORIATED KNOB IN MIDDLE OF BOW.

Backworth (Brit. Mus.) . . . Northumberland.
Chorley (Brit. Mus.) Lancashire.
Great Chesters (Newcastle Mus.) . Northumberland.
River Tyne (Newcastle Mus.) . . Northumberland.
Risingham (Newcastle Mus.) . . Northumberland.
Ribchester Lancashire.
Farley Heath Surrey.

KELTO-ROMAN DISC-SHAPED TYPE, WITH REPOUSSÉ ORNAMENT.

Brough (Brit. Mus.) Westmoreland.
Victoria Cave, Settle . . . Yorkshire.
Silchester (Strathfieldsaye House) . Hampshire.

KELTO-ROMAN S-SHAPED OR ZOÖMORPHIC TYPE, WITH ENAMELLED ORNAMENT.

Kirkby Thore Westmoreland.
Dowkerbottom Cave, Settle . . Yorkshire.
Malton Yorkshire.
Thirst House Cave, Deepdale . . Derbyshire.
Kilnsea Yorkshire.
Cirencester Gloucestershire.
Locality unknown (Brit. Mus.) . .

Metal pins do not seem to have been much used as dress-fasteners during the Late-Celtic period, judging from the number to be seen in our public museums. One of the most beautiful pins of this period now in existence is the one found with the burial previously mentioned at Danes' Graves,[1] near Driffield, Yorkshire, and now in the York Museum. The pin is of bronze, with a peculiar crook near the top and a circular head

[1] *Proc. Soc. Ant. Lond.* ser. 2, vol. xvii., p. 120.

(resembling a chariot-wheel with four spokes) inlaid
with shell, or, according to another account, ena-
melled. Two bronze pins, with plain turned heads,
were amongst the objects derived from the Thirst
House Cave,[1] Deepdale, Derbyshire.

Several pins of the class known as "hammer-headed"
have been discovered from time to time, chiefly in
Ireland and Scotland. These pins are of considerable
size, some being ten inches long, and have semi-
circular heads with the convex side facing downwards.
The top of the pin is bent at right angles, and the
head fixed on in front of it. At the top of the head
are usually from three to five projecting studs, and the
face of the head is enamelled with Late-Celtic designs.
From the associations in which such pins have been
found and the style of their decoration, they would
seem to belong to the transition period between
Paganism and Christianity. There is one in the
British Museum from Moresby, Cumberland, which
was associated with a small bronze ornament of
Late-Celtic character; another in the same collection
from Craigywarren,[2] Co. Antrim, has spiral patterns
upon it; whilst a third in the Edinburgh Museum,
from Norrie's Law,[3] Forfarshire, was associated with
coins of the seventh century, and silver leaf-shape pen-
dants engraved with the same mysterious symbols
which occur so frequently on the early Christian sculp-
tured stones of Scotland. A hammer-headed pin of
silver from Gaulcross,[4] Banffshire, has spiral designs
upon the head, but of a kind more nearly resembling

[1] *The Reliquary* for 1897, p. 96.

[2] Wood Martin's *Lake Dwellings of Ireland*, p. 110.

[2] Dr. J. Anderson's *Scotland in Early Christian Times*, 2nd ser.,
p. 36.

[4] Dr. J. Stuart's *Sculptured Stones of Scotland*, vol. ii., pl. 9.

that found on the Christian crosses of about the ninth century in Argyllshire than the Late-Celtic flamboyant designs of Pagan times. Other examples of pins of this kind have been found at Lagore,[2] Co. Meath, Urquhart,[3] Elginshire, on the Culbin Sands, Nairnshire, and in the island of Pabbay, Hebrides.

Unquestionably the finest Late-Celtic personal ornaments are the collars for wearing round the neck, of which, at least, two in gold and about ten in bronze are known to exist. Being larger than any other class of personal ornament, they naturally afford greater scope for the display of the elaborate forms of flamboyant designs in which the art metalworker of the period used to revel. One of the gold collars just referred to came from Broighter, on the western shore of Lough Foyle, near Limavady, Co. Londonderry. It was in the British Museum, but has recently been removed to Dublin. The collar, which formed part of one of the most valuable finds of gold ornaments yet made in Great Britain, is unique both as regards its form and the extraordinary artistic skill displayed in its decoration. The hoard was accidentally brought to light in 1896 whilst ploughing a field on the farm occupied by Mr. J. L. Gibson. We give a list of the various objects comprising the find below.

List of Objects in the Limavady Find of Gold Ornaments.

(1) Model of a boat, $7\frac{1}{4}$ inches long by 3 inches wide, weighing 3 ozs. 5 dwts., with benches and rowlocks for eighteen oarsmen (nine on each side) and rowlock for steering-paddle in the stern.

(2) Boat-fittings in miniature, consisting of fifteen oars,

[1] Wood Martin's *Lake Dwellings of Ireland.*
[2] *Proc. Soc. Ant. Scot.,* vol. xxxv., p. 279.

one grappling-iron, three forked implements, one yard-arm, and one small spar.

(3) Bowl, 3½ inches in diameter by 2 inches deep, weighing 1 oz. 5 dwts. 12 grs., provided with four small rings for suspension.

(4) Two twisted necklets (one broken), the perfect one 5 inches in diameter, weighing 3 ozs. 7 dwts. 9 grs.

(5) Two chains of plaited wire, one 1 foot 2½ inches long, weighing 2 ozs. 7 dwts., and the other 1 foot 4½ inches long, weighing 6 dwts. 12 grs.

(6) Late-Celtic collar, 7½ inches in diameter, made of a tubular ring 1⅛ inch in diameter.

The collar must have had a joint of some kind, which is now missing ; and the fastening is a most peculiar one, consisting of a T-shaped projection on the end, one-half of the tubular ring fitting into a slot in the end of the other half of the ring. The locking is effected by giving the slotted end a half turn after the T-shaped projection has been inserted. The whole of the exterior surface of the tube is decorated with long sweeping curves, narrow in the middle and with trumpet-shaped expansions at each end, combined with helixes resembling a snail-shell. The background is shaded with a sort of engine-turned pattern of fine lines drawn with a pair of compasses. This remarkable gold collar has been fully described and illustrated by Dr. Arthur Evans in the *Archæologia* (vol. lv., p. 397), and the facts relating to its discovery are related in detail by Mr. R. Cochrane, F.S.A., in a paper in the *Journal of the Royal Society of Antiquaries of Ireland* (vol. xxxiii., p. 211). An account of the evidence given by Mr. C. H. Read, F.S.A., before the committee appointed to inquire into the respective rights of the British Museum and the Museum of the Royal Irish Academy at Dublin to

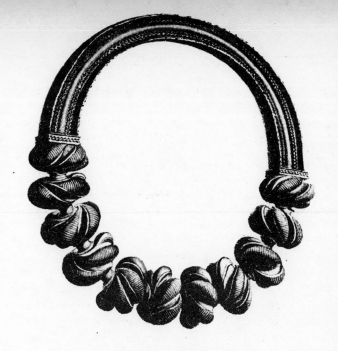

BRONZE BEADED TORQUE, FROM MOWROAD, NEAR ROCHDALE,
LANCASHIRE

SCALE ¾ LINEAR

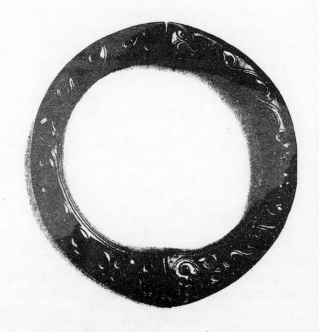

BRONZE COLLAR FROM WRAXHALL, SOMERSETSHIRE;
NOW IN THE BRISTOL MUSEUM

the possession of the hoard of gold ornaments will be found in the report of the inquiry in the Blue Book issued in 1899.

A second collar of gold now in the Museum of the Royal Irish Academy in Dublin, said to have come from Clonmacnois, King's Co., is illustrated in Sir W. Wilde's *Catalogue of Antiquities of Gold in Museum R.I.A.*, p. 47. It consists of a plain hollow ring 5½ inches in diameter with an ornamental bulb on each side, one of which seems to be made in imitation of one of the glass beads of the period.

The Bristol Museum possesses a perfect flat-jointed bronze collar, of a different kind from any of those just described, from Wraxhall,[1] Somerset, and a portion of another from Llandyssyl,[2] Cardiganshire. In the British Museum there are two similar collars, one from Trenoweth,[3] Cornwall, and the other from the Isle of Portland,[4] Dorsetshire. The Edinburgh Museum has also an exceedingly good example from Stitchell,[5] Roxburghshire. All these collars are elaborately ornamented in the Late-Celtic style. The date of the collar from the Isle of Portland is approximately fixed by its having been associated with a dish of Samian ware.

The existence of other Late-Celtic collars has been recorded at Mowroad,[6] near Rochdale, Lancashire; Embsay,[7] near Skipton, Yorkshire; Perdeswell,[8] Worcestershire; Lochar Moss,[9] Dumfriesshire; and

[1] *Archæologia Cambrensis*, ser. 6, vol. i., p. 83. [2] *Ibid.*

[3] *Archæologia*, vol. xvi., p. 127. [4] *Ibid.*, vol. liv., p. 496.

[5] Dr. J. Anderson's *Scotland in Pagan Times*.

[6] H. Fishwick's *History of the Parish of Rochdale*, p. 5.

[7] *Archæologia*, vol. xxxi., p. 517. [8] *Ibid.*, vol. xxx., p. 554.

[9] D. Wilson's *Prehistoric Annals of Scotland*, vol. ii., p. 141, and *Archæologia*, vol. xxxiii., p. 347.

Hyndford Crannog,[1] near Lanark. These five be-
long to a special class of what are not inaptly called
"beaded torques," because rather more than one-half
the collar is composed of bronze beads of two different
shapes, (one convex and the other concave) strung

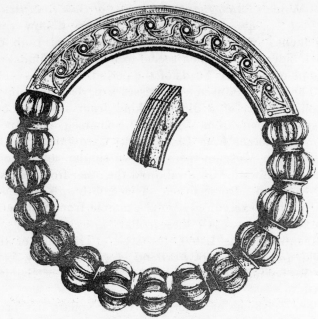

Bronze Beaded Torque from Lochar Moss, Dumfriesshire
Now in the British Museum

alternately on an iron rod of square cross-section, so
as to prevent the beads from revolving. The remain-
ing and smaller segment of the circle consists of a
bronze tube of rectangular cross-section, ornamented
on the exterior with a Late-Celtic flamboyant design,

[1] *Proc. Soc. Art. Scot.,* vol. xxxiii., p. 385.

The Perdeswell collar is incomplete, and the part which remains is formed of twenty beads resembling vertebræ strung on to an iron wire or bar, as in the case of the Lochar Moss collar.

The last class of personal ornaments of the Late-Celtic period to be noticed are the armlets. The most remarkable of these are of the Scottish type, as it may fairly be called, only one specimen having been found outside Scotland.[1] The armlets of this type are very heavy and massive, and their general form appears to have been suggested by a coiled serpent; as in the one from the Culbin Sands, Nairnshire, the ends of the coil terminate in actual serpents' heads. The armlets are usually found in pairs, and are highly ornamented with flamboyant work, and in some cases enamelled. Although they are of cast-bronze, the style of the decoration is evidently copied from the repoussé designs of the wrought metalwork of the period. Dr. J. Anderson has devoted a considerable portion of his Rhind Lectures on *Scotland in Pagan Times: Iron Age*, to the examination of the Scottish group of armlets, most of which are in the Edinburgh Museum. The following is a list of the known examples :—

List of Localities where Armlets of the Scottish Type have been found.

Culbin Sands, Nairnshire.	Bunrannoch, Perthshire.
Auchenbadie, Banffshire.	Seafield Tower, Fifeshire.
Castle Newe, Aberdeenshire.	Stanhope, Peeblesshire.
Belhelvie, Aberdeenshire.	Plunton Castle, Kirkcud-
Aboyne, Aberdeenshire.	brightshire.
Pitalpin, Forfarshire.	Locality unknown.
Grange of Conan, Forfarshire.	Newry, Co. Down.
Pitkelloney, Perthshire.	

[1] At Newry, Co. Down.

The armlet from Stanhope, Peeblesshire, was associated with a Romano-British saucepan, which suggests that this type belongs to the later part of the Celtic Pagan Iron Age.

Bronze armlets of La Tène, or continental type, have been derived from the burial mounds at Cowlam and Arras, Yorkshire. The bronze armlet from the Stamford Hill Cemetery, near Plymouth, is jointed like the collars, and decorated with flamboyant work.

A pair of penannular ring armlets of silver terminating in sepents' heads, which may possibly be Late-Celtic, was disposed of at the sale of the Bateman Collection from Lomberdale House, Derbyshire. They were found at Castlethorpe,[1] Buckinghamshire, in 1827, in a small urn containing Roman silver and brass coins, none later than the reign of Verus (A.D. 161--169), and a massive silver ring set with a carnelian engraved with a figure of Bonus Eventus. A similar pair of base silver armlets were found near the Carlswark Cavern,[2] in Middleton Dale, Derbyshire.

Three very elegant armlets of twisted and looped bronze wire were associated with a Late-Celtic burial outside Thirst House Cave,[3] Deepdale, Derbyshire. Armlets of the same make are illustrated in Lidenschmit's *Alterthümer*, (vol. ii., pt. 5, pl. 3).

The Late-Celtic toilet accessories are of three kinds, namely, hand-mirrors, hair-combs, and châtelaines. The mirrors are of bronze and circular in shape, with an ornamental handle. The back, or unpolished face of the mirror, is in nearly all cases decorated with incised circles of different sizes, combined with curved

[1] *The Reliquary*, vol. xiii., pl. 18; and *Jour.* ; and *Brit. Archæol. Assoc.*, vol. ii., p. 353.
[2] *The Reliquary*, vol. 1867, p. 113.　　　　[3] *Ibid.*, 1897, p. 101.

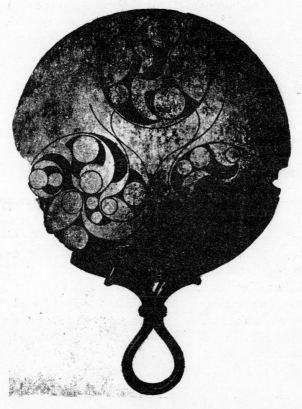

LATE-CELTIC BRONZE MIRROR, IN THE MAYER MUSEUM,
LIVERPOOL; LOCALITY UNKNOWN

lines and a peculiar sort of background filled in with
cross hatching. A list of mirrors such as those de-
scribed is given below.

List of Localities where Late-Celtic Mirrors have been found.

Warden (Bedford Mus.) . . .	Bedfordshire.
Stamford Hill, near Plymouth (Plymouth Mus.)	Devonshire.
Birdlip (Gloucester Mus.) . .	Gloucestershire.
Trelan Bahow (British Mus.) . .	Cornwall.
Balmaclellan (Edinburgh Mus.) .	Kirkcudbrightshire.
Locality unknown (Liverpool Mus.)	

Unornamented mirrors have been found with burials
at Arras,[1] Yorkshire, and Gilton,[2] Kent.

The hair-combs are of bone, and will therefore be
described subsequently when dealing with bonework.

The châtelaines of the Late-Celtic period are pretty
little objects of bronze, generally enamelled. At the
top is a loop for suspension ; there is a little rod below,
from which are hung tweezers, picks, files, etc. Speci-
mens have been discovered in the Thirst House Cave,[3]
Deepdale, Derbyshire, and at Canterbury,[4] and Craven
Arms,[5] Shropshire.

The domestic utensils and cooking appliances of the
Late-Celtic period include wooden tankards and buckets
with bronze mountings, bronze bowls and saucepans,
and iron fire-dogs. Some of the riveted caldrons
possibly also belong to this period, but as they cannot
be distinguished from those of the Bronze Age it will
be unnecessary to describe them here.

[1] W. Greenwell's *British Barrows*, p. 454.
[2] B. Faussett's *Inventorium Sepulchrale*, p. 30.
[3] *The Reliquary* for 1897, p. 95.
[4] *Proc. Soc. Ant. Lond.*, ser. 2, vol. vi., p. 376.
[5] *Archæologia Cambrensis*, ser. 5, vol. vi., p. 90.

There is a very perfect wooden tankard mounted with bronze in the Mayer Museum, Liverpool, from Trawsfynydd,[1] Merionethshire, having a handle ornamented in the Late-Celtic style with flamboyant tracery, which might easily be mistaken for Gothic work of the fourteenth century were it not for the trumpet-shaped expansions which occur in the details. Handles of similar tankards have been found at Aylesford,[2] Kent; Elveden,[3] Essex; Okstrow,[4] Orkney; and Carlingwark Loch,[5] Kirkcudbrightshire.

Late-Celtic wooden buckets with bronze mountings are of the greatest rarity, so much so that only two are known to exist, one from Aylesford,[6] Kent, in the British Museum, and the other from Marlborough,[7] Wilts, in the Devizes Museum. They are both decorated with repoussé designs representing men, animals, etc., treated much in the same way as on the Ancient British and Gaulish coins of the same period.

Bronze bowls have been frequently found on Late-Celtic inhabited sites and with Late-Celtic burials. A quite plain but extremely well-made bronze bowl is to be seen in the British Museum side by side with the beaded torque from Lochar Moss,[8] Dumfriesshire, which accompanied it. There is another plain bowl in the Gloucester Museum which was associated with the burial at Birdlip,[9] Gloucestershire, already described. A bronze bowl ornamented with projecting bosses is

[1] *Archæologia Cambrensis,* ser. 5, vol. xiii., p. 212.
[2] *Archæologia,* vol. lii., p. 44.
[3] *Ibid.,* vol. lii., p. 45.
[4] J. Anderson's *Scotland in Pagan Times : Iron Age,* p. 242.
[5] *Proc. Soc. Ant. Scot.,* vol. vii., p. 7.
[6] *The Reliquary* for 1897, p. 35.
[7] Sir R. Colt Hoare's *Ancient Wilts.*
[8] D. Wilson's *Prehistoric Annals of Scotland,* vol. i., p. 465, pl. 9.
[9] *Trans. of Bristol and Gloucestershire Archæol. Soc.,* vol. v., p. 137.

amongst the objects derived from the Glastonbury[1] Marsh Village; and a bowl in the Dublin Museum from Keshkerrigan,[2] Co. Leitrim, has a very characteristic Late-Celtic handle in the form of a beast made up of flamboyant curves. A special type of bronze bowls with zoömorphic handles and enamelled decorations will be dealt with subsequently.

Most of the saucepans in use during the Late-Celtic period were either imported from Italy and Gaul or were so nearly copied by local metalworkers as to be indistinguishable from the originals. None of these saucepans, as far as I am aware, have Celtic decoration upon them, although several are inscribed with Celtic names, and others are highly enamelled. Two specimens in the British Museum are of exceptional interest, one of bronze enamelled and inscribed with the name "BODVOGENVS," from Prickwillow,[3] near Ely, Cambridgeshire, and the other of silver, with a highly ornamented inscribed handle, which was found at Backworth,[4] Northumberland, with the pair of Kelto-Roman fibulæ previously mentioned. The more elaborate saucepans were probably used in connection with religious ceremonies and not for cooking, as is borne out by the dedicatory inscriptions upon the handles and the circumstances under which many of them have been found. A list has already been given of the saucepans associated with finds of Late-Celtic objects.

The metalworkers of the Late-Celtic period were not only capable of executing some of the finest pieces of repoussé bronze that the world has ever seen, but they

[1] *Proc. of Somersetshire Archæol. Soc.*, vol. xl., p. 149.
[2] *Reliquary* for 1900, p. 247.
[3] *Archæologia*, vol. xxviii., p. 436.
[4] *Archæol. Jour.*, vol. viii., p. 39.

also excelled in producing works of art in wrought-iron of great merit. As an example of their skill in this direction we have the remarkable pair of fire-dogs from Capel Garmon, Denbighshire,[1] now in the possession of Colonel Wynne Finch of Pentre Voelas, near Bettws-y-coed. The fire-dogs consist of two upright bars, each surmounted by the head of a beast with horns, and standing on an arched foot, connected near the bottom by a horizontal bar on which to rest the logs of wood used for the fire. The uprights are ornamented on each side with thinner pieces of iron bent into undulations and scrolls, and fixed to the uprights at intervals with rivets having large round heads.

Each of the beasts' heads has a very curious sort of crest ornamented with a row of circular holes and round knobs. Other fire-dogs of the same kind, made of plain iron bars, and with horned beasts' heads on the top of the uprights (each horn terminating in a round knob), have been found at Mount Bures,[2] Essex, Hay Hill,[3] near Cambridge, and Stamfordbury,[4] Bedfordshire, associated with Romano-British burials.

The only objects of the Late-Celtic period which may conjecturally have been used for religious purposes are the little bronze figures of animals from Hounslow,[5] Middlesex, now in the British Museum.

Under the head of musical instruments come the bone flutes from Thor's Cave, Staffordshire, and the magnificent bronze trumpet found in 1794 at Loughnashade, Co. Armagh, and now in the Museum of the Royal Irish Academy at Dublin. Most of the trumpets

[1] *Archæologia Cambrensis,* ser. 6, vol. i., p. 40.
[2] C. Roach Smith's *Collectanea Antiqua,* vol. ii., p. 25.
[3] *Archæologia,* vol. xix., p. 57.
[4] *Publications of Cambridge Ant. Soc.* for 1845
[5] *Proc. Soc. Ant. Lond.,* ser. 2, vol. iii., p. 90.

of this kind are of the Bronze Age, but the style of
the decoration on the annular disc at the mouth of the
one from Loughnashade shows clearly that it is of
the Iron Age.[1]

Amongst the objects of unknown use of the Late-

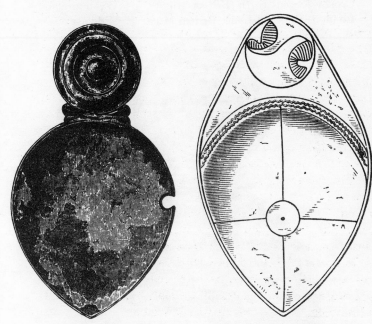

Late Celtic Bronze Spoon from Late Celtic Bronze Spoon from
Brickhill Lane, London Crosby Ravensworth, Westmoreland

Celtic period are certain so-called spoons, some peculiar
disc-and-hook ornaments, and a few highly ornamented
circular pieces of repoussé bronze with a cup-shaped
depression nearly in the centre.

The spoon-like objects have been very fully dealt

[1] Sir W. Wilde's *Catal.*, pp. 627 and 631.

with in a paper by Mr. Albert Way in the *Archæological Journal* (vol. xxvi., p. 52), and below is given a list of all the known specimens.

List of Localities where Spoon-like Objects with Late-Celtic Decoration have been found.

Crosby Ravensworth (British Mus.) . Westmoreland.
London, Brickhill Lane (British Mus.) . Middlesex.

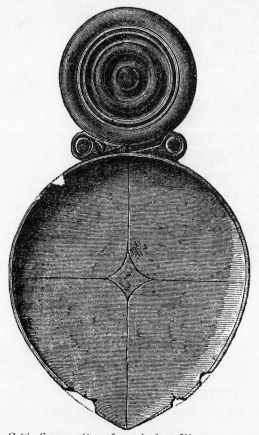

Late Celtic Spoon. One of a pair from Weston, near Bath.
Now in the Edinburgh Museum. Scale | linear

London, Thames (British Mus.)　.　.　Middlesex.
Weston, near Bath (Edinburgh Mus.)　.　Somersetshire.
Llanfair (Edinburgh Mus.)　.　.　.　Denbighshire.
Penbryn (Ashmolean Mus.)　.　.　.　Cardiganshire.
Locality unknown (Liverpool Mus.)　.　Ireland.
Locality unknown (Dublin Mus.)　.　.　Ireland.
Walmer .　.　.　.　.　.　.　Kent.

The body of these objects is shaped like a very shallow spoon with a pointed end, and the handle (if such it may be called) is circular or nearly circular, in many cases with two little round ears or projections at each side. The so-called spoons are generally found in pairs, one spoon having a cruciform design in the middle of the bowl; whilst its fellow has a small hole bored through the edge of the bowl. The handles of the spoons are always ornamented, sometimes on the front only, but more commonly on the back as well.

There are specimens of the other Late-Celtic objects of unknown use—namely, the hook-and-disc ornaments[1] and the circular pieces of repoussé metalwork with a cup-shaped depression—in the British Museum[2] and the Dublin Museum.[3]

No satisfactory explanation has been given of the use of certain wheel and triskele pendants of which examples have been found in Berkshire, Kingsholm, near Gloucester, Hunsbury, N. Hants, Seamill Fort, Ayrshire, and Treceiri, Carnarvonshire.

POTTERY AND GLASS

The pottery of the Late-Celtic period differs from that of the Bronze Age in being turned on a wheel instead of being hand-made. The firing is also better

[1] *The Reliquary* for 1901, p. 56.
[2] *Proc. Soc. Ant. Scot.*, vol. xix., p. 254.
[3] Sir W. Wylde's *Catal. Mus. R.I.A.*, p. 637.

done, and the quality of the ware superior in every way. Since the discovery of the Aylesford cemetery in Kent, in 1886, it has been possible to differentiate Late-Celtic pottery from Romano-British by the peculiar forms of the vases. Dr. Arthur Evans has dealt with this subject pretty exhaustively in his paper in the *Archæologia* (vol. lii., p. 315).

The most characteristic of the Aylesford urns is tall, with a narrow base and wide mouth. The base is in the shape of a low truncated cone, the top of which is the narrowest part of the vase, and from this point it gradually gets wider until the top rim is nearly reached, when it contracts again slightly. The curve thus produced is of such extreme elegance as to at once suggest a classical origin. The exterior surface of some of these pots is plain, but in many cases it is divided into bands by horizontal projecting bead mouldings. Dr. A. Evans does not find much difficulty in showing that the peculiarities of form can be directly traced to the metal *situlæ* from which the vases were copied. With regard to this, he says :—

" In most cases these (*i.e.* the Aylesford) vases, which for elegance of form may almost vie with the ceramic products of Italy or Greece, are divided into zones by the small raised ridges or cordons described above, the zones themselves being, in turn, decorated with finely incised linear striations. This type of vase, beautiful as it is in itself, is still more interesting from the comparisons to which it inevitably leads us. No one familiar with the ceramic forms of an important group of North-Italian cemeteries, belonging, for the most part, to the fourth or fifth centuries before our era, and of which the whole series of objects so admirably excavated and arranged by Professor Prosdocimi at Este[1] forms the most splendid illustration, can fail to be struck with the

[1] *Notizie degli Scavi,* etc., 1882, pp. 5-37.

manifold points of resemblance presented by the urns before us with the most characteristic of the vase-types there represented. The contour of the type referred to, with its shoulders sometimes angular, sometimes abruptly rounded off, its inverted conical body divided into vertical zones by raised cordons, and tapering off to a pedestal below, can only be described as identical with that of some of the finest of the Aylesford specimens. The only perceptible difference is that, whereas the British urns are almost uniformly covered with a black or brown coating—the colouring

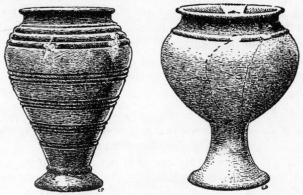

Late Celtic urns from Shoebury, Essex
Now in the Colchester Museum

matter may have been supplied by pounded charcoal—zones of the Euganean cineraries are coloured alternately with bands of graphite and red ochre. Some of the earlier of the Este vases are, however, of plain dark brown *bucchero*, and others, again, of later date, of an uniform red or grey. These North-Italian parallels have a still further value, inasmuch as they throw the clearest possible light on the actual genesis of this type. The cordoned vases of Este are, in fact, nothing more than copies in clay of certain forms of bronze *situlæ;* the commonest form of these, which is distributed through the whole of the geographical area where these vases are discovered, is zoned in the same

way as the pots, the zones answering to an universal method
of early metal industry, in accordance with which vessels
were built up of bands of thin metal riveted together at the
edges, each zone being often, in turn, defined by cordons or
beads of metal. These cordons themselves in their more
prominent form represent the wooden rings that surrounded
and kept together the framework of wooden staves, to which
in early times the metal plates themselves were riveted."

Besides the pedestalled vases from Aylesford,[1] made
in imitation of the cordoned *situlæ* of bronze from the
North-Italian region, there are others, perhaps derived
from them, with elegantly formed bases. There are also
vases without pedestals, and having somewhat globular
bodies as well as bowl-shaped and saucer-shaped pots.
Most of these are now in the British Museum.

The following list gives the finds of pottery of a
similar kind :—

*List of Localities where Finds of Late-Celtic Pottery of the
Aylesford Type have been made.*

Kit's Coty House (Maidstone Mus.). .	Kent.
Allington (Maidstone Mus.) . . .	Kent.
Northfleet	Kent.
Elveden	Essex.
Shoebury	Essex.
Braintree	Essex.
Locality unknown (Cambridge Mus.).	
Hitchin	Herts.
Aston Clinton (Aylesbury Mus.) . .	Bucks.
Abingdon (Ashmolean Mus.) . . .	Berks.
Whitechurch (Dorchester Mus.) . .	Dorset.
Weymouth (British Mus.) . . .	Dorset.

Another class of pottery is recognised to belong to
the Late-Celtic period, not so much by the forms of

[1] A fine example of this type from Sandy, Beds, is illustrated in
T. Fisher's *Bedfordshire*.

LATE-CELTIC POTTERY FROM YARNTON, OXFORDSHIRE;
NOW IN THE BRITISH MUSEUM

SCALE ¾ LINEAR

LATE-CELTIC POTTERY FROM KENT'S CAVERN, NEAR TORQUAY,
DEVONSHIRE; NOW IN THE BRITISH MUSEUM

SCALE ¾ LINEAR

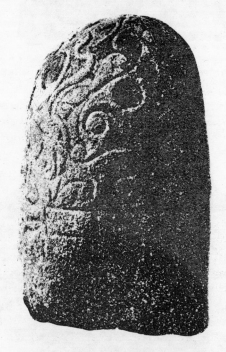

GRANITE MONOLITH, WITH LATE-CELTIC
SCULPTURE, AT TUROE, CO. GALWAY.

HEIGHT OF STONE, 4 FT.

*Reproduced from a photograph by Mr. A. McGoogan
illustrating Mr. George Coffey's paper in the
"Proceedings of the Royal Irish Academy"*

the vases (because most of them are in a very frag-
mentary condition) as by the patterns upon them,
which consist of incised curved lines, circles, dots, and
different kinds of cross-hatching and shading. A list
of the finds is given below.

*List of Localities where Finds of Late-Celtic Pottery, orna-
mented with Incised Lines, Circles, Dots, and Shading,
have been made.*

Hunsbury (Northampton Mus.) .	Northamptonshire.
Mount Caburn (Pitt-Rivers Coll.) .	Sussex.
(British Mus.)	
Brighton (Brighton Mus.) . .	Sussex.
Highfield Pits, near Salisbury (Black-more Mus., Salisbury) . . .	Wiltshire.
Kent's Cavern, Torquay (British Mus.)	Devonshire.
Glastonbury Marsh Village (Glaston-bury Mus.) 	Somersetshire.
Kingsholm (Ashmolean Mus.) . .	Gloucestershire.
Yarnton (British Mus.) . . .	Oxfordshire.

Those who wish to compare the Late-Celtic pottery
of Britain with Gaulish pottery of the same character
may, with advantage, consult the *Dictionnaire Archéo-
logique de la Gaule*, and Paul du Chatellier's *La Poterie
aux époques préhistoriques et gauloise en Armorique.*

As far as the available evidence goes, glass does not
seem to have been used for any other purpose by the
Late-Celtic people except the manufacture of personal
ornaments, the most important of which were beads
for necklaces. Some of the beads from Ireland and
Scotland, specimens of which may be seen in the
museums at Dublin and Edinburgh, are most artisti-
cally fashioned from twisted rods of glass of variegated
colour bent into peculiar shapes. They have been
obtained from the Irish crannogs at Lagore, Co. Meath,
and Lough Ravel.

A bracelet of green glass, with a cable-like ornament in white and blue strands surrounding its outer surface, was found a few years ago in the crannog at Hyndford, Co. Lanark.

WOODWORK, BONEWORK, AND THE KIMMERIDGE SHALE INDUSTRY

Owing to the perishable nature of the material very few examples of carved woodwork of the Late-Celtic period are now in existence. Those which we do possess have been derived from the Glastonbury Marsh Village and from the crannog at Lochlee, Ayrshire. Mr. Arthur Bulleid, F.S.A., has illustrated three specimens in an article on "Some Decorated Woodwork from the Glastonbury Lake Village" in the *Antiquary* for April, 1895, p. 109. No. 1 was dug up from the peat at a depth of 6 feet 6 inches below the surface, near the south-east edge of the village. It is a rectangular piece of wood dressed smooth all over, 1 foot 7 inches long by $3\frac{3}{4}$ inches wide by $\frac{1}{8}$ inch thick, decorated on one side with a step-pattern shaded after the fashion of chequerwork, with a cross-hatching of diagonal lines. No. 2 is the stave of a small bucket, which, when complete, must have been 7 inches high by $5\frac{1}{2}$ inches in diameter, decorated with a lozenge pattern shaded with parallel straight lines. No. 3 is a portion of a tub 6 inches high by 1 foot in diameter, cut out of a solid piece of ash, and having its exterior surface decorated with flowing lines of extreme beauty, resembling scrolls of foliage converted into geometrical ornament by successive copying. Where the flowing lines diverge, the trumpet-shaped expansions are shaded with diagonal cross-hatching and dots. There is a good model of this tub in the British Museum. The designs on the woodwork from Glastonbury are

produced by incising the surface with some fine sharp-pointed tool, and afterwards burnt in by passing a heated piece of metal along the incisions.

The specimen from the Lochlee crannog, which is illustrated in Dr. R. Munro's *Ancient Scottish Lake Dwellings* (p. 134), is a piece of ash 5 inches square, ornamented on one side with a triple spiral, and on the other with Late-Celtic flamboyant work.

A wooden bowl with a carved handle, found in a bog near Rathconrath, Co. Westmeath, and now in the Museum of the Royal Irish Academy in Dublin, may possibly belong to the same category.

Amongst the objects of bone belonging to the Late-Celtic period the most remarkable are the spatulæ, or flakes, of which no less than 5,000 are said to have been derived from cairn H of the Slieve-na-Caillighe series, near Oldcastle, Co. Meath. These chambered cairns were in the first instance erected as burial-places at the end of the Neolithic Age or the beginning of the Bronze Age, and the one marked H on the plan given in the *Proc. Soc. Ant. Scot.* (vol. xxvi., p. 294) appears to have been used as a workshop by an artificer in bone during the Early Iron Age. Ninety-one of the bone spatulæ from the cairn in question were engraved by compass, with circles, curves, and ornamental puncturings, and twelve were decorated on both sides. Unfortunately the whole of the bones have been lost, and we only know what they were like from the illustrations in E. Conwell's *Tomb of Ollamh Fodhla* (p. 53). A fragment of one of these bones which had been overlooked by the previous explorers of the cairn has recently been brought to light by Mr. E. Crofton Rotheram.[1] Perhaps the most interesting feature connected with the bones from Slieve-na-Caillighe is the discovery with them of

[1] *Journ. R. Soc. Ant. Ireland*, ser. 5, vol. vi., p. 257.

the pair of iron compasses used in producing the incised designs upon them.

Besides the bones just described, the other principal objects of the same material belonging to the Late-Celtic period are certain toilet-combs and spoon-shaped fibulæ, or dress-fasteners. Bone combs with Late-Celtic ornament have been found on the inhabited site at Ghegan Rock, near Seacliff, Haddingtonshire, and in the crannogs at Lagore,[1] Co. Meath, Ballinderry,[2] Co. Westmeath; and at Longbank crannog on the Clyde, near Glasgow. Spoon-shaped fibulæ of bone have been derived from the Victoria Cave, Settle, the Kelko Cave, Giggleswick, and Dowkerbottom Cave, Arncliffe, Yorkshire. The ornament upon them consists of concentric circles and dots.[3]

In addition to wood and bone, the Late-Celtic people used Kimmeridge shale for the manufacture of objects, chiefly turned vases with cordons, like the Aylesford pots previously described. Vessels of this kind have been found at Old Warden,[4] Bedfordshire, Great Chesterford[5] and Colchester,[6] Essex, and Corfe Castle,[7] Dorset.

STONEWORK

Only three sculptured monuments decorated with Late-Celtic patterns are known to exist at present.[8] They are all in Ireland and are fully described by Mr. G. Coffey in the *Proceedings of the Royal Irish Academy* (vol. xxiv., sect. c, p. 257).

[1] Sir W. Wilde's *Catal. Mus. R.I.A.,* p. 271, fig. 176.

[2] *Ibid.,* p. 271, fig. 177.

[3] Prof. W. Boyd Dawkins' *Cave Hunting,* pp. 91 and 131.

[4] "On the Materials of Two Sepulchral Vessels found at Warden, Co. Beds, by the Rev. J. S. Henslow (*Cambridge Ant. Soc. Publ.,* 1846).

[5] *Archæol. Jour.,* vol. xiv., p. 85.

[6] Henslow, *loc. cit*, p. 87.　　　[7] *Archæol. Jour*, vol. xxv., p. 301.

[8] At Mullaghmast, Co. Kildare; Castle Strange, Co. Roscommon; and Turoe, Co. Galway.

CHAPTER V

PAGAN CELTIC ART IN THE EARLY IRON AGE

TECHNICAL PROCESSES EMPLOYED DURING THE EARLY IRON AGE IN BRITAIN

THE fact must never be lost sight of that the picture presented to our mind of any particular prehistoric stage of culture must necessarily be extremely imperfect, since the extent of our knowledge is limited entirely by the number of relics which specially favourable circumstances have preserved from destruction. Of the textile fabrics of the Late-Celtic period, for instance, hardly anything is known, although we are certain that spinning and weaving must have been extensively practised from the quantities of long-handled weaving-combs, spindle-whorls, and loom-weights that have been found on almost every inhabited site. A people who showed such a high capacity for decorative design could not have failed to produce good artistic effects by means of pattern-weaving.[1] What such textile patterns may have been can only be guessed at by survivals (like the Scottish tartans) or by ornament of a textile character occurring on objects made of less perishable materials (like the step-pattern on a piece of wood from the Glastonbury Marsh Village).

[1] "The cloth was covered with an infinite number of little squares and lines as if it had been sprinkled with flowers, or was striped with crossing bars which formed a chequered design. Their favourite colour was red or a pretty crimson." C. Elton's *Origins of English History,* p. 114, quoting Pliny and Diodorus Siculus.

The Celts had already become expert workers in metal before the close of the Bronze Age; they could make beautiful hollow castings for the chapes of their sword-sheaths; they could beat out bronze into thin plates and rivet them together sufficiently well to form water-tight caldrons; they could ornament their circular bronze shields and golden diadems with repoussé patterns, consisting of corrugations and rows of raised bosses; and they were not unacquainted with the art of engraving on metal.

The Celt of the Early Iron Age attained to a still higher proficiency in metallurgy than his predecessor of the Bronze Age. Casting in bronze was applied to a much larger number of objects than before, such as—

> Handles of swords and daggers.
> Chapes of sword and dagger sheaths.
> Bridle-bits.
> Harness-mountings and rings.
> Chariot fittings.
> Collars and armlets.
> Handles of tankards and mirrors.
> Spoon-like objects of unknown use.

Wrought-bronze was used for—

> Sword and dagger sheaths.
> Shields and helmets.
> Mountings of wooden buckets and tankards.
> Caldrons and buckets.
> Circular discs of unknown use.

The ornamental features of the objects of cast-bronze were produced chiefly during the process of moulding, although the surface was in many cases further beautified afterwards by chasing, engraving, and enamelling.

Objects of wrought-bronze were usually decorated by means of repoussé-work, *i.e.* designs in relief

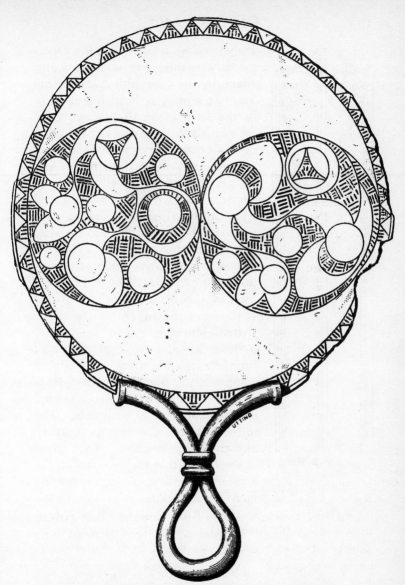

Late-Celtic Bronze Mirror from Trelan Bahow, Cornwall
Now in the British Museum

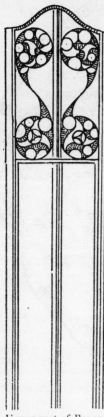

Upper part of Bronze
Sword-sheath from
Hunsbury

Now in the Northampton
Museum

hammered up from the back. Occasionally enamel was added (as, for example, on the shield from the Thames, now in the British Museum), in the form of small plaques fixed on with rivets. In place of the more or less crude corrugations and rows of raised pellets of the Bronze Age we get the most marvellous curved surfaces and conchoids, executed with an unerring eye and a skill which it would be difficult to surpass. The repoussé-work of the Late-Celtic period is seen in its greatest perfection on the circular discs of unknown use[1] in the Museum of the Royal Irish Academy in Dublin, and the British Museum.

Both cast and wrought objects of bronze were decorated with patterns composed of finely engraved lines shaded in places with a peculiar kind of cross-hatching or with dots. The mirror-backs,[2] the sword-sheaths,[3] and the harness-rings[4] afford good examples of this class of work.

Brazing and soldering appear to have been unknown to the metal-workers of the Late-Celtic period, as they pieced their metalwork together by means of rivets. The practice of riveting was learnt from the artificers

[1] See p. 121. [2] See list on p. 115.
[3] See list on p. 91 ; especially the one from Lisnacroghera.
[4] See list on p. 94 ; especially those from Polden Hill, Somerset.

who constructed the caldrons of the late Bronze Age already referred to, and they, no doubt, in their turn, acquired their knowledge from a foreign source. The bronze helmet from the Thames at Waterloo Bridge, now in the British Museum, illustrates the riveting of the Late-Celtic period at its best. The rivets generally have pointed conical heads, producing a good decorative effect. The way in which the different pieces of metal are held together is often ingeniously disguised by making the rivet-heads form part of the ornament, or by concealing the head behind a circular disc of enamel.

The evidence of both history and archæology tends to show that the art of enamelling on metal was, in the first instance, a British one. The historical evidence is confined to an oft-quoted passage from the *Icones* of Philostratus (a Greek sophist in the court of Julia Domna, wife of the Emperor Severus), which is as follows :—

" They say that the barbarians who live in the ocean pour these colours on heated brass, and that they adhere, become hard as stone, and preserve the designs that are made upon them."

Philostratus wrote this at the beginning of the third century A.D.; and by "the barbarians who live in the ocean" (τοὺς ἐν ᾽Ωκεανῷ βαρβάρους) he no doubt meant the Britons rather than the Gauls, as some French writers have assumed.[1]

The earliest enamels are those which occur on objects decorated in the pure Late-Celtic style without any trace of Roman influence, such as—

Bridle-bits from Rise, near Hull, Yorkshire ; and Birrenswark, Dumfriesshire.

[1] A. W. Franks in Kemble's *Horæ Ferales*, p. 186.

Harness-rings and mountings from—

Norton	Suffolk.
Westhall	Suffolk.
Alfriston	Sussex.
Polden Hill . . .	Somersetshire.
London	Middlesex.
Saham Toney . . .	Norfolk.
Uffizi Museum . .	Florence.
British Museum . .	Locality unknown.

Armlets from Castle Newe, Aberdeenshire; and Pitkelloney, Perthshire.

Handles of bowl from Barlaston, Staffordshire.

Next, in order of age, come objects which from their general form or from the associations they were found in are known to belong to the Romano-British period, but yet have Late-Celtic decoration upon them, such as—

Harp-shaped fibulæ from Risingham, Northumberland, River Tyne, in the Newcastle Museum.

S-shaped fibulæ from Norton, Yorkshire, and other places (see list on p. 107).

Seal-box from Lincoln, in the British Museum.

Four-legged stand, with round hole in the top, from Silchester, in the Reading Museum.

Lastly, there are survivals of the use of discs of Late-Celtic enamel in the decoration of bowls of early Saxon, and therefore post-Roman, age, the following examples of which have been found :—

List of Localities where Bowls of the Saxon Period, but with Late-Celtic enamelled decoration, have been found.

Crosthwaite (British Mus.) . .	Cumberland.
Middleton Moor (Sheffield Mus.) .	Derbyshire.
Over-Haddon	Derbyshire.
Benty Grange	Derbyshire.

Chesterton (Warwick Mus.) . . Warwickshire.
Caistor (now lost) Lincolnshire.
Oxford (Pitt-Rivers Collection) . Oxfordshire.
Needham Market (now lost) . . Suffolk.
Barrington (Sir John Evans' Col-
 lection) Cambridgeshire.
Lullingstone (Sir W. Hart Dyke's
 Collection) Kent.
Greenwich (Mr. J. Brent's Collec-
 tion) Kent.
Kingston Down Kent.

The hammer-headed pins, a list of which has already been given on page 108, are also instances of the use of Celtic enamel in post-Roman times.

Before going further it may be as well to say a few words about the art of enamelling in general, so as to show the position occupied by the Late-Celtic examples.

The term enamel is used to designate a particular kind of mixture or paste which can be applied to the surface of metals or other materials, so that when it has been vitrified by the application of heat, and afterwards cooled, it forms a decoration of great beauty and durability. The base of all enamels is a flux composed of silica (in the shape of silver sand or powdered flint), red lead, and potash. To this flux are added certain metallic oxides to produce different colours, and, if necessary, oxide of tin to render it opaque. The materials are mixed together, fused in a crucible, reduced to a fine powder when cold, made into a paste with water, and then applied to the surface of metal to be decorated. After vitrifaction in a furnace and polishing, the enamel is complete.

Mr. A. W. Franks[1] divides enamels into the following classes :—

(1) *Inlaid Enamel*, where the outlines are formed by metal divisions.

(2) *Transparent Enamel*, where the outlines and all the markings are produced by variations of depth in the sculptured ground over which the vitreous material is floated.

(3) *Painted Enamel*, where the outlines are made by a difference in the tint of the enamel itself, which completely conceals the metal base beneath.

The divisions between each of the colours in inlaid enamel are produced in two different ways, namely :—

(a) *Champlevé Enamel,* where the field (*champ*) or area to be occupied by each colour is dug out and removed (*levé*), so as to leave a very narrow band of metal at the level of the original surface to form the dividing line between the fields.

(b) *Cloisonné Enamel*, where the divisions or partitions (*cloison*) between the fields consist of thin strips of metal bent into the required shape and fixed to the surface to be enamelled.

All the enamels of the Late-Celtic period belong to the *champlevé* kind. The colours used are bright red, yellow and blue, and the designs are more often curvilinear than not, like those on the repoussé metalwork. The patterns were probably traced on the surface of the metal to be decorated with a finely pointed instrument, and the hollows to receive the enamel dug out with a scooping tool, in the case of small work, or with a long thin chisel and a chaser's hammer where the work was larger.

The late Sir Wollaston Franks, than whom no better

[1] Afterwards Sir Wollaston Franks ; see *Glass and Enamel,* by J. B. Waring and A. W. Franks.

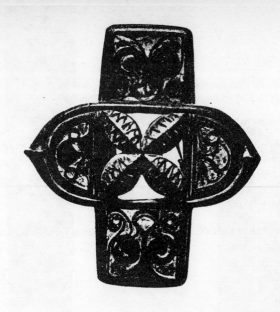

CRUCIFORM HARNESS MOUNTING OF BRONZE
ENAMELLED. LOCALITY UNKNOWN; NOW
IN THE BRITISH MUSEUM

SCALE $\frac{1}{1}$ LINEAR

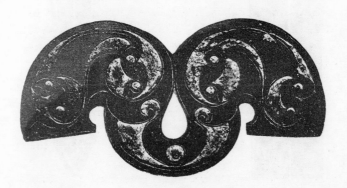

BRONZE ENAMELLED HARNESS MOUNTING FROM POLDEN HILL,
SOMERSETSHIRE; NOW IN THE BRITISH MUSEUM

SCALE $\frac{3}{4}$ LINEAR

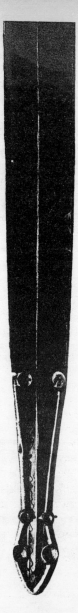

UPPER PART OF BRONZE
SWORD-SHEATH, FROM
LISNACROGHERA,
CO. ANTRIM;
NOW IN THE
BRITISH MUSEUM

LOWER PART OF BRONZE
SWORD-SHEATH, FROM
LISNACROGHERA,
CO. ANTRIM:
NOW IN THE
BRITISH MUSEUM

authority can be quoted, always maintained the Celtic origin of the art of enamelling in Western Europe, and gave the distinctive name of *opus Britannicum* to the special kind of enamel which was produced in greater perfection by the Celts inhabiting the British Isles than by any other people. The art of enamelling in the purely Celtic style commenced before the arrival of the Romans in this country, and after continuing throughout the whole period of their occupation, survived for some centuries after their departure from our shores. There are, however, numerous enamels which, though very possibly of Celtic workmanship, are altogether Roman as far as the ornamental patterns upon them are concerned. Dr. Joseph Anderson has described an exquisitely enamelled patera of this kind found in Linlithgowshire, and now in the Museum of Antiquities of Edinburgh. He says of it:—[1]

"Apart from the singular beauty of its decoration it is possessed of this special interest, that it is the only vessel of its kind and character known to exist in Scotland. It is, however, one of a class of objects, which, though few in number, are pretty widely distributed over the area, which may be termed the outskirts of the Roman Empire, towards the north and west—that is Britain, North Germany, and Scandinavia. We look in vain for anything like it within the area of the Roman Empire proper, and it may therefore be regarded as a product of a culture of some portion of the area of north-western Europe, where it was touched and modified by the Roman culture."

Other similar examples of enamelled vessels have been found at Braughing,[2] near Standon, Herts; the

[1] "Notice of an enamelled cup or patera of bronze found in Linlithgowshire, recently purchased for the Museum," in the *Proc. Ant. Scot.*, vol. xix., p. 45.

[2] *Proc. Soc. Ant. Lond.*, 2nd ser., vol. iv., p. 514.

Bartlow Hills,[1] Essex; Maltbeck,[2] Denmark; and Pyrmont,[3] in the Rhine valley. In addition to these we have two other enamelled vessels, but differing in their style of ornament, one from Rudge,[4] Wilts, now in the Duke of Northumberland's private museum at Alnwick Castle, and the other from Prickwillow,[5] Cambridgeshire, now in the British Museum.

Of the art of enamelling as carried on elsewhere than in Britain Dr. Anderson says :—[6]

"The Gauls as well as the Britons—of the same Celtic stock—practised enamel-working before the Roman conquest. The enamel workshops of Bibracte, with their furnaces, crucibles, moulds, polishing - stones, and with the crude enamels in their various stages of preparation, have been recently excavated from the ruins of the city destroyed by Cæsar and his legions. But the Bibracte enamels are the work of mere dabblers in the art compared with the British examples. The home of the art was Britain, and the style of the patterns as well as the associations in which the objects decorated with it were found, demonstrate with certainty that it had reached its highest stage of indigenous development before it came in contact with the Roman culture."

A full account of the discoveries made at Bibracte will be found in J. G. Bulliot's *Fouilles de Mont Beuvray*. Several beautiful enamels have been derived from the Belgo-Roman cemetery at Presles.

Romano-British enamels, without distinctively Celtic

[1] *Archæologia*, vol. xxvi., p. 300.
[2] *Mem. de la Soc. Royale des Antiquaires du Nord*, 1866–71, p. 151.
[3] *Jahrbücher des Vereins von Alterthumsfreunden in Rheinlande*, heft 38, p. 47.
[4] *Catal. of Mus. of R. Archæol. Inst. at Edinburgh*, 1856.
[5] *Archæologia*, vol. xxviii., p. 436.
[6] *Loc. cit.*, p. 49.

patterns upon them, have been dug up at many places
in Great Britain, but more especially at Prickwillow.

We shall see in a subsequent chapter how the diver-
gent spiral patterns on the circular discs of enamel
used to decorate the bronze bowls of the end of the
Late-Celtic period were transferred bodily to the pages
of the early Irish illuminated MSS. of the Gospels.

Another method of ornamenting metalwork besides
enamelling was by means of settings of different
materials fixed in place by small pins or rivets. As
instances we have the bronze shield from the River
Witham,[1] now in the British Museum, set with red
coral; the bronze fibula from Datchet, Oxon,[2] set with
amber and blue glass; and most curious of all, a
bronze object of unknown use from Carlton,[3] North-
amptonshire, now in the Northampton Museum, inlaid
with portions of the stem of a fossil encrinite.

A very effective kind of decorative metalwork may
be made out of wire, bent so as to form a series of
loops, of which we have British examples in the brace-
lets from the Early Iron Age burial in Deepdale,[4]
Derbyshire; and a foreign specimen in a fibula from
the cemetery of the La Tène period at Jezerine,[5] in
Bosnia-Herzegovina.

More or less akin to the looped wirework just men-
tioned are certain gold and silver chains made of fine
wire. Dr. Arthur Evans has gone pretty fully into
this subject in his paper in the *Archæologia* (vol. lv.,
p. 394), describing the find of gold ornaments at
Broighter, near Limavady, Co. Londonderry, amongst

[1] J. Kemble's *Horæ Ferales,* p. 14, and pl. 15.
[2] *Proc. Soc. Ant. Lond.,* ser. 2, vol. xv., p. 191.
[3] *Ibid.,* ser. 2, vol. xvii., p 166.
[4] *The Reliquary* for 1897, p. 101.
[5] R. Munro's *Bosnia-Herzegovina,* p. 170.

which were two chains of the kind referred to. The art of making these chains was no doubt of foreign origin, as they have been found in Etruscan tombs of the fifth century B.C. in Italy; with burials of the La Tène period in the cemetery of Jezerine, in Bosnia; and in a tomb in the Gaulish cemetery of Ornovasso, in the province of Turin. In Britain such chains were used during the period of the Roman occupation for the attachment of fibulæ worn in pairs, as in the case of those from Chorley,[1] Lancashire, and from New-castle-on-Tyne,[2] Northumberland. We shall see in a subsequent chapter that the manufacture of these finely wrought chains of silver survived in early Christian times in Ireland, the best-known examples being those attached to the Tara brooch,[3] and to an enamelled pin from Clonmacnois.[4] With regard to the date of the chains, Dr. Arthur Evans says:—[5]

"It thus appears that these fine chains were in use among the Celtic peoples during the first two centuries before and after our era.[6] In Britain, however, the finest class is, as far as I am aware, confined to the latter half of this period; the chains attached to the earlier British fibulæ, like the one in the British Museum from the Warren,[7] near Folkestone, which may date from the second century B.C., being, like those referred to from the Champagne[8] cemeteries, of simpler and coarser construction."

[1] *The Reliquary* for 1901, p. 198.

[2] *Ibid.* for 1895, p. 157.

[3] M. Stokes' *Early Christian Art in Ireland*, p. 75.

[4] *Jour. R. Soc. Ant. of Ireland*, ser. 5, vol. i., p. 318.

[5] *Archæologia*, vol. lv., p. 396.

[6] Dr. A. Evans appears to have forgotten the Christian survivals in Ireland.

[7] *The Reliquary* for 1901, p. 197.

[8] The coarser chains are made of ordinary circular or oval links, sometimes double (see illustrations given in the *Dictionnaire Archéologique de la Gaule* of those from the Marnian cemeteries).

Ornamental ironwork of the Late-Celtic period is extremely rare, either because the smiths were too busily employed in making weapons for the warrior and tools for the artisan to devote their time to decorative work, or because the specimens of their handiwork have disappeared in consequence of the perishable nature of the material of which they were made. Fortunately, however, the fire-dogs from Capel Garmon,[1] now at Colonel Wynne Finch's house at Voelas, are still in existence to show us what fine ornamental ironwork the Welsh smiths of the Romano-British period were capable of producing.

Turning now from the metalwork to the pottery of the Late-Celtic period, we find it to consist of unglazed vessels made on a wheel, fired in a kiln, and ornamented either by mouldings or by patterns engraved on the surface with a pointed instrument. The technical processes employed in its manufacture do not seem to have differed essentially from those of the Romano-British potters, except that slip-ware was unknown. As far as I am aware, no painted pottery like that from Mont Beuvray[2] (Bibracte), nor vessels incrusted with pebbles and polished with graphite like the one from Plouhinec[3] (Finistère) now in M. Paul du Chatellier's collection at the Château de Kernuz, near Quimper, have yet been discovered in this country.

As far as the existing evidence goes no ornamental glasswork was made during the Late-Celtic period in Britain except certain beads and armlets already described. The technical process of manufacturing these beads consisted in twisting together fine rods of different

[1] *Archæologia Cambrensis,* ser. 6, vol. i., p. 39.

[2] See J. G. Bulliot's *Fouilles de Mont Beuvray.*

[3] See *Revue Archéologique* for 1883, p. 11.

coloured glass, and then bending the composite rod into loops round a mandril so as to form the bead.

The art of the ornamental worker in wood in the Late-Celtic period is displayed at its best in the tankards, buckets, and tubs of which, fortunately, a

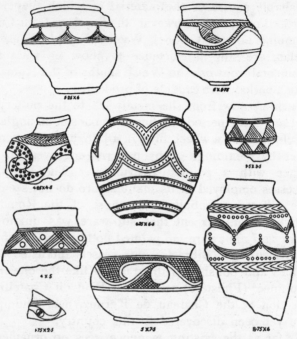

Late-Celtic Pottery from the Glastonbury Lake Village

few interesting specimens have been preserved. The tankard from Trawsfynydd,[1] Merionethshire, now in the Liverpool Museum, shows great ingenuity of construction, the staves of which it is composed being kept together at the bottom by a corrugated wire let

[1] *Archæologia Cambrensis,* ser. 5, vol. xiii., p. 212.

into the ends of the staves. Another tankard, belonging to Mr. T. Layton,[1] F.S.A., has the staves fastened together with wooden dowels and pins.

We have already described how the engraved patterns were produced on the ornamental woodwork from the Glastonbury Marsh Village by a finely pointed instrument, and afterwards burnt in.

Ornamental objects were also made out of bone and Kimmeridge shale during the Late-Celtic period, but there is nothing special to call for any comment in the technical methods employed, except to mention that the patterns on the bone objects were often engraved by means of a pair of compasses, and that the vessels of Kimmeridge shale were turned on a lathe.

Of the basketry in which the Celts excelled in the time of Cæsar[2] no specimens are now extant, but no doubt their natural talent for decorative art showed itself in this native industry of Britain, as in all others.

LEADING CHARACTERISTICS OF THE LATE-CELTIC STYLE OF ART

Once the eye of a trained archæologist has become familiar with the general appearance of the art products of the Late-Celtic school, it is comparatively easy for him to recognise other products of the same school almost by intuition ; but he would find it a much more difficult task if he were asked to define exactly what the peculiarities are by which he is enabled to distinguish this particular style from any other. Most of the decorative elements composing the style are of so fantastic and original a nature as to impress themselves first on the retina of the eye, and then on the mind ; yet, on that very account, they seem to elude the

[1] *Archæologia*, vol. lii., p. 359.
[2] C. Elton's *Origins of English History*, p. 122.

descriptive powers of the writer. The motives employed are neither purely geometrical in character nor have they been obviously arrived at by conventionalising natural forms, but are something between the two, being (like the designs on the ancient British coins) the result of successive copying. We will, however, notwithstanding the difficulties that have been pointed out, endeavour to analyse the decoration of the Late-Celtic period as far as it is possible to do so.

Unlike the art of the Bronze Age, the art of the Late-Celtic period does not appear to have been in any way influenced by religious symbolism, and therefore must be looked upon as purely decorative. The designs may be divided into three classes as regards the method of their execution, namely :—

 (1) Designs engraved on a flat surface.
 (2) Designs in relief on a flat surface.
 (3) Designs in the round.

The designs themselves may be classified as follows :—

 (1) Anthropomorphic designs.
 (2) Zoömorphic designs.
 (3) Designs derived from foliage.
 (4) Curvilinear geometrical designs.
 (5) Rectilinear geometrical designs.

Anthropomorphic and zoömorphic designs are extremely rare in Late-Celtic art in Great Britain, and the two best-known examples—the buckets from Marlborough[1] and Aylesford[2]—have, according to Dr. Arthur Evans, been imported from Gaul. The Marlborough bucket is encircled by four horizontal metal bands, the upper three of which are decorated with human heads

[1] Sir R. C. Hoare's *Ancient Wilts,* vol. ii., p. 34, and W. Cunnington's *Catal. of Stourhead Coll. in Devizes Museum,* p. 88.
[2] *Archæologia,* vol. lii., p. 374.

and pairs of animals in repoussé work. The projections
at each side of the rim, to which the crossbar at the
top is attached, have pairs of human heads upon them.
The mountings of the Aylesford bucket consist of three
bronze bands, the lower two of which are plain and the
uppermost one ornamented with pairs of animals and
a peculiar kind of scrollwork. Each of the attachments
for the handle at the top has upon it a single human
head surmounted by a sort of crested helmet.

The style of the art of the two buckets is the same,
and corresponds in some respects with that of the
Gaulish coins,[1] and in others with that of the sword-
sheaths from La Tène[2] and the bronze *situlæ* from
Hallstatt, Watsch, and Certosa.[3] Dr. Arthur Evans
has dealt so exhaustively with the details of these
buckets and the origins of the art they exhibit in his
paper on the Aylesford find in the *Archæologia*,[4] that
there is really little more to be said on the subject. It
may, however, be worth while directing attention to
the scrolls hanging down from the mouths of one of
the pairs of beasts on the Marlborough bucket. Any-
one unacquainted with the origin of these scrolls would
probably mistake them for the animal's tongue pro-
truding from its mouth, but on comparing the designs
on the Marlborough bucket with those on the *situlæ*
just referred to, the scrolls will be seen to be simply
degraded copies of the branch of a tree on which the
animal is feeding. The art metalworkers who made
the *situlæ* were, in fact, in the habit of using a simple
convention for emphasising the difference between the

[1] *Dictionnaire Archéologique de la Gaule.*

[2] E. Vouga, *Les Helvètes à La Tène.*

[3] Illustrated in the second edition of Dr. R. Munro's *Bosnia
Herzegovina*, p. 407.

[4] Vol. lii., p. 360.

herbivorous and carnivorous animals by showing, in
one case, the branch of a tree, and in the other the leg
of its prey protruding from its mouth. The Celtic
copyists were either ignorant of this convention or dis-
regarded it, so that in their hands both the branches
and legs were soon converted into meaningless scrolls
bearing hardly any resemblance to the original.
Throughout the whole range of Celtic art there is
displayed a tendency when dealing with plants and
animals to transform first the details and afterwards the
whole thing represented into curvilinear geometrical
ornament.

Besides the buckets just described, there are a few
other examples of zoömorphic designs in Late-Celtic
art, amongst which are the small bronze figures of
animals found at Hounslow,[1] Middlesex, now in the
British Museum; the bronze armlet, terminating in
serpents' heads, from the Culbin Sands,[2] Elginshire;
the knife-handle, terminating in a bull's head, from
Birdlip,[3] Gloucestershire; the iron fire-dogs,[4] with up-
rights terminating in horned beasts' heads, from
Mount Bures, Essex, Hay Hill, Cambridgeshire, and
Shefford, Bedfordshire; the horned bronze helmet from
Torrs,[5] Kirkcudbrightshire, now at Abbotsford; the
swine's head from Liechestown,[6] Banffshire, now in the
Banff Museum; and the bull's head from Ham Hill,[7]
Somerset, in the Taunton Museum.

The heads of the bull on the knife-handle from

[1] *Proc. Soc. Ant. Lond.*, ser. 2, vol. iii., p. 90.
[2] Dr. J. Anderson's *Scotland in Pagan Times : Iron Age*, p. 156.
[3] *Trans. Bristol and Gloucestersh. Archæol. Soc.*, vol. v., p. 137.
[4] *Archæologia Cambrensis*, ser. 6, vol. i., p. 41.
[5] Dr. J. Anderson's *Scotland in Pagan Times : Iron Age*, p. 113.
[6] *Ibid.*, p. 117.
[7] *Proc. Somersetsh. Archæol. Soc.*, ser. 3, vol. viii., p. 33.

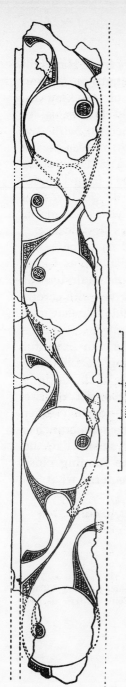

SCALE IN INCHES

Engraved Ornament on Late-Celtic Wooden Tub found at the Glastonbury Lake Village

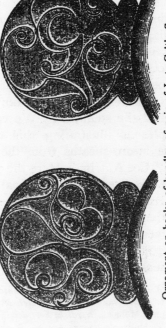

Ornament on backs of handles of pair of Late-Celtic Spoons
from Weston, near Bath
Scale ⅓ linear

Birdlip, and the beasts on the fire-dogs from Hay Hill and Shefford, have horns with round knobs on the end of each. Beasts with knobbed horns of this kind are represented on the Scandinavian gold bracteates[1] of the Early Iron Age, generally associated with the swastika symbol. Similar horns are to be seen on the helmet of a small bronze figure found in Denmark;[2] on a figure depicted on the silver bowl from Gundestrup,[3] Jutland; and on the handles of gold vessels from Rönninge,[4] Boeslund,[5] and Fyen,[6] Denmark. The horns probably have some religious significance.

Foliage so slightly conventionalised as to be easily recognised as such cannot be said to exist in Late-Celtic art, yet the foliageous origin of many of the designs at once betrays itself in the undulating curves with scrolls repeated at regular intervals on each side of what may be called the stem-line. We cannot select any better examples as illustrating this than the two beautiful bronze sword-sheaths from the crannog at Lisnacroghera,[7] Co. Antrim. Here the portions of the designs which represent the principal stem consist of two lines running close together parallel to each other until they reach the point where a smaller stem branches off, when they diverge. The smaller stems, like the principal stem, consist of parallel lines running close together, and these, again, diverge to form what re-

[1] Prof. G. Stevens' *Old Northern Runic Monuments*.

[2] J. J. A. Worsaae's *Industrial Arts of Denmark*, p. 109.

[3] Sophus Müller in *Nordiske Fortidsminder*, pt. 2, pl. 10.

[4] A. P. Madsen's *Bronze Age*, ii., pl. 25.

[5] *Industrial Arts of Denmark*, p. 105.

[6] P. B. Du Chaillu's *Viking Age*, vol. i., p. 97.

[7] *Jour. R. Hist. and A. A. of Ireland*, ser. 4, vol. vi., pp. 384–90. The decoration of a wooden tub found at the Glastonbury Marsh Village affords another very good instance of a Late-Celtic pattern derived from foliage.

presents the leaf. The ends of the leaves terminate in small spirals and their general shape resembles that of what are known as arabesques. We thus get the long sweeping S-shaped curves and the alternate contractions and expansions of the space between the two boundary lines which are common to nearly all Late-Celtic ornament. Now, for some inscrutable reason, the natural forms of plant life never seem to have appealed to the Celtic mind in the way they did, for instance, to the ecclesiastical sculptors of the twelfth and thirteenth centuries. Consequently the designs which were in the first instance copied from foliage soon became transformed into a succession of beautiful flamboyant curves, pleasing to the eye unquestionably, but suggesting but little to the mind as to their meaning. In reference to this, Dr. Arthur Evans remarks :—[1]

"The tendency of all Late-Celtic art was to reduce all naturalistic motives borrowed by it from the classical world to geometrical schemes. . . . Yet the whole history of Late-Celtic art instructs us that this geometrical scheme, elaborate as it is, was originally based on ornaments of a naturalistic kind."

Once the foliageous origin of the flamboyant patterns was lost sight of or disregarded, it became easy to elaborate fresh designs by placing the forms derived from the leaves and stems of plants in all sorts of unnatural positions relatively to each other, as, for instance, on the pair of bronze spoon-like objects from Weston, near Bath, which are now in the Edinburgh Museum of Antiquities, and in a particular class of pierced ornaments, several of which are illustrated in

[1] *Archæologia,* vol. lv., p. 404.

L. Lindenschmit's *Die Alterthümer unserer heidnischen Vorzeit.*[1]

A still further transformation resulted from the practice of drawing the various curves by means of a pair of compasses, and once this mechanical method had been adopted the temptation to introduce complete circles of different sizes into the designs would follow as a matter of course. This is very clearly seen on the ornamented bone spatulæ from Slieve-na-Caillighe, Co. Meath, already referred to as having been found with a pair of iron compasses; and also on backs of the bronze mirrors, of which a list is given on p. 115. It is most remarkable that the Late-Celtic artists should have succeeded in doing what has baffled everyone else before or since, namely, in producing "sweet" curves by means of a combination of circular arcs.

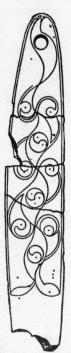

Engraved Bone object from Slieve-na-Caillighe, Co. Meath

Lastly, when the patterns which had thus been evolved from natural foliage on a flat surface were transferred to the relief of the repoussé metalwork, and raised bosses, volutes, and round plaques of enamel substituted for the complete flat circles, an entirely new style of decoration was brought into existence. The most appropriate name that can be given to this particular kind of Celtic ornament is *flamboyant* work. The French word *flamboyer* means to blaze, and the Gothic window tracery of the fourteenth century, in which S-shaped curves predominate, is called *flamboyant*

[1] Vol. i., pt. x., pl. 6; vol. ii., pt. viii., pl. 5; vol. iii., pt. vii., pl. 6. Compare these with the ornament found at Silchester, illustrated in the *Archæologia,* vol. liv., p 470.

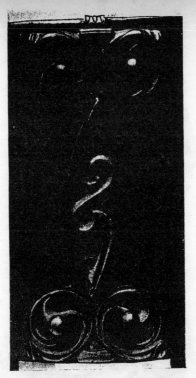

HANDLE OF LATE-CELTIC BRONZE
TANKARD FROM TRAWSFYNYDD,
MERIONETHSHIRE; NOW IN THE
MAYER MUSEUM, LIVERPOOL

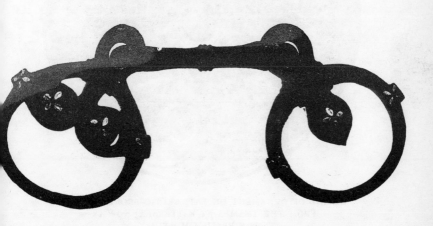

BRIDLE-BIT OF BRONZE ENAMELLED FROM RISE, NEAR HULL,
NOW IN THE BRITISH MUSEUM

SCALE ½ LINEAR

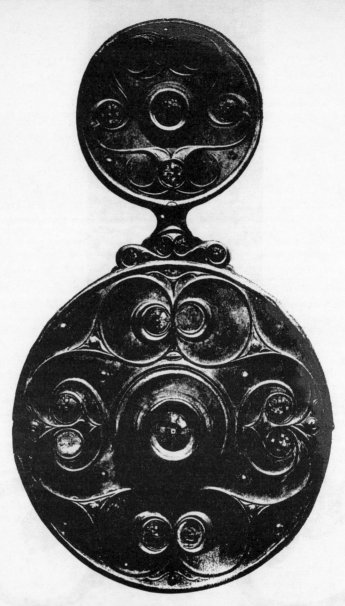

DETAIL OF ORNAMENT ON LATE-CELTIC BRONZE SHIELD
FROM THE THAMES AT BATTERSEA; NOW IN
THE BRITISH MUSEUM

on account of its resemblance to tongues of flame.
The handle of the Late-Celtic tankard from Traws-
fynydd,[1] Merionethshire, now in the Liverpool Museum,
if reproduced in stone on a larger scale, would certainly
be mistaken for a piece of Gothic tracery, so that it may
almost be looked upon as a blasphemous anticipation
of Christian art by the Pagan Celt.

The best examples of the Late-Celtic flamboyant
work, for purposes of study, are the bronze shield
from the river Thames, a circular disc of unknown
use from Ireland, both in the British Museum; the
gold collar from Limavady, Co. Londonderry, in the
Museum of the Royal Irish Academy, Dublin; and
the Æsica fibula, in the Newcastle Museum. There is
also a disc in the Dublin Museum of similar design to
the one in the British Museum, which is worth com-
paring with it.

The whole design of the shield from the Thames is
arranged with a due regard to symmetry. The small
circular plaques of enamel, which are a leading feature
in the scheme of decoration, are placed in definite
positions, in groups of four and eight, around a central
plaque within a raised boss. The plaques are con-
nected by S-shaped curves in relief, which vary in
width and in height above the background in different
places. The highest part of the curve is emphasised
by a sharp ridge which does not traverse the whole
length of the curve midway between the margins, but
at one place approaches near one edge, and a little
further on approaches the other. An extremely com-
plicated solid, bounded by curved surfaces, is thus
formed, the appearance of which can only be realised
by seeing the thing itself or a model of it.

[1] *Archæologia Cambrensis,* ser. 5, vol. xiii., p. 212.

The circular bronze discs and the gold collar from Ireland exhibit a class of flamboyant work which is somewhat different from that on the shield from the

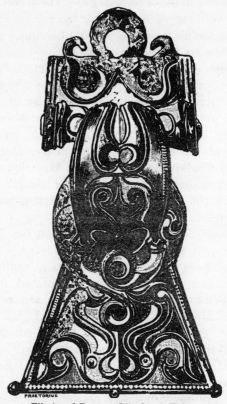

Fibula of Bronze Gilt from Æsica
Now in the Newcastle Museum. Scale ⅓ linear

Thames, and is still further removed from the original foliage motive designs. Here conchoids take the place of the circular enamelled plaques arranged in symmetrical positions, and the curves connecting them

with each other have the trumpet-shaped terminal expansions, which are so characteristic of the Late-Celtic style, very highly developed. A further modification that disguises the foliageous origin of the design is the substitution of two C-shaped curves meeting at an angle for the more gracefully flowing S-shaped curves. Examples of a running pattern composed of C-shaped curves meeting at an angle in the way described, occur on a bronze collar from Lochar Moss,[1] Dumfriesshire, now in the British Museum (see p. 112). A running pattern composed of C and S-shaped curves alternately meeting at an angle occurs on the enamelled mounting of a bronze bowl from Barlaston,[2] Staffordshire. We have pointed out the changes due to copying in relief a design engraved on a flat surface ; but curiously enough when the decoration of the repousse metalwork was again transferred to a flat surface, as in the enamelled fittings of the bronze bowls and in the spiral ornamentation of the illuminated MSS. of the Christian period, it did not return to what it was before, but became still

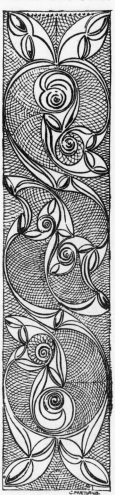

Flamboyant Ornament on Collar from Broighter, Limavady, Co. Londonderry

[1] *Archæologia,* vol. xxxiii., p. 347.
[2] *Ibid.*, vol. lvi., p. 44.

more unlike its foliageous prototype. It will be noticed that the ends of the trumpet-shaped expansions on the bronze discs and gold collar being in the highest relief catch the light. In the MSS. and enamels this effect is imitated by small almond-shaped spots of a different colour from the rest. The beautiful repoussé ornament on the bronze mirror from Balmaclellan, [1] Kirkcud

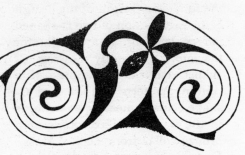

Spiral Ornament in Illuminated MS.
copied from repoussé metalwork

brightshire, now in the Edinburgh Museum of Antiquities, supplies us with another instance of little raised bosses which were afterwards reproduced on the flat by means of colour in the Christian MSS.

Many of the curvilinear Late-Celtic patterns which are used to fill a circular space are based upon the triskele and the swastika. A good example of a curved swastika pattern occurs on each of the three enamelled handles of a bronze bowl found at Barlaston,[2] Staffordshire. Triskele designs are much more common, especially on the round disc fibulæ, specimens of which have been found at Silchester,[3] Hampshire; Brough,[4] Westmoreland; and in the Victoria Cave,[5] near Settle, Yorkshire. There are other instances on the bronze

[1] Dr. J. Anderson's *Scotland in Pagan Times: Iron Age*, p. 127.
[2] *Archæologia*, vol lvi., p. 44.
[3] Now at Strathfieldsaye House.
[4] *Proc. Soc. Ant. Lond.*, ser. 1, vol. iv., p. 129.
[5] *Historic Soc. of Lanc. and Cheshire, Trans,* for 1866, p. 199.

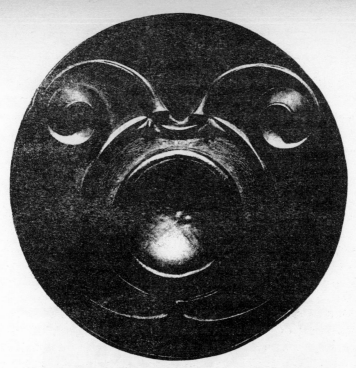

CIRCULAR DISC OF BRONZE WITH REPOUSSÉ ORNAMENT
FROM IRELAND; NOW IN THE BRITISH MUSEUM

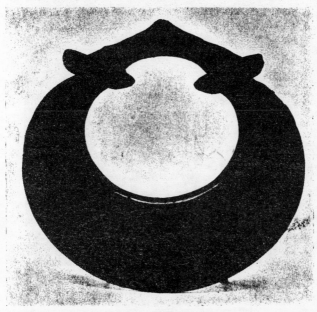

BRONZE ENAMELLED HARNESS-RING FROM WESTHALL,
SUFFOLK; NOW IN THE BRITISH MUSEUM

SCALE ¾ LINEAR

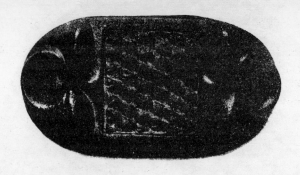

CAST OF METAL OBJECT (LOCALITY UNKNOWN) FROM THE
ALBERT WAY COLLECTION; NOW IN THE MUSEUM OF
THE SOCIETY OF ANTIQUARIES, BURLINGTON HOUSE,
LONDON

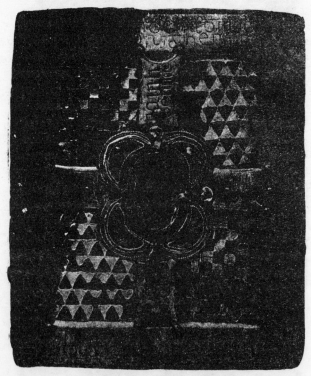

COVER OF THE STOWE MISSAL IN THE MUSEUM OF THE
ROYAL IRISH ACADEMY, DUBLIN

(A.D. 1023 TO 1052)

tankards from Elveden,[1] Essex, and Trawsfynydd,[2] Merionethshire; on the bronze shield from the Thames,[3] now in the British Museum; on a bronze disc-and-hook ornament in the Dublin Museum;[4] on a bronze plate in the Welshpool Museum;[5] on some bronze harness-mountings(?) from South Shields;[6] on bronze wheel-shaped pendants from Seamill Fort,[7] Ayrshire, from Berkshire, now in the British Museum, from Kingsholm,[8] near Gloucester, and from Treceiri, Carnarvonshire. These designs may have had a symbolical origin, as the triskele was a well-known sun symbol in the Bronze Age. The triskele arrangement of three spirals round a central spiral survived in the decoration of the illuminated MSS. of the Christian period.

In the repoussé metalwork of the Late-Celtic period certain portions of the design are thrown into relief in order to enable them to be distinguished from the rest which is not in relief. Much the same artistic effect can be obtained when the design is engraved on a flat surface by means of shading, and in the case of enamelled plaques, by employing different colours. In fact, by the use of relief, shading, or colour, the decorative effect of a pattern is doubled, because there are two things for the mind to comprehend, namely, the shape of the pattern itself and the shape of the background. Anyone who endeavours to realise both shapes simultaneously will find it an impossibility.

Several different kinds of shading are used in Late-

[1] *Archæologia*, vol. lii., p. 359.
[2] *Archæologia Cambrensis*, ser. 5, vol. xiii., p. 212.
[3] Kemble's *Horæ Ferales*, pl. 15.
[4] *The Reliquary* for 1901, p. 56. [5] Unpublished.
[6] *Jour. Brit. Archæol. Assoc.*, vol. xxxix., p. 90.
[7] R. Munro's *Prehistoric Scotland*, p. 378.
[8] Douglas' *Nenia Britannica* p. 134.

Celtic art, chiefly in ornament engraved on metal, wood, bone, and pottery, as will be seen by the following list :—

List showing different kinds of shading used in Late-Celtic Art, and the objects on which they occur.

(1) Shading of parallel lines.

On spoon-like bronze objects from Crosby Ravensworth, Westmoreland, and Ireland.
On bronze mirror from Stamford Hill, near Plymouth.
On engraved pottery from Glastonbury Marsh Village.
On bronze sword-sheath from Embleton.

(2) Cross-hatching placed diagonally.

On engraved piece of wood and engraved pottery from the Glastonbury Marsh Village.

(3) Cross-hatching placed diagonally, with dots in each of the square meshes.

On engraved wooden tub from the Glastonbury Marsh Village.

(4) Cross-hatching of double lines placed diagonally.

On engraved piece of wood from the Glastonbury Marsh Village.

(5) Chequerwork grass-matting shading.

On bronze sword-sheath from crannog at Lisnacroghera.

On bronze mirrors from Trelan Bahow, Cornwall ; Birdlip, Gloucestershire ; from unknown locality, now in the Liverpool Museum ; and from Stamford Hill, near Plymouth.

(6) Engine-turned shading.

On gold collar from Limavady.

(7) Dotted shading.

On bronze spoon-like objects in the Dublin Museum.

On bronze harness-ring from Polden Hill, Somersetshire.

On silver armlet from Stony Middleton, Bucks.

Besides the Late-Celtic objects just described, which exhibit curvilinear surface decoration derived from foliage, there are others with very peculiar forms "in the round." Amongst these are the harness-rings with projecting knobs from Polden Hill, Somersetshire ;

Stanwick, Yorkshire, and elsewhere; the beaded torques from Lochar Moss, Dumfriesshire; Hynford, Lanark; and the beaded bracelets from Arras and Cowlam, Yorkshire.

The projections on the harness-rings generally occur at three points round the circumference, and their shapes will be better understood from the illustrations than from any written description. It is not easy to say what the meaning or origin of these projections can be, as they bear no obvious resemblance to any natural or artificial object.

The beaded torques mentioned are composed of separate metal beads (usually of two different shapes) strung on a square iron rod, so that they cannot rotate or rattle about. The bracelets are, however, cast in one piece, and made in imitation of a string of beads. This style of bracelet is of foreign origin, as specimens have been found in France[1] and Germany,[2] many of which are elaborately ornamented with spiral-work in high relief.

Rectilinear patterns are of comparatively rare occurrence in Late-Celtic art, as the designers of the period appear to have had a rooted objection to using straight lines if they could possibly be avoided. There are, however, a few exceptions. The small circular enamelled plaques with which the bronze shield from the Thames, now in the British Museum, is decorated, have a swastika pattern on each. The swastika was probably a foreign importation, as it

Swastika design on Shield from the Thames

[1] *Dictionnaire Archéologique de la Gaule.*
[2] Lindenschmit's *Alterthümer.*

is used in the decoration of the Gaulish bronze helmet from Gorge-Meillet[1] (Marne), and of the iron lance-head from La Tène,[2] Switzerland.

The step-pattern in Late-Celtic art may have had a textile origin, *i.e.* have been copied from a woven belt or other fabric. Instances of it occur on a piece of engraved wood from the Glastonbury[3] Marsh Village; on the bronze mountings of a shield from Grimthorpe,[4] Yorkshire, now in the British Museum; on the bronze ferrule of a spear-shaft from the Crannog at Lisnacroghera,[5] Co. Antrim; and on a sculptured monolith at Turoe, Co. Galway. The step-pattern survived after the Pagan period in the Christian enamels, as in the bowl from Möklebust,[6] Norway, and the fragment at St. Columba's College,[7] Dublin. The key-pattern, or Greek fret, is unknown in Late-Celtic art.

The chequerwork pattern may also have had a textile origin. There is an example of it on the bronze sword-sheath from Embleton,[8] Cumberland, now in the British Museum.

The chevron and lozenge patterns are possibly survivals from the preceding Bronze Age. We have instances of the chevron pattern on the bronze mirror from Trelan Bahow,[9] Cornwall, and on a potsherd from the Glastonbury[10] Marsh Village; and of the lozenge on the stave of a bucket[11] from the same site.

[1] A. Bertrand's *Archéologie Celtique et Gauloise*, p. 367.
[2] E. Vouga's *Les Helvètes à La Tène*, pl. 5.
[3] *The Antiquary* for 1895, p. 110.
[4] Ll. Jewitt's *Grave Mounds and their Contents*, p. 246.
[5] *Jour. R. Hist. and Archæol. Assoc. of Ireland*, ser. 4, vol. vi., p. 394.
[6] *Mém. de la Soc. Ant. du Nord*, 1890, p. 35.
[7] J. B. Waring's *Manchester Fine Art Treasures Exhibition.*
[8] Kemble's *Horæ Ferales*, pl. 18, fig. 3.
[9] *Archæol. Jour.*, vol. xxx., p. 267.
[10] *Proc. Somersetsh. Archæol. Soc.*, vol. xl.
[11] *The Antiquary* for 1895, p. 110.

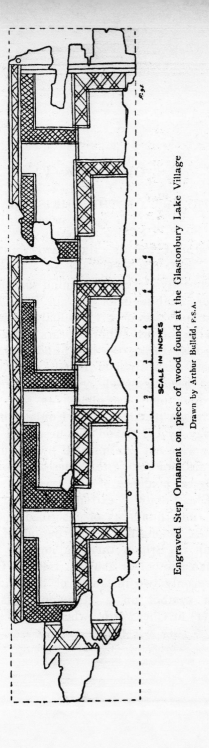

SCALE IN INCHES

Engraved Step Ornament on piece of wood found at the Glastonbury Lake Village

Drawn by Arthur Bulleid, F.S.A.

CHAPTER VI

CELTIC ART OF THE CHRISTIAN PERIOD
(A.D. 450 to 1066)

THE INTRODUCTION OF CHRISTIANITY INTO BRITAIN, AND ITS EFFECT ON NATIVE ART

IT must always be borne in mind that the conversion of the inhabitants of Britain from Paganism to Christianity was a very gradual process, extending over a period of two hundred years at least. It seems probable that during the last hundred years or so of the Roman occupation of Britain the Christian faith may have been accepted by a limited number of the native population; but almost as soon as the new religion began to take root in England it was entirely swept away by the Saxon conquest, and the few converts who were not exterminated by the ruthless Pagan invaders fled for refuge to Wales and Cornwall. The archæological evidence of the existence of Romano-British Christianity is extremely scanty. Out of the hundreds and hundreds of inscribed and sculptured monuments belonging to the period of the Roman occupation of Britain there is not one which bears a Christian symbol or shows a trace of Christian art. There are only two instances of the occurrence of a Christian symbol on a Romano-British structure, namely, (1) at Chedworth,[1] where the Chi-Rho Mono-

[1] *Journ. Brit. Archæol. Assoc.*, vol. xxiii., p. 228.

gram is carved twice upon a stone in the foundation of the steps leading into the corridor of a Roman villa there; and (2) at Frampton,[1] Dorsetshire, where the same Monogram forms part of the decoration of a mosaic pavement in one of the rooms of a Roman villa. As Romano-British Christianity produced no effect on the art of this country, we are not further concerned with it.

Whilst England remained under the dominion of Saxon Pagandom for a century and a half in some parts, and for nearly two centuries in others, Christianity spread rapidly from Gaul to Cornwall, Wales, and the south-west of Scotland, and thence to Ireland. After the Saxons were converted by St. Augustine, in A.D. 597, there was a return wave of Celtic Christianity from Ireland to Iona, and from Iona to Lindisfarne, in Northumbria, which was founded A.D. 635. The localities where Christianity was first planted in Britain are indicated archæologically by the geographical distribution of monuments bearing the Chi-Rho Monogram, which is as follows :—

CORNWALL. St. Just.
 St. Helen's Chapel.
 Phillack.
 Southill.
CARNARVONSHIRE. Penmachno.
WIGTOWNSHIRE. Kirkmadrine.
 Whithorn.

As the Chi-Rho Monogram does not occur on the early inscribed stones of Ireland, but in place of it the cross with equal arms expanded at the ends, enclosed in a circle, which is derived from the Monogram,[2] it

[1] S. Lysons' *Reliquiæ Brittanico Romanæ,* No. 3, pl. 5.
[2] See J. R. Allen's *Christian Symbolism,* p. 94. The Chi-Rho Monogram occurs on inscribed monuments in Gaul between A.D. 377 and 493.

naturally follows that Irish Christianity is later than that of Cornwall, Wales, and the south-west of Scotland.

Setting aside the vague and unsatisfactory statements of the mythical period (such as the one about the presence of three British at the Council of Arles in A.D. 314), we find that the real history of the Christianising of this country begins with the opening years of the fifth century, and that it followed directly from the foundation of the school of learning and centre of missionary enterprise by St. Martin at Tours, in France. In A.D. 397 St. Martin died, and not long after, in A.D. 412, his disciple, St. Ninian, built a stone church dedicated to his master at Whithorn, Wigtownshire. In A.D. 429 Germanus, Bishop of Auxerre, and Lupus, Bishop of Troyes, visited Britain in order to suppress the Pelagian heresy. About the same time the conversion of Ireland is believed to have been commenced by either St. Patrick or by St. Palladius (*circa* A.D. 432). The sixth century witnessed the foundation of the great school of ecclesiastical learning at Llantwit Major, Glamorganshire, where St. David, St. Samson, and Gildas the historian were educated ; but an event of even greater importance was the landing of St. Columba at Iona in A.D. 563, and the subsequent conversion of the northern Picts. The sixth century ends with the conversion of Kent by St. Augustine in A.D. 597. It was eighty-four years more before the South Saxons accepted Christianity and the conversion of England became complete. In the meantime the differences between the Saxon and Celtic Churches had been settled in favour of the former at the Synod of Whitby in A.D. 664.

Reviewing the historical facts just mentioned, it

appears that for about 200 years (from A.D. 450 to 650) there was a separate Celtic Church in Britain, which may appropriately be called the pre-Augustinian Church. The question now naturally suggests itself, to what extent did the introduction of Christianity influence the native art of Britain during the 200 years which followed the departure of the Romans from its shores? The answer supplied by archæology is that before about A.D. 650 there was no distinctively Christian art existing in this country.

The monuments belonging to the pre-Augustinian Church consist of rude pillar-stones with incised crosses of early form, or with Latin inscriptions in debased Roman capitals, sometimes with Celtic inscription in Ogams in addition. The monuments of this class do not, as a rule, show any trace of ornament or sculpture beyond the crosses and inscriptions. The only recorded exceptions are—

An Ogam-inscribed stone from Pentre Poeth,[1] Brecknockshire, now in the British Museum, having on one face a bishop with his crozier, St. Michael and the Dragon, and very rude zigzag ornament.

An Ogam-inscribed stone from Glenfahan,[2] Co. Kerry, now in the Dublin Museum, with rude spiral ornament, a figure of a man, a looped pattern, and several crosses.

An Ogam-inscribed stone at Killeen Cormac,[3] Co. Kildare, lying prostrate near the entrance gate, with a bust of Christ carrying the cross over the right shoulder.

St. Gobnet's Stone at Ballyvourney,[4] Co. Cork, with a cross enclosed in a circle, surmounted by the figure of a bishop holding his crozier.

[1] *Archæologia Cambrensis*, ser. 6, vol. i., p. 240.
[2] *Trans. Royal Irish Academy*, vol. xxxi., p. 318.
[3] *Journ. R. Hist. and A. A. of Ireland*, ser. 4, vol. ii., p. 546.
[4] *Archæol. Jour.*, vol. xii., p. 86.

A stone, with a minuscule inscription, at Reask,[1] Co. Kerry, having on the same face a cross in a circle, with incised spiral ornament at each side of the shaft.

The stones, with incised symbols of unknown meaning, which are so common in the north-east of Scotland,

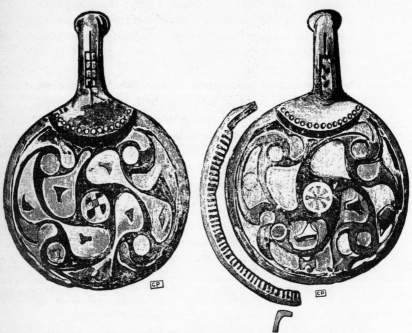

Enamelled Handles of Bronze Bowl found at Barlaston, Staffordshire
Now in the possession of Miss Amy Wedgwood. Scale ¼ linear

possibly belong to the same early period. The ornament on some of them has a very marked Late-Celtic character.

There are no Celtic MSS. with illuminations or ornament of any kind to which a date earlier than A.D. 650

[1] *Archæologia Cambrensis,* ser. 5, vol. ix., p. 147.

can be assigned, but there are a certain number of metal objects which illustrate the overlap of the Pagan and Christian styles of Celtic art. Amongst the most important of these are the bronze bowls with enamelled mountings and zoömorphic handles which have been

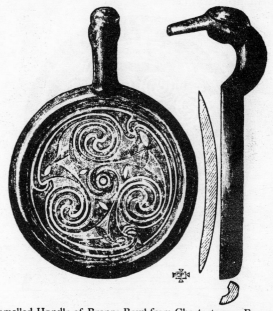

Enamelled Handle of Bronze Bowl from Chesterton-on-Fossway, Warwickshire

Now in the Warwick Museum. Scale ½ linear

described at some length by the author in the *Archæologia* (vol. lvi., p. 43). The chief peculiarities of the bowls is the hollow moulding just below the rim and the three or four handles with rings for suspension. The upper part of each handle is like a hook, terminating in a beast's head, which rests on the rim of the bowl and projects inwards over it. The lower part of

each handle is circular, or in the shape of the body of a bird, and is fixed to the convex sides of the bowl. The circular form is most common in the examples found in England, and the disc is either ornamented with *champlevé* enamel [1] or with piercings, giving a cruciform appearance. [2]

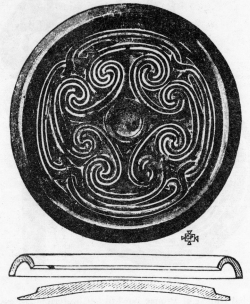

Enamelled Handle of Bronze Bowl from Chesterton-on-Fossway, Warwickshire

Now in the Warwick Museum. Scale ⅓ linear

The earliest of the series from Barlaston, Staffordshire, now in the possession of Miss Wedgwood, has three handles all alike, ornamented with discs of enamel,

[1] As in the specimens from Barlaston, Staffordshire; Chesterton-on-the-Fossway, Warwickshire; Barrington, Cambridgeshire; Crosthwaite, Cumberland; Middleton Moor, Derbyshire; Oxford; and Greenwich.

[2] As in the specimens from Wilton, Wilts; and Faversham, Kent.

the designs on which are distinctly Late-Celtic in style, and consist of small circles connected by C- and S-shaped curves. In the case of the enamelled handles of the other specimens, closely coiled spirals of the Bronze Age type take the place of the circles, and by this trifling alteration the character of the design is so completely changed as to be almost identical with the spiral decoration of the Book of Durrow and other Irish MSS. of the same period. We see here exactly

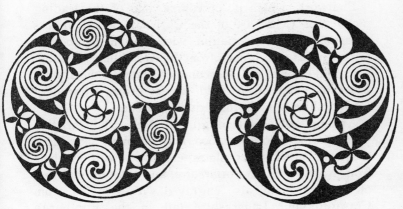

Spiral Ornament from the Book of Durrow

when and how the flamboyant ornament of Pagan Celtic art became transformed into the spiralwork of the Christian illuminated MSS. which was afterwards applied to the decoration of the sculptured crosses and ecclesiastical metalwork. The circumstances under which the bowls have been found show that they belong to the Pagan Saxon period between A.D. 450 and 600.

In the museum of the Society of Antiquaries at Burlington House there is the cast of an object from

the collection of Mr. Albert Way, the well-known antiquary, which exhibits a curious mixture of styles. Where the original is, or where it came from, is unfortunately not known, but it has every appearance of having been of metal. In the middle of the object is a square panel of triangular pierced work, exactly like that on the cover of the Stowe Missal[1] (made A.D. 1023 to 1052); whilst at each of the rounded ends are curved designs with trumpet-shaped expansions of pronounced Late-Celtic type.

Plaitwork, which is, of course, one of the leading motives of Celtic art of the Christian period, occurs occasionally in association with Pagan flamboyant ornament, as on a brooch from the Ardakillen[2] crannog, near Stokestown, Co. Roscommon (now in the Dublin Museum), and on a gold armlet from Rhayader,[3] Radnorshire (now in the British Museum).

Amongst objects belonging to the early Christian Celtic period before A.D. 600, may probably be classed the leaf-shaped silver plates engraved with symbols from Norrie's Law,[4] Forfarshire, and the terminal link of a silver chain, also engraved with symbols, from Crawfordjohn,[5] Lanarkshire (all in the Edinburgh Museum of Antiquities). The hammer-headed pins also, a list of which has already been given (p. 108), seem, from the enamelled designs upon them, to belong to the transitional period between Celtic Paganism and Christianity.

Although, as we have just seen, the introduction of

[1] Miss M. Stokes' *Early Christian Art in Ireland,* p. 92. The Stowe Missal is in the Museum of the R.I.A. at Dublin.

[2] Sir W. Wilde's *Catal. Mus. R.I.A.,* p. 569.

[3] *Archæologia Cambrensis,* ser. 5, vol. xvi., p. 261.

[4] Dr. J. Anderson's *Scotland in Early Christian Times,* nd ser., p. 38.

[5] *Ibid.,* p. 44.

Christianity into Britain did not immediately affect the native Pagan art to any appreciable extent, yet as soon as the Saxons were converted and communication with the Continent became easier and therefore more frequent, an entirely new style of decoration came into existence with extraordinary rapidity. The flamboyant designs of the Late-Celtic period were modified by combining them with the closely coiled spiral of the Bronze Age, and several new motives, such as interlaced-work, key-patterns, zoömorphs, and foliage, were introduced from foreign sources. At the same time a complete revolution took place in the class of objects to the decoration of which the skill of the artificer was applied. The priest took the place of the warrior as the patron of the fine arts, and monopolised all the available time of the metalworker and enameller in making beautiful vessels for the service of the church. Then, too, with Christianity came the art of writing and illuminating ecclesiastical MSS., which was unknown to the Pagan Celt. The influence of the draughtsman upon other arts was now possible for the first time, and the introduction of MSS. soon worked far-reaching changes. Fresh motives could be more easily transferred from one art centre to another, and decorative designs could be combined and elaborated in a way that was impossible when working in such intractable materials as metal or stone instead of drawing on parchment with a facile pen. The new Celtic style of the Christian period soon took a definite shape, and after the patterns had been ully developed in the illuminated MSS. they were afterwards applied to decorative work in stone and metal.

GENERAL NATURE OF THE MATERIALS AVAILABLE FOR
THE STUDY OF CELTIC ART OF THE CHRISTIAN
PERIOD IN GREAT BRITAIN

The materials available for the study of Celtic Art of the Christian period may be divided into four classes, namely :—

(1) Illuminated MSS.
(2) Sculptured Stones.
(3) Metalwork.
(4) Leatherwork, Woodwork, and Bonework.

The most important collections of Irish and Hiberno-Saxon MSS. in this country are in the libraries of Trinity College, Dublin ; of the Royal Irish Academy, Dublin ; and the British Museum, London. There are other smaller collections, or in some cases single volumes only, in the University and College libraries of Oxford and Cambridge ; in the Cathedral libraries at Durham, Lichfield, and Hereford ; and in the Archiepiscopal library at Lambeth. The chief libraries on the Continent which are fortunate enough to possess specimens of Irish calligraphy and illumination (either acquired by purchase or still the property of monasteries originally founded by Irish missionaries) are at Stockholm, St. Petersburg, Paris, St. Gall and Basle in Switzerland, and at Nuremberg, Fulda, and Trèves in Germany. The Irish MSS. from the monastery founded by St. Columbanus in A.D. 613 at Bobio, in Piedmont, are distributed over the libraries at Milan, Turin, and Naples. For descriptions and illustrations of these MSS. the reader may be referred to Prof. J. O. Westwood's *Palæographia Pictoria Sacra* and *Miniatures of the Anglo-Saxon and Irish MSS.;* C. Purton Cooper's *Report on Rymer's Fœdera, Appendix A,*

Sir H. James' *Facsimiles of the National MSS. of Ireland; Publications of the Palæographical Society;* Miss Margaret Stokes' *Early Christian Art in Ireland;* Dr. J. Stuart's *Book of Deer*, published by the Spalding Club of Aberdeen ; J. A. Bruun's *Illuminated Manuscripts of the Middle Ages;* and Dr. W. Reeve's paper on " Early Irish Caligraphy " in the *Ulster Journal of Archæology*, vol. viii., p. 210.

The following is a list of Irish MSS. selected on account of the beauty of their illuminated pages :—

GOSPELS

Book of Lindisfarne	. .	British Museum (Nero D. iv.).
Book of Kells	. . .	Trinity College, Dublin.
Book of Durrow	. .	*Ibid.*
Book of Armagh	. .	Royal Irish Academy, Dublin.
Book of St. Chad	. .	Lichfield.
Book of MacRegol	. .	Bodleian, Oxford.
Book of MacDurnan	. .	Lambeth.
Book of Deer	. . .	Public Library, Cambridge.
Codex No. 51	. . .	St. Gall, Switzerland.
Golden Gospels	. . .	Royal Library, Stockholm.
Gospels	Imperial Library, St. Peters-
Gospels of St. Arnoul, Metz	Nuremberg. [burg.	

PSALTERS

Vespasian A. i.	. . .	British Museum.
Vitellius F. xi.	. . .	*Ibid.*
Psalter of St. John's College	Cambridge.	
Psalter of Ricemarchus	.	Trinity College, Dublin.

Some of the above MSS. can be dated by means of entries giving the name of the scribe or other person, who can be identified by contemporary or nearly contemporary historical record. The oldest MS. with

illuminations in the Hiberno-Saxon style which can be thus dated is the Lindisfarne Book. It contains two entries written in an English hand of the tenth century, which show that the volume was written by Eadfrith, Bishop of Lindisfarne; that Æthilwold, Bishop of Lindisfarne, made the cover for it; that Billfrith, the anchorite, wrought the metalwork for it; and that Aldred, the priest, over-glossed it in English for the love of God and St. Cuthbert. Eadfrith held the see of Lindisfarne from A.D. 698 to 721, and was then succeeded by Æthilwold, who held the bishopric of the island until his death in A.D. 740. The Book of Lindisfarne, therefore, must have been written either during the last two years of the seventh century or the first twenty-one years of the eighth century. This may be looked upon as the starting-point of all Hiberno-Saxon art, and its origin may be fairly traced to Lindisfarne, where the Scotic and Anglo-Saxon schools were able to mingle, each reinvigorating the other to their mutual advantage.

The Book of Kells makes its first appearance in history in A.D. 1006, during which year it is recorded in the *Annals of the Four Masters* that the Great Gospels of Columkille was stolen. Although the name of the scribe who wrote and illuminated this book is unknown, it is probable, from the style of the decoration and lettering, that it belongs to about the same period as the Lindisfarne Book, but somewhat later, as the Book of Kells contains foliage amongst the ornament, and is altogether more elaborate.

The Book of Durrow was written by a scribe named Columba, who can hardly have been the celebrated Saint of that name, as his time is far too early for it. Since the spiral patterns in the Book of Durrow

approximate more nearly to the flamboyant designs of the Pagan-Celtic metalwork than those in any other MS., it cannot be dated later than the eighth century.

The Book of St. Chad should more properly be called the Book of St. Teilo, as it contains an entry stating that the volume was purchased by Gelhi, son of Arihtuid, from Cingal for his best horse, and dedicated to God and St. Teilo. Before it was at Lichfield it lay on the altar of Teilo, at Llandaff. This MS. has also a good claim to be of the eighth century.

The Book of Armagh and the Golden Gospels of Stockholm are of the ninth century. The former was written by Ferdomnach, "a sage and choice scribe of Armagh," who died in A.D. 844. The Stockholm Gospels contains a deed of gift, which shows that the volume was bought by the Earl Ælfred and Wetburg his wife from a Viking, and presented by them to the Cathedral of Canterbury. The deed is signed by Ælfred, Wetburg, and their daughter Alhtryth, who have all been identified by the will of Ælfred, which is attested by Ældered, Archbishop of Canterbury, from A.D. 871-9. The Gospels of MacRegol also belongs to the ninth century, if the identification of the scribe who wrote it with "MacRiagoil nepos Magleni, Scriba et Episcopus Abbas Biror" can be relied upon. His death is recorded in the Irish Annals under the year A.D. 820.

The Gospels of MacDurnan is of the tenth century. It has an inscription on one of the blank pages of the MS. showing that the book was either written for, or was in the possession of, Maelbrigid MacDurnan, and that it was given by King Athelstan to the city of Canterbury. Maelbrigid MacDurnan was Abbot of Derry in the ninth century, and was afterwards

promoted to the see of Armagh in A.D. 927. He died in A.D. 927. Athelstan reigned from A.D. 925 to 941.

The Psalter of Ricemarchus is of the eleventh century. It contains a Latin poem, from which we gather that the book was written by Ricemarch Sulgenson, with the assistance of Ithael, "whose name makes learning golden," and that the initial letters were illuminated by John. Ricemarch, or Rhyddmarch, succeeded his father Sulgen in the see of St. Davids in A.D. 1089, and died in A.D. 1096.

The examples given afford a very good series arranged in chronological order, showing the modifications which the style underwent in the course of the four centuries between A.D. 650 and 1050. We are somewhat sceptical as to there having been any fine illuminated Hiberno-Saxon MSS. before A.D. 700; but assuming that there may have been some which are no longer in existence, the best period is from A.D. 650 to 850; then from A.D. 850 to 950 there is a middle period of rather inferior excellence; and, lastly, from A.D. 950 to 1050 a distinct period of decline which went on with increasing decadence for a century or two after the Norman Conquest.

The number of illuminated pages in the different MSS. varies considerably, sometimes because the volumes are imperfect, but also because they were less lavishly illustrated in the first instance. The illuminated pages in the copies of the Gospels are of the following kinds :—

 (1) Initial pages.
 (2) Ornamental or Cross pages.
 (3) Symbols of the Evangelists.
 (4) Portraits of the Evangelists.
 (5) Scenes from the Life of Christ.
 (6) Tables of Eusebian Canons.

As an instance of a very completely illustrated MS. of the Gospels we may take the Lindisfarne Book, which contains twenty-three full pages of illumination as specified below :—

Four portraits of the Evangelists with their Symbols, one for each Gospel.

Five ornamental pages, one before St. Jerome's Epistle and one before each Gospel.

Six *Initial pages*, namely—

"Novum opus," commencing St. Jerome's Epistle.

"Liber generationis," commencing St. Matthew's Gospel.

"XPI autem generatio," commencing the Genealogy of Christ in St. Matthew's Gospel.

"Initium Evangelii," commencing St. Mark's Gospel.

"Quoniam quidem," commencing St. Luke's Gospel.

"In principio erat," commencing St. John's Gospel.

Eight pages of tables of Eusebian Canons.

The Book of Durrow has sixteen illuminated pages, namely, four of the Symbols of the Evangelists ; six ornamental pages, one at the frontispiece, one before the Preface of St. Jerome, and one before each Gospel ; and the usual six initial pages.

The Book of Kells is more profusely illustrated than any other Irish MS. in existence. Besides innumerable large and small initials, it contains three portraits of the Evangelists, three combined symbols of the Four Evangelists, three scenes from the Life of Christ— namely, the Virgin and Child, Christ seized by the Jews, and the Temptation of Christ, and eight pages of Eusebian Canons.

The St. Gall Gospels (Codex No. 51) has twelve full pages of illumination, namely, four portraits of the Evangelists, five initial pages, one ornamental cross-

page, and two scenes from the Life of Christ—the Crucifixion and Christ in Glory.

As an instance of the method of illustrating the Irish MSS. of the Psalter we may take the one in the library of St. John's College, Cambridge. This has six illuminated pages, namely—

(1) " Beatus vir," commencing the 1st Psalm.
(2) " Quid gloriaris " ,, ,, 51st ,,
(3) " Dnē exaudi " ,, ,, 101st ,,
(4) Miniature of the Crucifixion.
(5) ,, David and Goliath.
(6) ,, David and the Lion.

The Vit. F. xi. Psalter in the British Museum has two initial pages and two miniatures, namely, David and Goliath, and David playing the harp.

The Vesp. A. i. Psalter in the British Museum has only one miniature, namely, David playing the harp; but it has a great number of extremely beautiful initial letters ornamented with spiralwork of the best quality. Figure subjects (one of David and the Lion) are introduced in the initials of the 26th, 52nd, 68th, 97th, and 109th Psalms.

The details of the ornamental patterns in the MSS. will be dealt with when we come to consider the leading characteristics of the style; all that we need do now, therefore, is to point out the manner in which the patterns are distributed. The treatment of the miniatures of the Evangelists and of the scenes from the Life of Christ and the Life of David is very simple; the picture is enclosed within a rectangular frame divided into panels, each filled in with a separate piece of ornament complete in itself. Sometimes, as in the case of the miniatures of Christ seized by the Jews in the Book of Kells, and David playing the harp in the

Vesp. A. i. Psalter, the figures are placed beneath an arch supported by columns at each side. The architectural origin of the design is entirely concealed by converting the columns and the arch into pieces of flat ornament arranged in panels. The pages of Eusebian Canons are also treated architecturally, the tables being placed under arcading so disguised by the incrustations of ornament as to be almost unrecognisable. The initial pages of the Gospels are only partially surrounded by a rectangular frame, so as to allow the tops of the large capital letters to project beyond the frame into the margin. The incomplete portion of the frame on the right side of the page is coverted into a zoömorph in a characteristically Celtic manner by adding the head of a monster at the top and a fish-like tail at the bottom. The frame and the larger initials within it are covered with panels of ornament. The pages of ornament are generally arranged in rectangular panels, so as to give the appearance of a cross; or sometimes, as in the Book of Durrow, there is a small equal-armed cross within a circle in the middle of the page, the remainder of which is entirely filled up with ornament. In many cases where the miniatures, etc., are surrounded by a rectangular frame the outer margins are extended and formed into ornamental knots at each of the four corners.

After the Celtic style of decorative art of the Christian period had been fully developed in the Irish and Hiberno-Saxon illuminated MSS. of the eighth century, it was afterwards applied to sculptured stonework in the ninth, tenth, and eleventh centuries. There are so few details of pre-Norman Celtic buildings[1]

[1] The sculptured architectural details of the Round Towers and early churches in Ireland and Scotland consist chiefly of crosses or crucifixes over the doorways and terminal heads.

which afford examples of ornamental sculpture that they are hardly worth considering, so that we need only take cognisance of the sepulchral and other monuments. These are of the following different kinds :—

(1) Recumbent cross-slabs.
(2) Recumbent hog-backed and coped stones.
(3) Erect cross-slabs.
(4) Erect wheel-crosses.
(5) Erect free-standing crosses.
(6) Erect pillar crosses, with shafts of round or square cross-section.

The recumbent cross-slabs are confined almost exclusively to Ireland, although there are one or two in Cornwall, Wales, and Scotland. Much the largest collection is at Clonmacnois, King's Co., where there are not far short of 200 sepulchral cross-slabs with inscriptions in Irish minuscule letters, giving the name of the deceased and requesting a prayer for his or her soul. A considerable number of the names on the slabs have been identified on sufficiently satisfactory evidence, thus giving reliable dates for a series arranged in chronological order. Clonmacnois was founded by St. Ciaran in A.D. 554, but the greater part of the dated cross-slabs belong to the ninth, tenth, and eleventh centuries. The earliest of these inscribed cross-slabs which exhibits any decorative features is that of Tuathgal,[1] who has been identified with the seventh abbot of Clonmacnois. The death of abbot Tuathgal took place in A.D. 806. There are, therefore, no ornamental cross-slabs at Clonmacnois older than the beginning of the ninth century. The best ex-

[1] Petrie's *Christian Inscriptions in the Irish Language*, vol. i., pl. 12, No. 29.

amples of recumbent cross-slabs with Celtic ornament
in Ireland to which reliable dates can be assigned
are those of Suibine McMailæhumai[1] at Clonmacnois
(A.D. 887), and St. Berechtir[2] at Tullylease, Co. Cork.

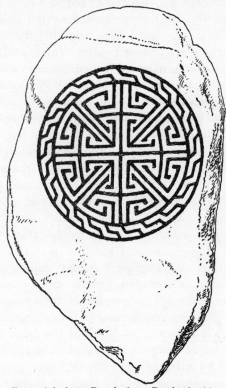

Cross-slab from Pen-Arthur, Pembrokeshire
Now in St. David's Cathedral. Scale ⅓ linear

The latter is specially interesting as having upon
it a combination of interlaced-work, key-patterns, and
spiral ornament.

[1] *Ibid.*, vol. i., pl. 31, No. 82. [2] *Ibid.*, vol. ii., pl. 30.

Outside the limits of Ireland there are slabs of the same type, but of unknown date, at Camborne,[1] Cornwall; Pen Arthur[2] (now in St. David's Cathedral), Pembrokeshire; and Baglan,[3] Glamorganshire.

The recumbent hog-backed or coped stones are more likely to be of Anglian or Scandinavian origin than Celtic. They are most common in the north of England; there are one or two in Wales, and none in Ireland. As instances of coped stones with Celtic ornament we have those at Meigle,[4] Perthshire; and Lanivet,[5] Cornwall.

The erect cross-slabs are, with a few unimportant exceptions, peculiar to Scotland and the Isle of Man. They are probably older than the free-standing crosses, because the erect cross-slabs are not treated architecturally (as the high crosses of Ireland are), but resemble more nearly than anything else ornamental pages from the Celtic illuminated MSS. directly transferred to stone with hardly any modification whatever to suit the requirements of the new material to which the decoration was applied. A particularly good instance of this is afforded by the erect cross-slab at Nigg,[6] Ross-shire. On one side of the monument is a cross with the ornament arranged in rectangular panels exactly as it is in the cross-pages of the Irish Gospels; and on the other a figure subject (David and the Lion) surrounded by a frame, also divided into panels, as in those of the miniatures in the Book of Kells.

[1] *Archæologia Cambrensis,* ser. 5, vol. vi., p. 357.

[2] Prof. J. O. Westwood's *Lapidarium Walliæ*, pl. 60.

[3] *Ibid.*, pl. 14.

[4] Dr. J. Stuart's *Sculptured Stones of Scotland*, vol. ii., pl. 131.

[5] A. G. Langdon's *Old Cornish Crosses*, p. 412.

[6] Dr. J. Stuart's *Sculptured Stones of Scotland*, vol. i., p. 28. See also casts in the South Kensington and Edinburgh Museums.

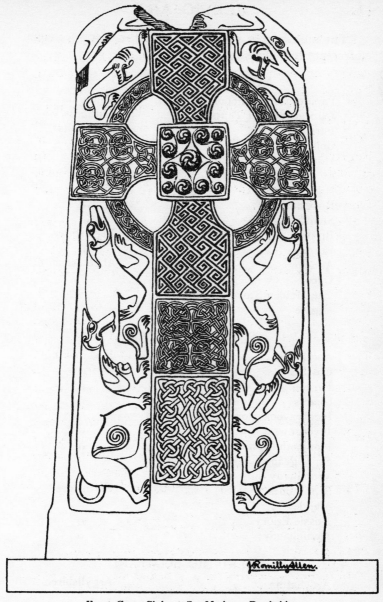

J Romilly Allen.

Erect Cross-Slab at St. Madoes, Perthshire

Scale ½ linear

The following is a list of some of the best specimens of erect cross-slabs in Scotland :—

NORTHERN PICT-LAND

Papil (now at Edinburgh)	Shetland.
Ulbster (now at Thurso)	Caithness.
Farr	Sutherland.
Golspie	,,
Hilton of Cadboll (now at Invergordon)	Ross-shire.
Nigg	,,
Rosemarkie	,,
Shandwick	,,
Brodie	Elginshire.
Forres	,,
Aboyne	Aberdeenshire.
Dyce	,,
The Maiden Stone	,,
Migvie	,,

SOUTHERN PICT-LAND

Aberlemno	Forfarshire.
Cossins	,,
Farnell	,,
Glamis	,,
Inchbrayock (now at Montrose)	,,
Invergowrie	,,
Monifieth (now at Edinburgh)	,,
St. Vigeans	,,
Woodwray (now at Abbotsford)	,,
St. Madoes	Perthshire.
Meigle	,,
Rossie Priory	,,
Dunfallandy	,,

DALRIADIC SCOTLAND

Ardchattan	Argyllshire.

ERECT CROSS-SLAB IN ABERLEMNO CHURCHYARD,
FORFARSHIRE

John Patrick of Edinburgh, photo.

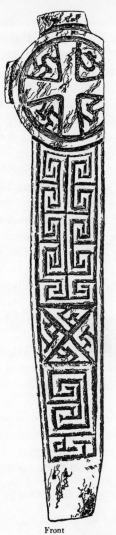 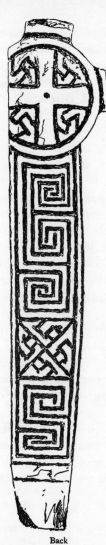

Front Back

Cross at Penmon, Anglesey

Drawn by Harold Hughes

Scale $\frac{1}{8}$ linear

The erect cross-slabs of the Isle of Man show a mixture of Celtic and Scandinavian art, but there are a few which appear to be purely Celtic, as, for instance, those at Kirk Maughold[1] (on the village green) and at Kirk Bride.[2]

The erect free-standing cross seems to have been evolved from the erect cross-slab by removing one part of the background of the cross after another, until at last nothing but the cross itself was left. We see the first stage in the Papil stone from Shetland, now in the Edinburgh Museum of Antiquities. Here the top of the slab is rounded to suit the curve of the circle, within which the head of the cross is enclosed. The wheel-cross comes next, in which the portion of the background of the cross on each side of the shaft is dispensed with, as in the specimens at Margam[3] and Llantwit Major,[4] both in Glamorganshire. Then the ends of the arms of the cross are allowed to project beyond the circular ring, as at Penmon,[5] Anglesey. Lastly, the portions of the background of the cross between the quadrants of the ring and the arms are pierced right through the slab, thus giving us the "four-hole" cross of Cornwall[6] and the typical High Cross of Ireland.[7]

We have used the term "wheel-cross" to describe the class of monuments with a round head and a shaft of less width than the diameter of the head rather because it is convenient than on account of its appro-

[1] J. G. Cumming's *Runic Remains of the Isle of Man.*
[2] *Ibid.*
[3] Prof. J. O. Westwood's *Lapidarium Walliæ*, pl. 15.
[4] *Ibid.*, pl. 5.
[5] *Ibid.*, pl. 84.
[6] A. G. Langdon's *Old Cornish Crosses.*
[7] H. O'Neill's *Ancient Crosses of Ireland.*

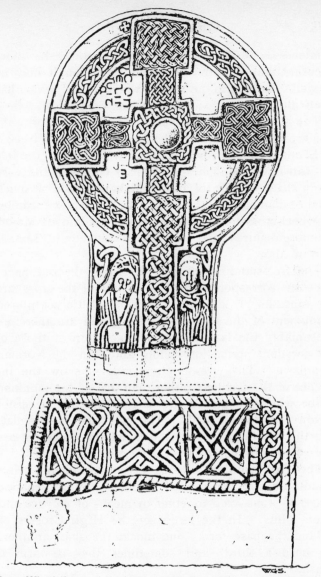

Great Wheel-Cross of Conbelin at Margam Abbey, Glamorganshire

Drawn by Worthington G. Smith

Scale $\frac{1}{8}$ linear

priateness. Perhaps "disc-cross" would be more accurate, but in order to avoid confusion it may be as well to adhere to the term "wheel-cross," which has been adopted by previous writers on the subject.

The wheel-crosses are peculiar to Wales, Cornwall, and the Isle of Man, there being none either in Ireland or Scotland. The wheel-crosses of Wales and the Isle of Man have round heads of large diameter and very short shafts ; those of Cornwall have heads of much smaller diameter with a taller shaft. The best examples of wheel-crosses are at Margam and Llantwit Major, Glamorganshire ; and at Kirk Braddan and Lonan, Isle of Man.

The free-standing crosses, in which the outline of the stone corresponds with the outline of the cross, are the most highly developed type of Celtic sculptured monument of the Christian period, and are therefore presumably the latest, with the exception of those of the decadent period just before and after the Norman Conquest. The free-standing crosses show the influence of the architect rather than that of the monkish scribe who embellished the early Irish and Hiberno-Saxon illuminated MSS. The sculpture is less flat, and the mouldings round the panels of ornament are more elaborate than on the earlier erect cross-slabs.

The free-standing crosses also, instead of being monolithic, are constructed of two or more separate pieces of stone fixed together by means of mortice and tenon joints. In the larger of the High Crosses of Ireland the base forms one block, the shaft another, the head a third, and sometimes the top arm a fourth.

The High Crosses of Ireland are in most cases associated with a characteristic set of ecclesiastical

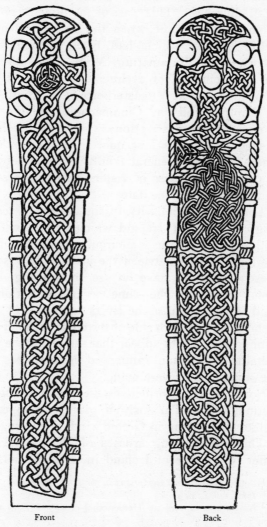

Front Back

Cross at Neuadd Siarman, near Builth, Brecknockshire

Scale $\frac{1}{12}$ linear

structures consisting of a Round Tower and several small churches. This class of monument consequently belongs to the time when the artistic talents of the Celtic monks, which had been previously entirely absorbed in illuminating MSS., was directed into the new channel of architecture. The High Cross of Muiredach[1] at Monasterboice, Co. Louth, and that of King Fland[2] at Clonmacnois, King's Co., are proved by the inscriptions upon them to have been erected during the first quarter of the tenth century. There is such a general family likeness between most of the High Crosses of Ireland that they are probably all of about the same date.

There is a peculiarity in the design of some of the High Crosses of Ireland which should not pass unnoticed, namely, the semicircular projection in each of the four hollows between the arms.[3] In a stone cross these projections have no use or meaning, but in the metal crosses of the same period projections of this kind serve to diguise the rivets by means of which the metal plates on each side of the cross are held together.[4] From this it would appear that the art of the worker in metal to some extent influenced the sculptors by whom the stone crosses were made.

Some of the Cornish crosses have triangular projections in a similar position, giving an appearance not unlike the cusping in Gothic window tracery.

The free-standing crosses of Wales and Cornwall differ from those of Ireland in having heads of much

[1] Petrie's *Christian Inscriptions in the Irish Language*, vol. ii., p. 66.
[2] *Ibid.*, vol. i., p. 43.
[3] As on the crosses at Monasterboice, Co. Louth, and Durrow, King's Co.
[4] As on the Cross of Cong in the Dublin Museum, and on the pectoral cross of St. Cuthbert in the Library of Durham Cathedral.

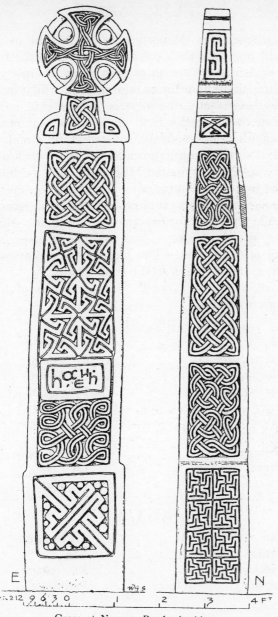

E WGS N

Cross at Nevern, Pembrokeshire

Scale ¼ linear

smaller diameter in proportion to the height of the shaft, and bases are the exception rather than the rule. In the Welsh and Cornish crosses figure sculpture is made altogether subordinate to ornament, whilst in the Irish crosses exactly the reverse is the case. The fronts and backs of the Irish crosses, and sometimes the sides also, are entirely covered with panels of symbolical figure subjects forming a cycle, which does not occur in the illuminated MSS., although evidently borrowed from a Byzantine source. The subordination of ornament to figure subjects on the Irish crosses shows that they are further removed from the MSS. than the Welsh, Cornish, and Scottish crosses, and therefore of later date. The free-standing crosses of Scotland seem to belong to the Irish group.

The following list gives the best examples of free-standing crosses :—

IRELAND

Kells	Co. Meath.
Monasterboice	Co. Louth.
Termonfechin	Co. Louth.
Clonmacnois	King's Co.
Durrow	King's Co.
Castle Dermot	Co. Kildare.
Moone Abbey	Co. Kildare.
Kilklispeen	Co. Kilkenny.
Kilfenora	Co. Clare.
Drumcliff	Co. Sligo.

SCOTLAND

Iona	Argyllshire.
Kildalton	Islay.
Barrochan	Renfrewshire.
Dupplin	Perthshire.

WALES

Penmon	Anglesey.
Maen Achyfan	Flintshire.
Neuadd Siarman	Brecknockshire.
Llanbadarn Fawr	Cardiganshire.
Llantwit Major	Glamorganshire.
Margam	,,
Carew	Pembrokeshire.
Nevern	,,
Penally	,,

The shafts of the erect free-standing crosses which have just been described are rectangular in section, but there are a few exceptional monuments with shafts of square section or of round section, or partly of square and partly of round section. As an instance of a cross of square section we have the one at Llandough, Glamorganshire. At Llantwit Major, in the same county, is a cylindrical pillar with a vertical groove down one side of it, the use of which has caused much futile speculation amongst antiquaries. The pillar of Eliseg at Valle Crucis, Denbighshire, is round at the bottom and square at the top, thus corresponding in shape to a well-known type of monument which is common in Mercia. These round pillar crosses usually occur in pairs.

There are a few unique monuments that cannot be classed with any of those already described, such as the ornamented stone coffin at Govan, Renfrewshire, and the altar tomb at St. Andrews, Fifeshire.

Descriptions and illustrations of nearly all the monuments mentioned will be found in Dr. J. Stuart's *Sculptured Stones of Scotland* (published by the Spalding Club of Aberdeen); Dr. J. Anderson and J. R. Allen's *Early Christian Monuments of Scotland*

(published by the Society of Antiquaries of Scotland);
R. C. Graham's *Carved Stones of Islay;* H. O'Neill's
Sculptured Crosses of Ancient Ireland; Dr. Petrie's
Christian Inscriptions in the Irish Language (published
by the R. Soc. Ant. of Ireland); Miss M. Stokes'
Early Christian Art in Ireland; Prof. J. O. West-
wood's *Lapidarium Walliæ;* A. G. Langdon's *Old
Cornish Crosses;* J. G. Cumming's *Runic Remains of
the Isle of Man.*

The Celtic metalwork of the Christian period may be
arranged under the following heads :—

Bells.	Book shrines.
Croziers.	Relic shrines.
Chalices.	Plaques for book-covers.
Processional crosses.	Penannular brooches.
Bell shrines.	Hammer-headed pins.

With a few exceptions all the existing specimens are
now preserved in the Museum of the Royal Irish
Academy in Dublin, the National Museum of Anti-
quities of Scotland in Edinburgh, and the British
Museum in London.

Ecclesiastical bells are of two different kinds, namely,
(1) *portable* bells, sufficiently light to be carried in the
hand ; and (2) *fixed* bells, whose weight renders a
trussed framework of wood necessary for their support.
Each kind of bell can be rung in two separate ways,
namely, (1) by holding the bell stationary and striking
it on the outside with a hammer ; or (2) by providing
the bell with a tongue, or clapper, suspended from the
inside and swinging the bell backwards and forwards,
so as to cause the clapper to strike against the interior
and thus produce sound. The method of bell-ringing
by means of a hammer is frequently illustrated in the

illuminated psalters of the thirteenth and fourteenth
centuries, and is also to be seen on the sculptured
capitals in the Abbey of St. George's de Boscherville,[1]
in Normandy. The great bells of the Kremlin at
Moscow, and in other Greek churches throughout
Russia, are rung in this fashion. Portable bells with
clappers have a handle at the top, by which they can
be swung backwards and forwards in the hand, in the
manner depicted upon the Bayeux Tapestry.[2] Fixed
bells with clappers have loops at the top for suspension
by iron bands to a horizontal wooden axle or rocking
bar working in bearings supported on a trussed frame-
work of timber, usually within a masonry tower. The
required rocking motion is given by a lever and rope
or a grooved wheel and rope.

The bells used in the Celtic Church seem to have
belonged exclusively to the class of portable bells rung
by hand. During the earlier period of Christianity in
Ireland, when the monks lived together in small isolated
communities, bells which were intended to carry sound
to a great distance would be unnecessary, so that the
absence of belfries in connection with the primitive
dry-built stone oratories of the sixth and seventh
centuries is easily explained. When, however, at a
later period, the congregations became larger and
more widely scattered, the lofty tower served a useful
purpose in greatly increasing the area over which the
sound of the bell could be heard.

The commencement of the building of belfries in
Ireland coincides with the introduction of Lombardo-
Byzantine architecture into that country, and the Irish
round tower is obviously nothing more than a local

[1] Didron's *Annales Archéologiques*, vol. vi., p. 315.
[2] F. R. Fowke's *Bayeux Tapestry*, pl. 31.

variety of the Italian campanile. The Viking invasions at the same time gave an additional impetus to the erection of structures which could be used not only for ecclesiatical purposes, but also as watch-towers to detect the approach of the enemy, as bell-towers to alarm the neighbourhood, and as towers of defence to secure the lives and property of the congregation. The fact that the Irish round towers are called by the name of *cloiccthec*, or bell-house, in the ancient annals is sufficient proof they were used as belfries, but it does not appear to be known whether the bells were rung by swinging in the hand or fixed to a framework and swung on pivots. At any rate, no Irish bells of this period (A.D. 800 to 1000) have survived except the portable hand-bells. If any mechanical appliance was employed for bell-ringing in the Irish round towers it was probably constructed by fixing an ordinary hand-bell to a horizontal axle-bar of wood or iron, working in two bearings, and swung backwards and forwards by means of a rocking lever with a rope attached to it, as is done in many village churches at the present day. The large, heavy metal bells made specially with a view to being fixed in a tower and rung by a grooved wheel and cord belong to a much later period, after the Norman Conquest, when the art of making castings in bronze of great size had been learnt.

The portable bell of the early Celtic Church is merely an ordinary cattle bell,[1] such as would, no doubt, be common in Pagan times, adapted to ecclesiastical purposes and slightly modified to suit the requirements of the monks. It differs hardly at all, except as regards size, from the common sheep-bell

[1] Probably the earliest representation of a cow-bell in Great Britain is on the pre-Norman cross at Fowlis Wester, near Crieff, Perthshire.

still to be found in many parts of England. Dr.
Joseph Anderson tersely sums up the peculiarities of
the Celtic ecclesiastical bell, as regards its material,
manufacture, form, and size, in his *Scotland in Early
Christian Times* (first series), p. 183, somewhat as
follows :—

 (1) *Material*—iron coated with bronze.
 (2) *Manufacture*—hammered and riveted ; coating of
 bronze put on by means of a process analogous
 to tinning.
 (3) *Form* — tall, narrow, tapering, foursided ; ends
 flattened ; sides bulged.
 (4) *Size*—portable ; provided with handle so as to be
 easily swung by hand.

The original home of ecclesiastical bells of this type
was in Ireland, where there are still the greatest num-
ber in existence, and thence they spread to Scotland,
Wales, England, Brittany, France, and Switzerland.

The largest iron bell of this kind is preserved in
the Church of Birnie, near Elgin, N.B. It is 1 foot
2 inches high, and 7 inches by 5 inches at the bottom,
tapering to 4½ inches by 3 inches at the top. It is
riveted down each of the narrow sides with four rivets,
and the handle is fixed to the top by four much smaller
rivets. As a rule, however, the height of such bells
rarely exceeds 1 foot or is less than 8 inches.

The Celtic ecclesiastical bell of wrought-iron was
afterwards copied in cast bronze. It is reasonable to
suppose that the bronze bells are of later date than those
of iron (1) because the rectangular shape is useless and
meaningless in the case of a bronze bell, and results
from copying an iron bell, in which the rectangular
shape is necessitated by its method of construction ;
(2) because the bronze bells are of more refined shape

and better manufacture than those of iron; and (3) because the bronze bells are in many cases ornamented. Celtic ecclesiastical bells of cast bronze may be divided into the following classes:—

(1) Bronze bells without ornament.
(2) Bronze bells without ornament, but inscribed.
(3) Bronze bells with ornamented handles.
(4) Bronze bells with ornamented bodies.

Examples of Celtic quadrangular bells of cast bronze without ornament have been recorded at the following places:—

WALES—
Llanrhyddlad, Anglesey (*Archæologia Cambrensis*, 4th ser., vol. ii., p. 275).
Llangystenyn, Carnarvonshire; now in the Powysland Museum at Welshpool (*Montgomeryshire Collections*, vol. xxv., p. 327).

SCOTLAND—
Eilean Finan, Loch Shiel, Argyllshire (Dr. J. Anderson's *Scotland in Early Christian Times*, 1st ser., p. 198).
Insh, near Kingussie, Inverness-shire (*Ibid.*, p. 195).
Little Dunkeld, Perthshire (*Proc. Soc. Ant. Scot.*, vol. xxiii., p. 119).
Forteviot, Perthshire (*Ibid.*, vol. xxvi., p. 434).

IRELAND—
Garton, Co. Donegal (Rev. H. T. Ellacombe's *Church Bells of Devon—Supplement*, p. 342).
Lower Badony, Co. Tyrone (*Ibid.*, p. 344).
Scattery Island, Co. Clare; now in the British Museum (*Ibid.*, p. 344).
Kilbroney, Rostrevor, Co. Down (R. Welch, photo. No. 1,932; *Jour. R. Soc. Ant. of Ireland*, vol. xxxiii., p. 55).
Kilmainham (*Jour. R. Soc. Ant. of Ireland*, 5th ser., vol. x., p. 41).

Ireland—

 Cappagh, Co. Tyrone (*Jour. R. Soc. Ant. of Ireland,*
 vol. xxxiii., p. 52).

 Drumragh, Co. Tyrone (*Ibid.*, vol. xxxiii., p. 54).

France—

 Goulien, Finistère (*Ibid.*, 5th ser., vol. viii., p. 167).

As has already been pointed out, the bells of cast
bronze are copies in another material of the wrought-
iron bells, the quadrangular form of which had its origin
in the method of construction out of a thin sheet of
metal with riveted joints being still adhered to in the
bronze bell, where joints were not required. The only
difference in the shape of the iron and the bronze bells
is that the latter have in most cases a flange, or an
expansion and thickening of the metal round the
mouth. The handles vary from those which are
almost rectangular to those which are quite round.
The bell still preserved in the church at Insh, near
Kingussie, Inverness-shire, may be taken as a fair
sample of the Celtic quadrangular bell of cast bronze
without ornament. It is 10 inches high, and measures
9 inches by 7¾ inches at the mouth. The handle is
oval and the mouth expanded. The remaining bells
of the same class vary from 4 inches to 11 inches in
height, with their other dimensions in proportion.

 There are three Celtic quadrangular bells of cast
bronze without ornament, but inscribed, at the follow-
ing places :—

Ireland—

 Clogher, Co. Tyrone (H. T. Ellacombe's *Church Bells
of Devon—Supplement*, p. 369).

 Armagh ; now in the Museum of the R.I.A. at Dublin
(M. Stokes' *Early Christian Art in Ireland*, p. 65).

BRITTANY—
 Stival (*Mémoires de l'Institut Impériale de France; Académie des Inscriptions et Belles-Lettres*, vol. xxiv., pt. ii., p. 387).

The bell of Clogher is inscribed, in one horizontal line, with Roman capital letters—

PATRICI

The bell of Armagh is inscribed, in three horizontal lines, with Hiberno-Saxon minuscules—

✠ oroit ar chu

mascach m̄

ailello

"✠ A prayer for Cumascach, son of Ailell."

The bell of Stival is inscribed, in one vertical line, with Carlovingian minuscules—

pirtur ficifti

"Pirtur made this" (?).

Or, according to the Vicomte Hersart de la Villemarqué:

pir turfic is ti

"Sweet-sounding art thou."

The Cumascach mentioned on the bell of Armagh was probably the steward of Armagh, who, according to the *Annals of the Four Masters*, died in A.D. 904, thus fixing the date of at least one of the bells of this class.

Celtic quadrangular bells of cast bronze with ornamented handles exist at the following places :—

WALES—
 Llangwynodl, Carnarvonshire ; now in the possession of W. C. Yale-Jones-Parry, Esq., of Madryn Castle, Pwllheli, Carnarvonshire (*Archæologia Cambrensis*, 1st ser., vol. iv., p. 167 ; and 4th ser., vol. ii., p. 274).

SCOTLAND—

Strathfillan (Bell of St. Fillan), Perthshire ; now in the National Museum at Edinburgh (Dr. J. Anderson's *Scotland in Early Christian Times*, 1st ser., p. 186).

IRELAND—

Lorrha (Bell of St. Ruadhan), Co. Tipperary ; now in the British Museum (H. T. Ellacombe's *Church Bells of Devon—Supplement*, p. 344).

FRANCE—

St. Pol de Léon (Bell of St. Meriadec) (Rohault de Fleury's *La Messe*, vol. vi., pl. CDXVIII. ; Ellacombe, p. 383).

The ornament on the handles is of two kinds—zoömorphic and phyllomorphic. The former consists of the head of a beast at each end of the loop handle where it joins the body of the bell, and the latter of a leaf in the same position. The bell of Llangwynodl[1] has a good typical example of a zoömorphic handle, and the bell of St. Pol de Léon is the only one with leaf terminations to the handle. The Llangwynodl bell is 5 inches high, and measures 6½ inches by 4 inches across the mouth ; and the St. Pol de Léon bell is 9½ inches high, and measures 6½ inches across the mouth. St. Fillan's bell is 1 foot high, and St. Ruadhan's bell only 2 inches or 3 inches high.

Celtic quadrangular bells of cast bronze with ornamented bodies exist at the following places :—

IRELAND—

Lough Lene Castle, Co. Westmeath ; now in the Museum of the R.I.A. at Dublin ; Bangor, Co. Down (*Ulster Journal of Archæology*, vol. i., p. 179 ; Ellacombe, p. 340).
Cashel ; now at Adare Manor (Lady Dunraven's *Memorials of Adare Manor*, p. 152 ; Ellacombe, p. 340).

[1] We are indebted to Mr. W. Corbet Yale-Jones-Parry, of Madryn Castle, Pwllheli, the present owner of the Bell, for permission to reproduce the photograph.

By the courtesy of Mr. George Coffey, M.R.I.A., of the Museum of the Royal Irish Academy, we are able to illustrate the bell from Lough Lene Castle.

It is 1 foot 1¼ inches high, including the handle, and measures 8⅛ inches by 7¼ inches across the mouth. The shape of the body of the bell resembles that of the iron quadrangular bells, but exhibits much greater refinement in the delicate and almost imperceptible curves of the sides. The handle is semicircular. The cross of the well-known Irish type, with a border of key pattern below, round the mouth of the bell, on one of the border faces; and a border of angular interlaced-work in a similar position on each of the narrower faces.

The bell of Bangor was found at the place of that name, in Co. Louth, and was subsequently in the possession of Dr. Stephenson, of Belfast. It now belongs to Colonel MacCance, of Knocknagoney House, Holywood, Co. Down.[1] It is 1 foot 2½ inches high, and measures 9 inches by 8 inches across the mouth.

This bell is also ornamented with a cross and key patterns, like the one just described, the only difference being that the cross is not combined with a circular ring, and the design of the key pattern is not quite the same.

The bell of Cashel was found at the place of that name, in Co. Tipperary, in 1849, and is now preserved at Lord Dunraven's house at Adare Manor, Co. Limerick. It resembles the bell of Bangor almost exactly, except that there are four round dots in the

[1] Mr. R. Welch, of Belfast, tells me that it is kept in a fire-proof safe, and that over £300 was refused for it.

BRONZE BELL WITH ENGRAVED ORNAMENT FROM LOUGH
LENE CASTLE, CO. WESTMEATH, IN THE MUSEUM
OF THE ROYAL IRISH ACADEMY

hollows between the arms of the cross. The handle is broken off, and without this the bell is 1 foot high. Its dimensions across the mouth are 9½ inches by 6¼ inches.

These three bells are so nearly alike as regards their size, shape, and ornamentation that they are probably all the same date, and may even have been the work of one artificer in metal. A peculiarity occurs in the key patterns on the bells from Lough Lene Castle and from Bangor which may perhaps help to fix the date. It will be noticed that the square spaces in the middle of the key patterns are filled in with an almond-shaped figure. This is also a feature of the key patterns in the Irish Gospels (Codex No. 51) at St. Gall, in Switzerland.[1]

There is in the British Museum a Celtic quadrangular bell of iron with an ornamental bronze cap fixed to the top of it, but it is not clear whether the cap forms part of the original design or was added subsequently. This bell is called the Bell of Conall Gael, and came from Inishkeel, in the Barony of Boylagh, Co. Donegal. It was enclosed within a metal shrine in the fifteenth century.

All the other Celtic ecclesiastical bells which have been enshrined are entirely of iron, a fact tending to show that the bronze bells are of later date than the iron ones, because the enshrined bells were those belonging as a general rule to the saint who founded the church. The bronze bells probably came into use long after most of the older churches had been founded.

[1] R. Purton Cooper's Appendix A to Rymer's *Foedera*, p. 90 and pl. 7 (St. Mark miniature), and pl. 10 (initial page of St. John's Gospel).

It may be interesting to give a list of the bell-shrines still in existence :—

IRELAND—

Shrine of the Bell of St. Patrick's Will ; now in the Museum of the R.I.A. at Dublin (H. O'Neill's *Fine Arts of Ancient Ireland*, p. 46).

Shrine of the Bell of St. Culan, called the *Barnaan Cuilaun ;* now in the British Museum (*Transactions of the Royal Irish Academy*, vol. xiv., p. 31).

Shrine of the Bell of St. Mogue.

Shrine of the Bell of Maelbrigde (Miss M. Stokes' *Early Christian Art in Ireland*, p. 67).

Shrine of the Bell of St. Mura, from the Abbey of Fahan, Co. Donegal (*Ulster Journal of Archæology*, vol. i., p. 274).

Shrine of the Bell of Conall Gael, from Inishkeel, Co. Donegal ; now in the British Museum (H. T. Ellacombe's *Church Bells of Devon—Supplement*, p. 365).

SCOTLAND—

Bell-shrine of Kilmichael Glassary, Argyllshire, dug up on Torrebhlaurn Farm in 1814 ; now in the National Museum at Edinburgh (Dr. J. Anderson's *Scotland in Early Christian Times*, 1st ser., p. 207).

Bell-shrine, preserved at Guthrie Castle, Forfarshire (*Ibid.*, p. 209).

The bells of the Celtic Church, whether they be of iron or bronze, whether devoid of lettering or inscribed, ornamented or plain, possess a far higher interest than that attaching to ordinary museum specimens, because most of them have an authentic history, going back in some cases to the time when Christianity was first introduced into this country. The bell, the book, and the crozier which belonged to the Celtic saints who founded churches, were always looked upon

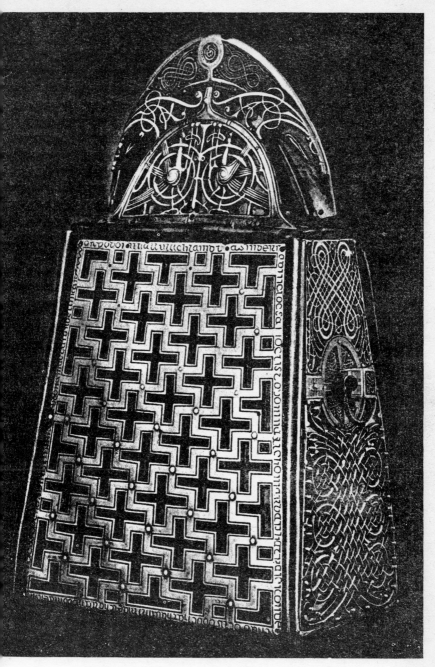

THE SHRINE OF THE BELL OF ST. PATRICK'S WILL IN THE
MUSEUM OF THE ROYAL IRISH ACADEMY, DUBLIN

A.D. 1091 TO 1105

with the highest veneration, and were used for a variety of superstitious purposes, such as healing the sick, procuring victory in battle, and the solemnising of oaths. The relics of the saints of the fifth, sixth, and seventh centuries were enclosed in costly metal shrines, generally a few hundred years after the death of the saint, and an hereditary keeper was appointed to be responsible for the safety of the relics when borrowed for effecting cures and other purposes. The shrines and their contents were thus handed down from generation to generation, and in most cases sold by their last hereditary keepers to collectors of antiquities, from whom they were acquired by the national museums of England, Scotland, and Ireland. The relics still bear the names of the saints to whom they originally belonged; the names of their hereditary keepers are well known, and they have been obtained from the localities where the saint founded his church, and where the relics remained for centuries afterwards undisturbed. No class of antiquities, therefore, possesses a better record or a more satisfactory pedigree.

The Irish and Scottish bell-shrines which have been enumerated are cases of metal of the same shape as the bell they contain, having four sloping sides and an arched top. The sides are usually made of bronze plates ornamented with gold, silver, enamel, and settings of crystal and precious stones. Two features which are characteristic of the ornamental bronze bells are repeated in the shrines, namely, the zoömorphic terminations of the handles and the cross on the body of the bell. In the two Scottish bell-shrines the Crucifixion takes the place of the Cross. The ornament on the bell-shrines is much further removed in style from that of the illuminated MSS. than is the

case with the sculptured stones. This is only what might be expected, considering the late date of the bell-shrines as compared with that of the crosses. On two of the bell-shrines Scandinavian influence may be clearly detected in the ornament upon them. Thus on the Shrine of the Bell of St. Patrick's Will the pear-shaped eyes of the beast's heads on each side of the arched top are placed with the point outwards in the Scandinavian fashion; and on the Shrine of the Bell of St. Mura the "tendril pattern," which is so common on the Rune-inscribed monuments of the Isle of Man, may be noticed.

The dates of three of the bell-shrines have been ascertained by means of the inscriptions upon them, namely, Maelbrigde's Bell-shrine, *circa* A.D. 954; the Shrine of the Bell of St. Patrick's Will, A.D. 1091 to 1105; and the Guthrie Bell-shrine, 14th century. Judging merely from the style of the ornament, the Shrine of the Bell of St. Culanus should be of the twelfth century, and the Shrines of the Bell of St. Mura and of Kilmichael Glassary perhaps as late as the beginning of the thirteenth century.

The metal croziers of the Celtic Church are in reality shrines enclosing the wooden pastoral staffs of the different saints, whose names most of them still bear. The chief peculiarity of the Celtic crozier is the shape of the head, which is like the hook of a modern walking-stick, but with a remarkable flattened end. The inside curve of the hook is nearly circular, but the outside curve is only partially semicircular, and suddenly changes to a nearly vertical straight line just before the end of the crook is reached. At the bottom of the crozier is a pointed ferrule, and the straight portion consists of two cylindrical tubes of

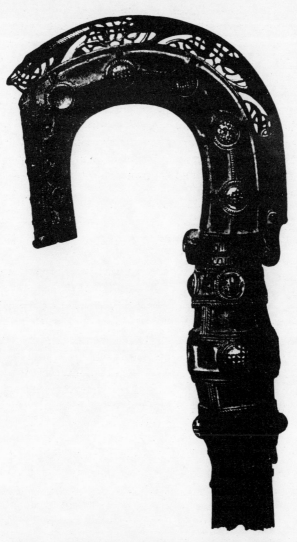

HEAD OF THE LISMORE CROZIER AT LISMORE CASTLE,
CO. WATERFORD

A.D. 1090 TO 1113

thin metal joined together in the middle by a bulbous collar. The upper tube is joined to the head at the top by a similar bulbous collar, and the lower tube is joined to the ferrule at the bottom by a third bulbous collar.

One of the most perfect of the Irish crozers is preserved at Lismore Castle,[1] Co. Waterford. It bears an inscription showing that it was made by Nectan, the artisan, for Niall, son of MacAeducain. Mac Mic Aeducain was Bishop of Lismore from A.D. 1090 to 1113. Another fine crozier in the British Museum[2] has an inscription asking a prayer for Maelfinnia and Condulig. The former was Bishop of Kells, and died in A.D. 967. Condulig was an ecclesiastic of the same monastery, and died in A.D. 1047.

The best examples of uninscribed croziers are the croziers of Clonmacnois[3] and of St. Berach in the Museum of the Royal Irish Academy in Dublin, and a crozier now in the possession of the Roman Catholic Bishop of Killarney. Besides the complete croziers mentioned there are several heads and other portions of croziers in the Museum of the Royal Irish Academy, and in the Edinburgh Museum of Antiquities may be seen the head of the crozier of St. Fillan,[4] which has an unusually interesting history.

The decoration of the Celtic croziers is concentrated on the head, the ferrule, and the collars round the straight portion of the staff. Most of the croziers have a zoömorphic cresting[5] on the outside curve of the head, sometimes consisting of a procession of

[1] Petrie's *Christian Inscriptions in the Irish Language*, vol. ii., p. 118; and H. O'Neill's *Fine Arts of Ancient Ireland*, p. 42.
[2] Petrie's *Christian Inscriptions in the Irish Language*, vol. ii., p. 116.
[3] Miss M. Stokes' *Early Christian Art in Ireland*, p. 105.
[4] Dr. J. Anderson's *Scotland in Early Christian Times*, 1st ser., p. 219.
[5] As on the croziers of Lismore, Clonmacnois, and Dysert.

beasts one behind the other, and sometimes only having terminal beasts' heads at each end.[1] The flat portion of the crook of the crozier at the end is decorated in some cases with the head of the saint or bishop, and a crystal setting below.[2] Zoömorphism enters very largely into the ornamentation of the Celtic croziers, and the beasts with only two toes instead of three on the Crozier of Clonmacnois obviously betray their Scandinavian origin by this detail. The decoration of the heads of the croziers is treated in at least three different ways: (1) the head of the Lismore crozier is divided into rectangular panels with raised bosses of enamel at the intersections of the bands, which form the divisions between the panels; (2) the heads of the croziers of Dysert, Blathmac, and St. Fillan are divided into lozenge-shaped panels by a sort of raised lattice-work; and (3) the head of the crozier of Clonmacnois is not divided into panels, but the surface entirely covered with zoömorphic strap-work.

The croziers are all of the eleventh century or later, and their decoration has little in common with that of the early illuminated MSS.

"Cumdachs," or book-shrines, are peculiar to Ireland. Three MSS. still in existence are known, from historical evidence, to have had cumdachs, although they have been lost.

These are :—

The Book of Durrow enshrined A.D. 877 to 914.
The Book of Armagh ,, A.D. 938.
The Book of Kells ,, before A.D. 1007.

[1] As on St. Fillan's crozier.
[2] As on St. Fillan's crozier.

The existing cumdachs are as follows :—

In the Museum of the Royal Irish Academy.

Cumdach of Molaise's Gospels . A.D. 1001 to 1025.
,, ,, the Stowe Missal . A.D. 1023.
,, ,, Columba's Psalter . A.D. 1084.
,, ,, St. Patrick's Gospels.

In the Library of Trinity College, Dublin.

Cumdach of Dimma's Book . A.D. 1150.

The cumdachs are simply rectangular boxes, sufficiently large to hold the MS., made either of wood or bronze and plated with silver. The decoration of the principal face of the cumdach is generally arranged in the form of a cross, the treatment being much the same as in the ornamental pages of the MSS. of the Gospels. The cross on the cumdach of Molaise's Gospels is formed of a flat silver plate with panels pierced right through the thickness of the metal, and filled in with interlaced patterns in filigree-work. The cross in the middle is surrounded by the Symbols of the Four Evangelists, with their names inscribed at the side of each. The centre of the cross and the ends of the four arms are ornamented with settings of crystal.

On one of the narrow faces of this cumdach are some very curious figures of two ecclesiastics, one holding a bell and the other a pastoral staff; and a harper, with an angel above his head, between them.

The cumdach of the Stowe Missal has upon the principal face a cross within a rectangular frame. The centre of the cross is ornamented with a crystal setting, and the recessed panels of the background are filled in with a peculiar kind of triangular and square chequer-work made of pierced metal plates.

The cumdach of Dimma's Book has also on the principal face a cross surrounded by a rectangular frame, and ornamented with thirteen crystal settings. The four recessed panels of the background of the cross are filled in with zoömorphic designs in the same style as those on the High Cross of Tuam,[1] Co. Galway, which is of about the same period, having been erected in A.D. 1123.

The relic-shrines of the Celtic Church are of two kinds, namely, (1) those made in the shape of the portion of the body of the saint enshrined; and (2) those made in the shape of a small oratory or house with a steep pitched roof having hipped ends. As an example of the first kind we have the Shrine of St. Lachtin's Arm.[2]

The most beautiful and perfect example of a reliquary in the form of a small oratory is the one now in the possession of Sir Archibald Grant, and preserved at Monymusk House,[3] Aberdeenshire. It is a wooden box, hollowed out of the solid, and covered with plates of bronze and silver. It is decorated with enamel, settings of precious stones, and raised circular medallions and rectangular plaques of interlaced-work on a chased background of zoömorphic designs. Another reliquary of the same kind was found in Lough Erne,[4] between Enniskillen and Belleek, in 1891, and belongs to Mr. T. Plunkett, of Enniskillen. It is 7 inches long by $3\frac{1}{2}$ inches wide by $5\frac{7}{8}$ inches high, and is made of plates of bronze covering an inner box scooped out of two solid pieces of yew-wood. The decoration,

[1] H. O'Neill's *Sculptured Crosses of Ancient Ireland*, pl. 12.
[2] *Vetusta Monumenta*, vol. vi., pl. 19.
[3] Dr. J. Anderson's *Scotland in Early Christian Times*, 1st ser., p. 249.
[4] *Journ. R. Soc. Ant. of Ireland*, 5th ser., vol. ii. (1892), p. 349.

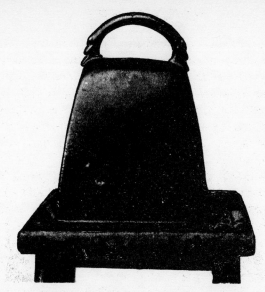

CELTIC QUADRANGULAR BELL OF BRONZE WITH ZOÖMORPHIC
HANDLES FROM LLANGWYNODL CHURCH, CARNARVONSHIRE;
NOW IN THE POSSESSION OF W. CORBET YALE-JONES-PARRY, ESQ.,
OF MADRYN CASTLE, PWLLHELI

W. Morgan Evans, of Pwllheli, photo.

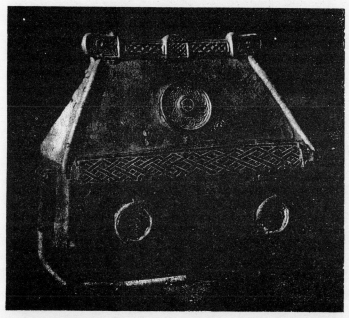

BRONZE RELIQUARY FROM LOWER LOUGH ERNE; NOW IN THE
POSSESSION OF T. PLUNKETT, ESQ., OF ENNISKILLEN

7 INS. LONG BY 5 7-8 INS. HIGH BY 3½ INS. WIDE

R. Welch, of Belfast, photo.

which consists of interlaced-work, is concentrated upon
the ridge-piece of the roof; upon a band concealing
the joint between the eaves of the roof and the sides;
upon six circular raised medallions, one on each of the
longest sloping faces of the roof and two on each of
the longest sides; and upon the hinges at each end
of the box to which the bars for suspending the shrine
round the neck of its hereditary keeper were attached.
There is a third reliquary, like the two just described,
from Norway, in the Copenhagen Museum.[1] It has
raised circular medallions arranged in the same way as
on the Lough Erne shrine, but they are decorated with
spiral designs, and the background, instead of being
plain, is covered with elaborate interlaced-work. An
inscription in later Runes on this shrine reads "Ran-
vaig owns this casket." The Edinburgh Museum
possesses a fourth shrine of the same class found in
the Shannon[2] in a very dilapidated condition.

Dr. J. Anderson[3] has pointed out the identity of the
form of the Temple at Jerusalem, as represented in the
Book of Kells, with the form of this particular class of
reliquary.

The Breac Moedoc,[4] or shrine of St. Mogue, from
Drumlane, now in the Museum of the Royal Irish
Academy at Dublin, resembles the reliquaries of the
Monymusk type in shape except that the roof is gabled
instead of being hipped, and the method of applying
the decoration also is entirely different. It is $7\frac{1}{4}$ inches
long by $8\frac{7}{8}$ inches wide by $3\frac{1}{2}$ inches wide, and is made
of bronze, with decorations of bronze gilt, enamel,

[1] J. J. A. Worsaae's *Nordiske Oldsager i det Kongelige Museum i Kjöbenhavn*, p. 129, Fig. 524.

[2] Dr. J. Anderson's *Scotland in Early Christian Times*, 1st ser., p. 246.

[3] *Ibid.*, p. 247.

[4] *Archæologia*, vol. xliii., p. 131.

and glass. The front is divided into rectangular panels, each containing a group of figures of male and female saints numbering twenty-one altogether ; and on one of the gabled ends is a bearded figure playing a harp on which a bird is perched. The back and bottom of the shrine are ornamented with cruciform patterns in pierced work, as on the shrines of the Bell of St. Patrick's Will, of the Stowe Missal, and of Dimma's Book.

The relic-shrine of St. Manchan[1] differs from all those previously described in being considerably larger, and in being shaped like the gabled roof of a house, but without any house ; that is to say, it has two rectangular faces meeting in a horizontal ridge and two nearly vertical triangular ends. It was formerly in the keeping of the ancient Irish family of Mooney, of the Doon, but it is now preserved in the Roman Catholic Church of Boher, in the parish of Lemanaghan, near Clara, King's Co. The Shrine of St. Manchan is 1 foot 11 inches long by 1 foot 1 inch wide by 1 foot 7 inches high. The framework of the shrine is made of yew boards. The front and back are each ornamented with an equal-armed cross having large circular raised bosses in the centre, and on the ends of the four arms. The four spaces forming the background of each of the crosses are filled in with rows of small figures fixed to the bronze plate behind with rivets. The front, back, and two ends of the shrine are partially surrounded by a border of zoömorphic ornament. The bosses in relief of the crosses on the front and back, and the recessed triangular panels on the two ends are also elaborately decorated with zoömorphs. At each of the four corners

[1] *The Reliquary*, vol. xv. (1875), p. 193.

of the base is a circular ring, probably for carrying the shrine about. The clamps of the rings, the borders round the bottom of the shrine, and the narrow parts of the arms of the crosses have step-patterns in red and yellow enamel upon them. The whole of the bronze was originally gilt. The style of the ornament is so similar to that on the Cross of Cong that we shall not be far wrong if we attribute the shrine of St. Manchan to the same period, namely, the twelfth century.

There is only a single example of a processional cross belonging to the Celtic Church now in existence, namely, the Cross of Cong[1] in the Museum of the Royal Irish Academy at Dublin. It is 2 feet 6 inches high by 1 foot 6¾ inches across the arms by 1¾ inches thick. The cross is of oak covered with copper plates, and has a boss of rock-crystal in the centre, beneath which the portion of the true cross was enshrined. The outer margin of the cross is formed by a roll moulding of silver, with eighteen small enamelled knobs at intervals to emphasise the cuspings of the outline of the cross. The face of the cross within the margin is divided into two rows of panels by a narrow longitudinal band in the middle of the arms, with enamelled bosses of enamel in relief and circular silver discs alternately marking the points where the cross-bars branch off at right angles to the central stem, so as to divide the surface into panels. The eight panels surrounding the boss of rock-crystal in the centre of the cross are filled in with scrolls of gold filigree-work,

[1] *Proc. R.I.A.*, vol. ii., p. 113, and vol. iv., p. 572; Petrie's *Christian Inscriptions in the Irish Language*, vol. ii., p. 118; Miss M. Stokes' *Early Christian Art in Ireland*, p. 108; and *Journ. R. Soc. Ant. Ireland*, vol. xxxi. (1901), p. 40.

and the remaining thirty-eight panels on the arms and shaft are filled in with zoömorphic designs in cast bronze gilt, riveted to the copper plates beneath. At the bottom of the cross is a beast's head with a bulbous projection between it and the socket to receive the staff. The bulbous portion is ornamented with small bosses of blue enamel and panels of zoömorphic designs. The general effect of the whole is extremely rich, and shows great artistic feeling. The prevalence of the zoömorphic element in the design and the arrangement of the panels reminds us of the croziers of the same period, more especially the one at Lismore Castle, Co. Waterford.

The inscriptions on the Cross of Cong, of which the first is in Latin (twice repeated) and the remaining four in Irish, may be thus rendered in English :—

(1) "This Cross covers the Cross on which the Saviour of the World suffered."

(2) "Pray for Murdoch O'Duffy, the Senior of Ireland."

(3) "Pray for Turloch O'Connor, for the King of Ireland, for whom this shrine was made."

(4) "Pray for Donnell M'Flannagan O'Duffy, for the Bishop of Connaught, for the successor of Coman and Ciaran, under whose superintendence this shrine was made."

(5) "Pray for Maeljesu MacBratdan O'Echan, who made this shrine."

Murdoch O'Duffy, Archbishop of Connaught, died in A.D. 1150, and it is recorded in the *Annals of Innisfallen* that in the year 1123 a bit of the true cross came into Ireland and was enshrined by Turlogh O'Connor, thus fixing the date of the Cross of Cong some time in the first half of the twelfth century. The cross was

removed from Tuam to Cong either by Archbishop
O'Duffy or King Roderic O'Conor, and was found
there in 1839, when it was purchased by Prof. Mac
Cullach and presented by him to the Museum of the
Royal Irish Academy.

Chalices of earlier date than the Norman Conquest
are of extreme rarity either in Great Britain or on the
Continent. Perhaps the three most ancient specimens
abroad are (1) the chalice, found with gold coins of
Justinian (A.D. 508 to 527), at Gourdon,[1] Chalons-sur-
Saône, and now in the National Library at Paris ; (2)
the chalice of Tassilo,[2] Duke of Bavaria (A.D. 757 to
781), at Kremsmünster in Lower Austria ; and (3) the
chalice of St. Gozlin[3] of Toul (A.D. 922 to 962), now
in the treasury of the Cathedral of Nancy. The first
and last of these have two handles. The chalice of
Tassilo, however, has no handles. It is profusely
decorated with interlaced-work, zoömorphic designs,
and figure subjects, and has round the foot the follow-
ing inscription in capital letters, not unlike those used
in the Hiberno-Saxon MSS :—

" + TASSILO DVX FORTIS LVITPIRC VIRGA REGALIS."

The lady referred to was Luitberga, wife of Duke
Tassilo, and daughter of Desiderius, the last king of
the Lombards. The chalice is 10 inches high and is
made of copper ornamented with gold, silver, and
niello. The figures are placed in oval medallions
round the bowl and the base. The principal figure
is that of Christ giving the benediction, and the re-
mainder appear to be those of saints. The style of the

[1] De Caumont's *Abécédaire d'Archéologie Architecture Religieuse*,
p. 117.
[2] Dr. R. Munro's *Boznia-Herzegovina and Dalmatia*, p. 292.
[3] De Caumont, *loc. cit.*, p. 118.

decoration resembles that of the Irish metalwork to a certain extent, and the chalice of Tassilo may very possibly have been made abroad under the direction of some Irish monk.

Only one metal chalice of undoubted Irish work has been preserved until the present time, namely, the Ardagh Chalice[1] in the Museum of the Royal Irish Academy at Dublin. It was found in 1868 in a rath in the townland of Reerasta, in the parish of Ardagh, Co. Limerick. The chalice belongs to the two-handled type, and has a hemispherical bowl, a very short cylindrical stem, and a conical base with a flat rim round the bottom. It is 7 inches high by $9\frac{1}{2}$ inches in diameter at the top, and $6\frac{1}{2}$ inches in diameter at the bottom, the bowl being 4 inches deep and of sufficient capacity to hold three pints of liquid. The chalice is composed of gold (1 oz. 2 dwts.), silver (20 ozs. 13 dwts.), bronze (9 ozs.), lead, enamel, glass, amber, and mica. No less than 354 different pieces, including 20 rivets, are used in the construction of the vessel.

The exterior of the bowl of the Ardagh chalice is inscribed with the names of the Twelve Apostles in Hiberno-Saxon capitals, finely engraved on the silver. The forms of the letters correspond with those used in the Books of Kells, Dimma, St. Chad, Durham, and Mac Regol.

The raised decoration of the chalice, which is made in separate pieces and fixed on with rivets, is concentrated on the following parts :—

(1) A horizontal band just below the rim and running through the handles.

[1] Petrie's *Christian Inscriptions in the Irish Language*, vol. ii., p. 123; *Trans. R.I.A.*, vol. xxiv., p. 433; Miss M. Stokes' *Early Christian Art in Ireland*, p. 83.

BRONZE FIBULA WITH PLAITWORK AND LATE-CELTIC
ORNAMENT FROM THE ARDAKILLEN CRANNOG, NEAR
STROKESTOWN, CO. ROSCOMMON; NOW IN THE MUSEUM
OF THE ROYAL IRISH ACADEMY, DUBLIN

DETAIL OF ORNAMENT ON THE UNDER-SIDE OF THE FOOT
OF THE ARDAGH CHALICE IN THE MUSEUM OF THE
ROYAL IRISH ACADEMY, DUBLIN

(2) The two handles.
(3) Two circular medallions on the lower side of the bowl midway between the handles.
(4) The stem.
(5) The flat rim at the bottom of the base.
(6) The under side of the flat rim round the base.
(7) The circular medallion in the centre of the under side of the conical base.

The ornament consists of interlaced-work, step-patterns, key-patterns, spiralwork, zoömorphic designs, and scrollwork, arranged in panels after the usual Celtic fashion. The step patterns are confined to the plaques and bosses of enamel, and the other patterns are executed in delicate gold filigree-work on a repoussé background of gold. On the under side of the flat rim round the base panels of most beautifully plaited silver wire are introduced. Amber is used on the handles for the borders round the raised bosses of enamel, and there is a narrow ring of the same material between the concentric rings of ornament in the middle of the under side of the base. The heads of the rivets by which the circular medallions on the sides of the bowl are fixed are concealed by two small bosses of blue glass and two of amber. The heads of the rivets for securing the two handles in place are disguised in a similar manner. The stem and supports of the chalice are of bronze gilt, highly ornamented. They are attached to the bowl by a bronze-gilt ball, with a strong square tang, and most ingeniously fastened by an iron bolt which secures all together. A plate of lead is inserted between the upper and under sides of the flat rim round the base to give weight and stability. The flat rim round the base is ornamented with gold and bronze-gilt plaques of open-

work on a background of mica, in order to show up
the beauty of the patterns. The flat rim round the
base has on its under side, between the panels of
ornament, rectangular tablets of blue glass, under-
neath which are decorated pieces of wrought-silver,
which give a brilliant appearance in a strong light.
In the centre of the under side of the base is a circular
setting of rock-crystal. The rim of the bowl of the
chalice is of brass.

Enough has been said of the elaborate nature of the
construction and ornamentation of the Ardagh Chalice
to show that it is a masterpiece of Celtic art metalwork
of the best period. The style of the lettering of the
inscription upon it and the general character of the
decorative features indicate that it belongs to the same
school as the Book of Kells, the Durham Book, St.
Chad's Gospels, and the Tara Brooch, and cannot
consequently be of much later date than the eighth
century. It will be noticed that in the decoration
of the Ardagh Chalice spiral patterns of the best
quality are present, and that the zoömorphs are kept
under proper restraint so as not to swamp the whole
design. Both these points are an indication of early
date.

There are at least three examples known of bronze
plaques with representations upon them of the Cruci-
fixion treated in the archaic Irish fashion. The most
interesting of these was found at Athlone,[1] and is now
in the Museum of the Irish Academy in Dublin. The
Saviour is shown wearing a tunic, the surface of which
is almost entirely covered with spirals, key-patterns,
and interlaced-work. Another smaller and less orna-
mental plaque with the Crucifixion may be seen in the

[1] Dr. J. Stuart's *Sculptured Stones of Scotland*, vol. ii., pl. 10.

same museum;[1] and a third, belonging to Mr. M. J. Arketell, has been illustrated by Prof. J. O. Westwood in his *Miniatures and Ornaments of the Anglo-Saxon and Irish MSS.*[2]

Leaving Celtic ecclesiastical metalwork, we come to personal ornaments, which, although exhibiting the same style of decoration, were not necessarily intended to be worn by persons taking part in the ceremonies of the Church. These personal ornaments consist of pins, brooches, and buckles. We have previously given a list of the hammer-headed pins, which may either be Pagan or Christian. Another peculiarly Celtic type of pin consisted of three parts, namely, (1) a long pin; (2) a kite-shaped pendant; and (3) a short bar hinged at one end to the top of the pin, and at the other to the rounded top of the pendant. A remarkably fine pin of this description was found about 1883 at Clonmacnois,[3] King's Co., and is now in the possession of the Rev. Timothy Lee, of Limerick. The pin is 7½ inches long, the coupling-bar ¾ inch long, and the kite-shaped pendant 2½ inches long by 1⅛ inches wide by ⅙ inch thick. The whole is of silver, decorated with gold filigree, enamel, niello, and settings of claret-coloured glass or precious stone. The coupling-bar has on one side a lozenge-shaped panel of filigree-work, and on the other an interlaced pattern in niello. The front of the pendant is ornamented with a cross having a large rectangular setting of glass in the centre, three smaller rectangular settings at the ends of the top and two side arms, and a small triangular setting at the bottom of the shaft. The background of the cross consists of four panels

[1] *Miniatures*, pl. 51. Fig. 7. [2] Pl. 51, Fig. 8.
[3] *Journ. R. Soc. Ant. Ireland*, ser. 5, vol. i. (1890-1), p. 318.

of interlaced filigree-work, three of which are missing.
The point of the kite-shaped pendant terminates in a
beast's head. On the back of the pendant there is
a cross of similar shape to that on the front, but with
an ornamental border of spiralwork round it, and the
whole design executed in niello. At the pointed end
at the bottom is fixed a small ring through which
passes a silver plaited chain of Trichinopoly-work,
like the one attached to the Tara Brooch. There is
another pin of similar shape ornamented with zoö-
morphic designs in the Museum of the Royal Irish
Academy,[1] in Dublin.

Dr. Hans Hildebrand, in his excellent South Ken-
sington handbook of *The Industrial Arts of Scandinavia*
(p. 21), remarks that "every work of human art, higher
as well as lower, has its shape determined by two
agents : the end which it is to serve, and the taste of
the people and the time of which it is a fruit." In
other words, there is a utilitarian as well as an orna-
mental side to almost every object fashioned by man to
satisfy his wants. The form of an object must depend
primarily upon the practical use to which it is intended
to be put, and the decorative features generally follow
afterwards in due course. The function of the deco-
rative features, however, should be to add grace and
beauty to the original form of the object, but not to
attempt to disguise the utilitarian purpose it fulfils.

No relics of antiquity are more deserving of study
than personal ornaments, and of all personal orna-
ments perhaps the brooch is the most important as
affording an insight into the character of the people by
whom it was worn. Their ingenuity can be measured
by the perfection of the mechanism of the working

[1] R.I.A. photo, A 165.

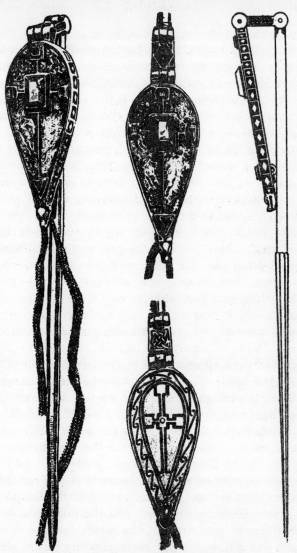

Pin-brooch from Clonmacnois, King's Co.

Now in the possession of the Rev. Timothy Lee, of Limerick

Drawn by R. Cochrane, F.S.A.

parts, their culture by the refinement of the ornament, and their skill as craftsmen by the finish of the workmanship. Much, again, is to be learnt of the habits of the people by investigating the different methods of wearing the brooch. Thus it is that almost every age and every country possesses its typical form of brooch.

Looked at from its practical side, a brooch is a contrivance for fastening together temporarily any two points on a garment. It is obviously a higher development of the pin. Going back to first principles, the pin may have been suggested by the natural spikes, or thorns, found in the vegetable world. It would not require much intelligence to see that a small knob added to the blunt end of the pin would facilitate its removal from the fabric when it was required to be withdrawn, and would also prevent the pin going further than was desirable through the fabric. The problem which was solved by the invention of the brooch, however, was one of much greater complexity, namely, how to secure the pin in position so as to prevent it from slipping out of the fabric in the direction of the head. This might have been effected either by fixing a removable knob, or stop of some kind, on the pointed end after it had been inserted in the fabric, or by connecting the head with the point temporarily, so as to form a complete ring for the time being. In the brooch the latter alternative is chosen. The pin must necessarily be straight, so as to pierce the fabric with the least amount of resistance, and the temporary connection between the head and the point has to be approximately semicircular, the whole forming a ring shaped like a bow, the pin corresponding to the string and the body of the brooch to the bow.

In order to be able to remove the brooch from the

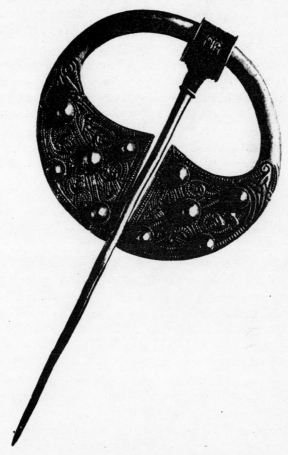

SILVER PENANNULAR BROOCH FROM IRELAND;
NOW IN THE BRITISH MUSEUM

SCALE ¾ LINEAR

fabric at pleasure, some contrivance must be hit upon by which a gap, or break, can be made in the ring, and be closed up again whenever it is desired to do so. The opening is attained by placing a hinge where the head of a pin joins the body of the brooch, and the closing by having a groove-shaped catch at the opposite extremity. A spring is also required to prevent the pin coming unfastened accidentally from the catch. These different contrivances constitute the essential parts of a brooch, which, divested of its ornamental appendages, is represented by the ordinary "safety-pin" of the present day.

If the rigid bow-like connection between the head and point of the pin be doubled we get an annular brooch, and if the central portion of the ring be filled in we get the discoidal brooch. In these cases the ring or disc is placed parallel to the plane of the fabric instead of at right angles to it.

The somewhat dry disquisition just inflicted upon the unsuspecting reader is necessary in order to place him in a position to fully understand the mechanism of the typical Celtic brooch, the leading characteristics of which are that the ring has a break in its continuity (whence the name "penannular"), and that the length of the pin considerably exceeds the diameter of the ring. The object of the break in the continuity of the ring is that it enables the spring-catch to be dispensed with, the method of fixing the brooch in the dress being as follows: First, the long pin is inserted in the fabric at two points close together, in such a manner that the apex goes right through it and appears again above the surface; the pin is then forced through the break, and the ring is given a turn through a right angle in the plane of the fabric, thus fixing the brooch

by the friction produced by the drag of the weight of the garment on the pin.

We are now brought face to face with the question as to how the Celtic penannular brooch was worn. This can not only be conjecturally determined by an examination of the specimens to be found in museums, but fortunately can be settled beyond a shadow of a doubt in two ways, each of which confirms the other. First, there are at least two contemporary representations of persons actually wearing a penannular brooch (one on a cross at Monasterboice, Co. Louth, and the other on a cross at Kells, Co. Meath, in Ireland); and this ancient form of fibula has survived, and is in use at the present time in Algeria and elsewhere.

The example at Monasterboice[1] is on the bottom panel of the side of the shaft of the cross of Muiredach (or Murdoch), which was erected in A.D. 924. The scene represented on the panel has been conjectured by the late Prof. J. O. Westwood, from its similarity to a miniature in the Book of Kells at Trinity College, Dublin, to be intended for Christ seized by the Jews. If this be so, the central figure is our Lord, and on each side is a soldier armed with a drawn sword. The sculpture is in good preservation, considering its great age, and the details of the costume, which are very elaborate, can be made out fairly well. Our Lord wears a sort of cloak with a penannular brooch fixed on His right shoulder. The split in the ring of the brooch faces downwards, and the pin is inclined upwards at an angle of about 30 degrees to the horizontal, the point being outwards. Probably the heavy head of the pin is placed downwards because its weight would always tend to bring it to this position; as the

[1] *Illustrated Archæologist* for 1893, p. 164.

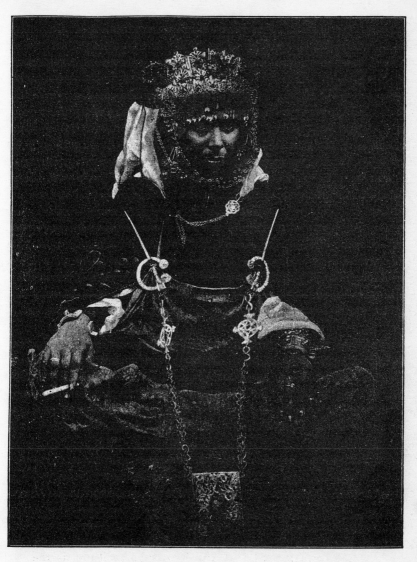

BISKRA WOMAN WEARING A PAIR OF PENANNULAR BROOCHES,
THE ENDS OF THE PINS POINTING UPWARDS

one of most stable equilibrium, but it may also have been to avoid injury from the point of the long pin.

The second example is on the bottom panel of the side of the broken cross-shaft in Kells[1] churchyard. The exact date of this monument is unknown, but it is probably of the ninth or tenth century. The subject on the panel is the Baptism of Christ, with the sources of the two imaginary rivers, Jor and Dan, which, when united, were supposed to contribute their waters to the Jordan, indicated conventionally in a most remarkable manner. John the Baptist pours the water over the head of Christ with a sort of ladle. Above is the Holy Dove, and on the left are two figures wearing pen-annular brooches exactly in the same manner as on the Monasterboice cross, with the pin pointing upwards. In the case of the figure furthest to the left, the end of the long pin is inserted a second time into the fabric of the dress, beyond the ring.

The method of wearing the penannular brooch at the present day in Algeria is clearly indicated on the re-production of a photograph[2] here given. The only difference in the way of wearing the brooch in Algeria and in ancient Ireland is, that in the former case they are worn in pairs instead of singly, and there is a connecting chain with a small pendant scent-box hung from the middle. The size of the box is exaggerated out of all proportion by being placed nearer the camera than the rest of the figure.

In Great Britain the penannular brooches appear to have been worn singly, as they are never found in

[1] *Illustrated Archæologist* for 1893, p. 165.

[2] Obtained from Albert Hautecœur, 2, Boulevard des Capucines, Paris.

pairs; thus offering a contrast to the Scandinavian bowl-shaped brooches, which are always found in pairs, and were connected by a chain, as in the case of the Algerian brooches.

It would be interesting to know how the penannular form of brooch was first introduced into this country, for its seems hardly conceivable that it could have been invented here, or else it would not be found in Algeria, which never had any connection with Great Britain, it being extremely unlikely that so peculiar a type of brooch was evolved independently in the two countries.

The most probable suggestion is that the Algerians and the ancient Irish got it from a common source, namely, the East, and that its introduction into our own islands dates from the time when the traffic in silver bullion from the East commenced. The existence of a trade route which was made use of by the dealers in silver bullion is made clear by the number of finds of Mahomedan silver coins associated with ingots, rings, and ornaments of silver, made both in Scandinavia and in Great Britain. Dr. Hans Hildebrand, in his *Industrial Arts of Scandinavia* (p. 81), informs us that "considerable stores of such coins, most of them of the Samanid dynasty, have been found in Sweden. It is satisfactorily proved by Russian finds, that these coins were brought from states near the Caspian Sea, through Russia to the shores of the Baltic Sea, and thence to the commerce established by the inhabitants of Gotland over to that island. From Gotland, and probably also by direct intercourse with Russia, the Mahomedan coins were spread over Scandinavia, being of course more common in the eastern provinces of Sweden than in the western and in Norway." No

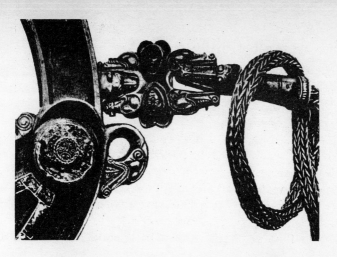

DETAIL OF ORNAMENT ON THE TARA BROOCH

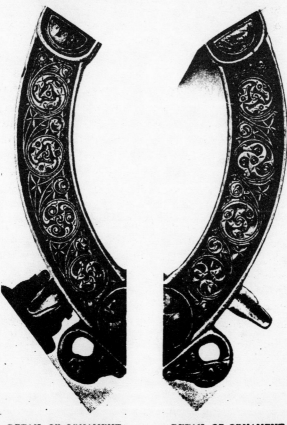

DETAIL OF ORNAMENT
ON THE TARA BROOCH

DETAIL OF ORNAMENT
ON THE TARA BROOCH

DETAIL OF ORNAMENT
OF THE LOW ARCHER

DETAIL OF ORNAMENT
OF THE TYMPANUM

less than 20,000 Mahomedan silver coins have already been discovered in Sweden, mostly dating between A.D. 880 and 955, the latest belonging to the year A.D. 1010.

Penannular brooches have been found in association with Mahomedan coins of the ninth and tenth centuries, at Skaill, in Orkney; at Storr, in Skye; and at Cuerdale, near Preston, in Lancashire.

Although the general form of the penannular brooch is probably of Eastern origin, the decorative features vary according to the race of people who adopted it. Thus the examples from Algeria have Mahomedan ornament; those from Gotland, Scandinavian patterns; whilst those from Ireland and Scotland are thoroughly Celtic in design. With the decoration of the foreign specimens we are not now concerned, but a few words with regard to the various types found in Great Britain will form a fitting conclusion to this article.

The finest collections of penannular brooches are to be seen in the British Museum, the National Museum of Antiquities of Scotland, in Edinburgh, and in the Museum of the Royal Irish Academy in Dublin. A few good specimens are in private hands, and there is a splendid one from Orton Scar,[1] in Westmoreland, in the Museum of the Society of Antiquaries at Burlington House.

The portions of the brooch, the forms of which are altered so as to adapt them better to the reception of ornament, are the head of the pin and the two terminations of the ring, where the break occurs. The two chief ways of altering the shapes of these parts are (1) by making them spherical, and (2) by expanding into a wide flat surface; the object in both cases being

[1] *Reliquary* for 1903, p. 203.

to increase the area available for decoration. Sometimes, also, the ring and the long end of the pin are flattened and widened for a similar purpose.

As an example of a penannular brooch with bulbous terminations to the ring and head of the pin, we have one from Co. Kildare in Ireland (R.I.A. photo, B 172). The knobs are covered with a prickly ornament produced by incised lines drawn diagonally in two directions, crossing each other, giving the whole the appearance of the head of a thistle. Several brooches of this kind have been obtained from different localities in Ireland, and there was one along with the three brooches of the type with flattened and expanded ends found with the Ardagh Chalice—a hoard of objects of purely Irish types—but their ornamentation appears to be more Scandinavian than Celtic. One of the best specimens from Skaill, in Orkney, now in the Edinburgh Museum, has a pin 1 foot 3 inches long, and the bulbous ends covered with zoömorphic designs similar to those on the Manx crosses, and on an iron axe-head inlaid with silver from the Mammen How,[1] Denmark.

We next come to brooches with discoidal terminations, of a date not later than the beginning of the ninth century, as the simplest example of which may be taken one from Croy, in Inverness-shire (*Scotland in Early Christian Times*, 2nd ser., p. 23). Another, found near Perth (*ibid.*, p. 21), has three raised heads on each disc; whilst one from Rogart, in Sutherland-shire (*ibid.*, p. 7), has four raised heads outside the circumference of the disc, so that the terminations are altered into the shape of a quartrefoil.

Lastly, we have brooches with flat expanded ends to

[1] Dr. J. Anderson's *Scotland in Pagan Times: Iron Age*, p. 97.

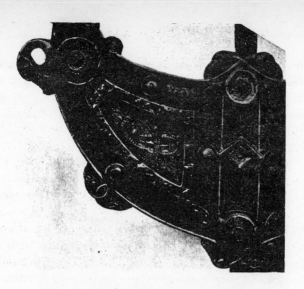

DETAIL OF ORNAMENT ON THE TARA BROOCH
IN THE DUBLIN MUSEUM

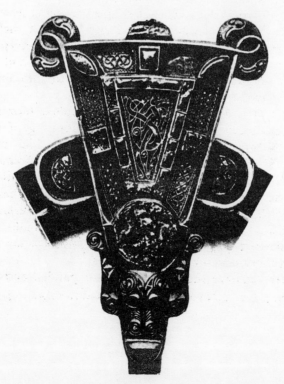

DETAIL OF ORNAMENT ON THE TARA BROOCH
IN THE DUBLIN MUSEUM

the ring, of which kind three specimens in the Museum of the Royal Irish Academy at Dublin are illustrated, in order to show the way of ornamenting the expansions with one, four, and five raised bosses, having zoömorphic designs on the background (R.I.A. photos, B 163 and B 164). The area of the head of the pin available for decoration is increased by making it into a cylindrical tube.

In the final stage of the development of the penannular brooch in Ireland it ceased to be penannular, if we may be permitted to use such an Irish expression. The break in the ring was entirely filled up, although its position can still be traced by the method of arranging the pattern, which survived in its old form long after the split had disappeared. The celebrated Tara Brooch, in the Museum of the Royal Irish Academy (R.I.A. photo, A 161), affords a striking example of this. The doing away of the break in the ring must have entirely defeated the original purpose the brooch was intended to serve, and it would, therefore, appear that these highly decorated brooches were made rather for ceremonial use, than to be of any practical value as dress-fasteners.

It may be pointed out that all the characteristic modifications of the form of the penannular brooch made by the Celtic artist arose from his desire to provide more space for the ornamental patterns, which were the very salt of his existence.

Dr. Joseph Anderson contributes the following note apropos of the long pin :—

"In the *Brehon Laws*, vol. iii., p. 291, men are exempted from liability to fine for injury from the pin of their brooch (in a crush? or at a fair?) if they have the brooch on their shoulder so as not to project beyond it. Women also are

exempt if they have their brooch similarly on their bosom."
Vol. iv., p. 323, "a precious brooch worth an ounce [of
silver?] is enumerated among the customary insignia of
a chief."

The Tara Brooch[1] was found in 1850 by some
children whilst playing on the strand near Drogheda,
Co. Meath. It was offered by the mother of the
children to a dealer in metals in Drogheda, but he
refused to purchase it, after which she took it to a
watchmaker in the town, who gave her a trifle for it.
The watchmaker cleaned it up, and subsequently sold it
to Messrs. Waterhouse, of Dame Street, Dublin. The
Tara Brooch is now in the Museum of the Royal Irish
Academy. The body of the brooch is made of an
alloy of copper and tin called white bronze, and the
decorations with which it is encrusted consist of gold
filigree in small recessed panels, niello, enamel, and
settings of amber and glass. The ornament includes
interlaced-work, spirals, step-patterns, scrollwork, zoö-
morphs, and anthropomorphs. The spiralwork is of
the best kind, such as is only found in MSS. like
the Book of Kells. The designs on the back of the
brooch appear to be chased or cut into the solid metal
of the body, and not composed of plaques fixed on
with rivets. Attention should be particularly directed
to the rows of birds, each biting the leg of the one in
front of it, on the back of the brooch. Similar designs
occur in the Lindisfarne Gospels[2] and on a cross-shaft
from Aberlady,[3] now at Carlowrie Castle, near Kirk-

[1] H. O'Neill's *Fine Arts of Ancient Ireland*, p. 49.

[2] *Publication of the Palæographical Soc.*, and G. F. Warner's *Illu-
minated Manuscripts in the British Museum*, 3rd series.

[3] Allen and Anderson's *Early Christian Monuments of Scotland*,
p. 428.

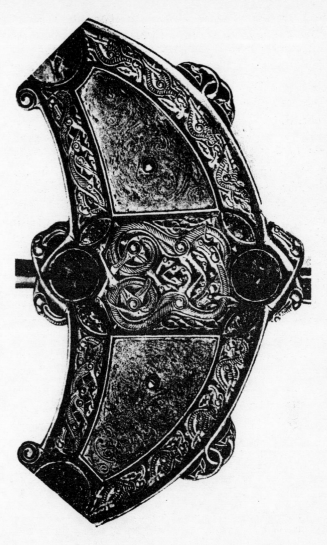

DETAIL OF ORNAMENT ON THE TARA BROOCH IN THE
MUSEUM OF THE ROYAL IRISH ACADEMY, DUBLIN

liston, Linlithgowshire, clearly showing Northumbrian influence, as bird-motived ornament of this kind is in no way characteristic of pure Irish work.

There are several beautiful penannular brooches in the National Museum of Antiquities of Scotland, at Edinburgh, most of which are described and illustrated in Dr. J. Anderson's *Scotland in Early Christian Times* series. The finest of these is the Hunterston Brooch,[1] which has a Runic inscription upon it and is decorated with interlaced-work, zoömorphs, and spiralwork almost equal to that on the Tara Brooch. The Cadboll Brooch[2] from Rogart, Sutherlandshire, and a brooch from Perth[3] are also very beautiful examples.

The best examples of early Irish ornamental leather-work are the satchel of the Book of Armagh[4] in the Library of Trinity College, Dublin, and the satchel of St. Moedog's reliquary[5] in the Museum of the Royal Irish Academy. The patterns on the former consist of interlaced-work and zoömorphs, and those on the latter of interlaced-work only. There are also specimens of leather shoes in the Museum of the Royal Irish Academy with Celtic ornament upon them.[6]

There are very few objects of wood or bone now in existence which exhibit Celtic ornament of the Christian period.

[1] Dr. J. Anderson's *Scotland in Early Christian Times,* 2nd ser., p. 2.
[2] *Ibid.*, p. 7.
[3] *Ibid.*, p. 21.
[4] Rev. J. P. Mahaffy's *Book of Trinity College.*
[5] *Archæologia,* vol. xliii., p. 131.
[6] Sir W. Wilde's *Catal. Mus. R.I.A.*, p. 284.

CHAPTER VII

CELTIC ART OF THE CHRISTIAN PERIOD

TECHNICAL PROCESSES AND MATERIALS EMPLOYED DURING THE CHRISTIAN CELTIC PERIOD IN GREAT BRITAIN

ECCLESIASTICAL and other MSS. written on sheets of vellum and bound up in the form of a book were introduced into this country with Christianity. The materials and tools used by the Celtic scribes and illuminators probably did not differ to any great extent from those used throughout Europe during the Middle Ages. The parchment of the Irish MSS. is, however, generally much thicker[1] than that of the Carlovingian and other foreign MSS. The letters in the Irish MSS. of the best period, such as the Book of Kells, are composed partly of extremely fine lines, drawn with a firm hand, which gradually expand in width to form the other parts of the letters. These could hardly have been made with a reed or a brush, so that it is probable that the pens of the Irish scribes were made from the quills of swans, geese, crows, and other birds. The black ink used in the Irish MSS. is remarkable for its blackness and durability; and Bede, the historian, speaks highly in praise of the colours prepared in Ireland, and especially of

[1] Sir E. M. Thompson's *Greek and Latin Palæography*, p. 38.

the brilliancy and permanence of the red made from whelks.[1] Some colours, such as yellow, are put on thin and transparent; whilst others, such as red, have a thick body made of titurated earth or other skilfully prepared material, mixed with some strong binding material of the nature of gum or varnish.[2]

The material employed for the highly ornamented sculptured monuments of the Christian Celtic period was generally that most readily procurable on the spot, but a preference was always shown for a freestone, which could be easily worked. The greater proportion of the best crosses are carved in a fine-grained sandstone. In Cornwall granite was most generally used, although Polyphant stone was also used. In the Isle of Man nearly all the crosses are of slate. Hard, volcanic rocks were avoided where possible on account of the difficulty of working. There are, however, crosses of trap-rock at Carew, Pembrokeshire, and Moel Siarman, Brecknockshire.

On some of the crosses the marks of the tool with which they were carved can still be clearly seen, as on the Cross of Iltyd at Llantwit Major, and the cross-base at Llangevelach, both in Glamorganshire. As far as it is possible to judge from the tool-marks, either a pick or a pointed chisel must have been employed by the early Christian Celtic stone-carvers. Similar tool-marks have been observed on the cup-and-ring sculptures of the Bronze Age.

In the churchyard at Kells, Co. Meath, there is an unfinished cross which is of great interest as showing the exact methods used in the construction and decoration of this class of monument. The stone was first

[1] Bede's *Eccl. Hist.*, bk. i., chap. 1.
[2] Dr. Ferdinand Keller in the *Ulster Journal of Archæology*, vol. viii.

squared and the design roughly set out upon it. Draughts were then cut across the faces, leaving certain portions standing out in high relief, upon which the figure subjects were afterwards sculptured. The unfinished cross at Kells was formerly lying on the ground, but it has recently been erected on its original base, which is also unfinished.

When the crosses are constructed of two or more pieces they are fitted together by means of mortice and tenon joints. Sometimes the quadrants of the circular ring connecting the arms were made in separate pieces, as in the case of the large broken cross at Iona.[1]

The metals in use during the Christian Celtic period were gold, silver, copper, lead, bronze, brass, and other alloys. These were cast and wrought and ornamented by means of enamelling, niello, plating, gilding, repoussé-work, chasing, engraving, piercing, inlaying, filigree-work, Trichinopoly chainwork, and settings of precious stones, amber, and glass. The different pieces of the metal objects were fixed together by rivets, and if soldering and brazing were known, they were certainly not employed to any great extent. Even when the specimens can be removed from their show-cases in museums and examined carefully by an expert it is not always possible to be certain of the exact technical processes by which the various decorative effects have been produced, and unless the objects can be dissected many of the constructive features must necessarily be a matter for conjecture. The Ardagh Chalice and the Tara Brooch illustrate nearly all the materials, technical processes, and methods of construction used at this period.

[1] *Proc. Soc. Ant. Scot.*, vol. xxxv., p. 90.

Three different kinds of enamel are used in the decoration of the Ardagh Chalice, namely, (1) a peculiar variety of *cloisonné* in which the compartments, or *cloisons,* are all cut out of a single piece of metal and the open framework thus formed is pressed into the surface of the enamel when soft until it rises up and fills each compartment; (2) a combination of *cloisonné* and *champlevé* enamel in which the compartments are all cut out of a single piece of metal, some being pierced right through and the remainder only sunk partially through the thickness of the metal; the framework is pressed into the enamel when soft, thus filling up the open compartments, as in the first kind just described, and the remaining dug-out compartments are filled with fusible enamel as in *champlevé;* and (3) a species of *champlevé* enamel, in which the surface of a piece of glass was engraved with a design in *intaglio* and the hollows filled up with an enamel of a different colour. The Celtic enamels of the Christian period usually occur in the form of small round bosses, of which there are good instances on the Ardagh Chalice, the Ardagh Brooch, the Tara Brooch, the Lismore Crozier, and the Cross of Cong.

The use of bands of silver with borders of niello is well illustrated by the head of a crozier[1] formerly belonging to the late Dr. W. Frazer, M.R.I.A., of Dublin. Portions of the silver have been stripped, showing how the surface of the metal into which it was inlaid was roughened with a pointed tool to make the inlay adhere better. Niello is a black composition made of silver, lead, sulphur, and copper, which is reduced to powder and placed in cavities or lines cut for its reception in the surface of the metal,

[1] *Proc. R.I.A.*, 3rd ser., vol. i., p. 207.

and afterwards incorporated with it by being passed through the furnace. Niello probably found its way to Ireland from the East. It was used by the Byzantines as early as the beginning of the ninth century.[1]

A peculiar kind of decoration which is specially characteristic of the early Irish ecclesiastical metalwork consists of plates perforated with triangles, squares, and crosses, so as to form a geometrical pattern. The plates are usually of bronze covered with silver, and the contrast between the bright surface of the white silver and the pierced portions through which the dark bronze below can be seen gives the general appearance of chequerwork. There are good instances of this class of decoration on the Shrine of the Bell of St. Patrick's Will, and the Cumdachs of Dimma's Book, the Stowe Missal, and the Shrine of St. Mogue. Cruciform pierced work of a similar kind also occurs on an ivory of the tenth century representing the raising of the widow of Nain's son, in the British Museum ;[2] on an ivory of the tenth century, representing Christ in the Temple, in the Royal Library at Berlin ;[3] and on the chair of the image of St. Faith, in the treasury of Conques[4] (Aveyron). The wards of ecclesiastical keys are often made to form cruciform patterns, as in the case of those of Netley Abbey, St. Serrais Maestricht, and Liège.[5] The cruciform patterns on the west face of

[1] J. H. Pollen's *Gold and Silver*, p. 53.

[2] J. O. Westwood's *Catal. of Fictile Ivories in S. K. Mus.*

[3] *Ibid.*

[4] *Annales de la Société Archéologique de Bruxelles*, vol. xv. (1901), p. 434.

[5] Le Chanoine Rensens' *Éléments d'Archéologie Chrétienne*, 2nd ed. (Aix, 1885), vol. i., pp. 241 and 262.

the cross at Dysert O'Dea,[1] Co. Clare, seem to be copied from metalwork.

Filigree-work of gold wire is used to make the panels of interlaced-work, scrollwork, and zoömorphic designs with which some of the best specimens of Christian Celtic metalwork are decorated, such as the Ardagh Chalice, the Tara Brooch, the Hunterston Brooch, and the Clonmacnois Pin. The filigree-work is often covered with minute granulations, which add greatly to the richness of the effect produced by their texture.

We have already referred to the Trichinopoly chain-work of silver wire used in the Ardagh Chalice, the Tara Brooch, and the Clonmacnois Pin. This kind of chainwork can be traced back to the Pagan Celtic period, as chains of similar character were found with the Late-Celtic gold collar at Limavady, Co. Londonderry, and with the pair of silver-gilt Kelto-Roman fibulæ from Chorley, Lancashire, now in the British Museum.

Settings of coral and enamel were, as we have seen, employed for the decoration of the Late-Celtic metalwork, but in the Christian Celtic period numerous other substances were also employed, such as glass, rock crystal, amber, and other precious stones. In some cases the settings of stones and glass were rectangular with a flat top and bevelled edges, but they were more generally round, oval, or almond-shaped and "tallow-cut," *i.e.* polished without facets.

The process used for producing the patterns on the leather satchels and shoes previously mentioned was probably of the same nature as that by which the *cuir bouilli* cases of later times were decorated.

[1] *Jour. R. Soc. Ant. Ireland*, ser. 5, vol. ix., p. 251.

Objects of wood, bone, ivory, and pottery and textile fabrics of the Christian Celtic period are so rare that there is really nothing to be said about the technical processes involved in their manufacture.

THE ORIGIN AND DEVELOPMENT OF EARLY CHRISTIAN ART IN GREAT BRITAIN

Attention has been recently directed to the problem of how decorative art was evolved, in the first instance, by the primitive races of mankind in remote ages. Mr. Henry Balfour, Mr. C. H. Read, and Dr. Colley March have shown us how much light may be thrown on this difficult question by a critical examination of the various forms of ornament used by the savage—or, rather, the uncultured—peoples existing at the present day in countries where they have had only limited opportunities of coming in contact with modern civilisation.

There is, however, at least as difficult a problem nearer our own doors awaiting solution, namely, that of the origin and development of early Christian decorative art in the British Isles. This problem is not one of a wholly uncultured race left to itself to work out its own ideas, as suggested by external natural objects or otherwise, but it is a problem of a race already in a state of semi-culture being brought suddenly face to face with a higher civilisation, through the introduction of a new religion, and afterwards influencing, or being influenced by, other conquering races—also in a state of semi-culture—whom they converted by missionary enterprise. That is to say, the Celts of Ireland, Scotland, the Isle of Man, Wales,

and Cornwall became acquainted with Italo-Byzantine
art when they were first Christianised, about the middle
of the fifth century. In the seventh century they came
in contact with the Anglo-Saxons, and in the ninth
with the Norsemen and Danes. It is the object of
the present inquiry to determine in what measure the
Christian art of this country before the Norman Con-
quest was affected by the absorption of these new
racial elements.

The style of art we are now dealing with was
formerly, quite wrongly, called Runic, because some
of the monuments on which characteristic forms of
ornament occur bear Runic inscriptions. Later au-
thorities have called the style Hiberno-Saxon, Kelto-
Northumbrian, Celtic, and Irish, but this is simply
begging the whole question. The term we have
chosen, namely, early Christian, is scientifically cor-
rect, and does not commit us to the assumption of any
unproved facts.

Early Christian art in this country is essentially
decorative, and to a lesser extent symbolic. The
figure subjects are obviously barbarous copies of
Byzantine originals, for no matter how they are dis-
guised by bad drawing or incrusted with ornament,
the conventional grouping and accessories still remain
to prove their origin. The miniature of the Temptation
of Christ in the Book of Kells is perhaps the most
remarkable instance of a Byzantine design Celticised,
if one may use the expression. Comparing this with a
miniature in the Psalter of Misselinda (A.D. 1066) in
the British Museum (Add. 19,352), we find all the
essential features of the scene the same, even to the
black Devil; but in the Book of Kells the Temple
with its Byzantine cupolas has been converted into an

Irish stone-roofed oratory, shaped like a metal shrine of the period, and covered with ornament; the Devil, too, has been decorated with spiral curves after the Celtic fashion.

The miniatures of the Evangelists, with their symbols, which form the frontispieces of the Irish Gospels, are also taken from a Byzantine source and similarly disguised, although not so effectually as to conceal their derivation. The Irish illuminator put as much local colour into his copy as a Chinaman or a Japanese would, but in a different way, if told to make a replica of an English picture.

In distilling the original Byzantine idea through the alembic of the mind of the Irish scribe it has absorbed so much of his individuality that it assumes an archaic and semi-barbarous appearance which is very misleading at first sight. We hope to be able to show that some of the elements of the ornament may be traced to a Byzantine source, and that the only obstacle in the way of our at once recognising whence the Irish designer received his inspiration is his marvellous power of adaptation and skill in evolving fresh combinations of simple elements. The ancient Irish artists appear in some respects to have resembled the Japanese in the rapidity with which they absorbed new ideas and turned them to good account in their decorative designs.

The materials available for the study of early Christian art in Britain consist of illuminated MSS., ecclesiastical and other metalwork, sculptured monuments, and a few miscellaneous objects. I propose now to direct attention chiefly to the sculptured monuments, because they afford a much more certain means than any other of determining the charac-

teristics of the various local styles throughout the country.

If a monument is found in a particular district, it may generally be assumed that it was the art product of the district, unless there is some special reason for thinking otherwise. The number of MSS. and examples of metalwork is comparatively much smaller than the number of monuments, and it is only in a few exceptional cases that a MS. can be traced to the monastic establishment where it was written. In Scotland, for example, although richer than any other part of Great Britain in sculptured monuments, the Book of Deer is the only pre-Norman MS. known to have been written there. Wales, again, can only claim the Psalter of Ricemarchus.

I am of opinion that if we are ever to arrive at any definite conclusions with regard to the evolution of early Christian art in Great Britain, it must be by means of a careful examination and comparison of the minute details of the ornament. The science of palæography is entirely founded on the observation of every small variation in the form of each letter, and if the same trouble was taken with ornament equally valuable results would be obtained.

We will now proceed to analyse the decorative features of the monuments, and endeavour to find an origin for the component elements which go to make up the style. I must assume the reader to possess a certain amount of acquaintance with the art of the early Christian period, and to know what is meant by most of the technical terms, but I shall give examples of the various classes of patterns in case anyone should be unfamiliar with their appearance.

Broadly speaking, early Christian ornament in Great

Britain is made up of the following elements, generally arranged in separate panels :—

(1) Interlaced-work. ⎫
(2) Step-patterns. ⎪ Geometrical.
(3) Key-patterns. ⎬
(4) Spirals. ⎭
(5) Zöomorphic Designs. ⎫ Suggested by Animal,
(6) Anthropomorphic Designs. ⎬ Human, and Vege-
(7) Phyllomorphic Designs. ⎭ table Forms.

Now the question is, what are the possible or probable sources whence each of these different kinds of patterns was derived?

First of all, there are the native and imported styles of decorative art existing in Great Britain previous to the introduction of Christianity (*circa* A.D. 450), comprising the art of the ages of Stone, Bronze, and Iron, and Romano-British art. Next, the external influences which came into play after A.D. 450, and before A.D. 1066, were Italo-Byzantine, Anglo-Saxon, Frankish, and Scandinavian.

Early Christian art in Great Britain was produced, in the first instance, by grafting the Italo-Byzantine style upon the native style of the Iron Age (sometimes called Late-Celtic), and was subsequently modified by Anglo-Saxon and Scandinavian influence.

Of the forms of decoration used in the Stone Age in this country we know hardly anything, and therefore they will not come within the scope of our investigations. The ornamental patterns of the Bronze Age, as far as we are acquainted with them from a study of the sepulchral urns, implements, personal ornaments, and sculptured cists and chambered tumuli, are of a very simple description, consisting chiefly of chevrons, concentric circles, and rudely drawn spirals. The latter

may have been the forerunners of the beautifully de-
signed volutes of the Iron Age, the nearest approach
to perfection being on the sculptured slab at the
entrance to the New Grange tumulus, Co. Meath,
and on the slabs forming the sides of a chambered
cairn at Clover Hill, Co. Sligo.

When we come down to the Iron Age we find a very
beautiful and refined system of decoration applied to
bronze objects, such as hand-mirrors, shields, helmets,
sword-sheaths, and horse-trappings, the leading *motif*
of which is the divergent, or trumpet-shaped spiral.
This style of decoration has received the name Late-
Celtic in this country, and La Tène on the Continent.

No one can fail to be struck with the similarity
between the Late-Celtic spiral ornament and that found
in the early Irish MSS., the patterns in some cases
being absolutely identical. It is thus possible to trace
this particular element in the decorative art of the early
Christian period to a native Pagan source.

Late-Celtic objects have been found in all parts of
the United Kingdom, but probably the style of decora-
tion only survived into Christian times in Ireland,
although there is really no reason why it should not
have done so elsewhere—in the north of Scotland,
for instance, which was quite as much cut off from
civilisation as Ireland during the Saxon conquests.
The closest resemblance between the spiral decoration
of the Pagan period and that of the Christian period
is to be found on the discoidal ornaments with pat-
terns in *champlevé* enamel, forming the attachments of
the handles of certain bronze bowls, several examples
of which have been discovered from time to time in
different parts of England.[1]

[1] *Archæologia*, vol. lvi., p. 43.

I believe that the only element in early Christian decorative art in this country that can be traced to a native Pagan source is the divergent spiral. It has been suggested that the Irish and Saxon designers derived some of their ideas from the Roman pavements, but I can see nothing in the decoration of the MSS. on monuments of the pre-Norman period that can be fairly attributed to a Romano-British origin.

We have now to consider the external influences which came into play after the introduction of Christianity (*circa* A.D. 450). First amongst these was the influence of Italy, and thus more indirectly that of Byzantium. It is to this source that it is possible to trace the interlaced-work and scrolls of foliage which occur so frequently on the early sculptured monuments in Great Britain. We can refer to no better text-book whilst dealing with this portion of our investigation than *L'Architettura in Italia,* by Professor Raffaele Cattaneo (Venezia, 1888), who, by a careful study of the subject, has been able to divide early Italian ecclesiastical architecture into the following styles and corresponding periods :—

(1) Latino-Barbaro . . A.D. 300 to A.D. 600.
(2) Bizantino-Barbaro . . A.D. 600 to A.D. 800.
(3) Italo-Bizantino . . A.D. 800 to A.D. 1000.

As an example of the first period we have the Ciborium in the Church of San Clemente at Rome (A.D. 514–23), decorated with plaitwork and foliage, both evidently of Classical origin. Belonging to the second period we have the Ciborium of San Giorgio di Valpolicella[1] (A.D. 712), decorated with broken plait-

[1] Also the jambs of the doorway of the chapel of S. Zeno in the church of S. Prassede, Rome (A.D. 772–95).

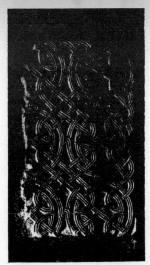

CIRCULAR KNOTWORK ON
SLAB IN CHURCH OF
STA. SABINA, ROME

CIRCULAR KNOTWORK ON
SLAB IN CHURCH OF
STA. SABINA, ROME

DOORWAY OF THE CHAPEL OF S. ZENO IN THE CHURCH OF
S. PRASSEDE AT ROME, SHOWING BROKEN PLAITWORK
ON JAMBS

(A.D. 772 TO 795)

work, and the Baptistery of Cividale (A.D. 737), with
fully developed knotwork. And belonging to the third
period the Ciborium of Sant' Apollinare in Classe,
near Ravenna (A.D. 806–16), with interlaced-work and

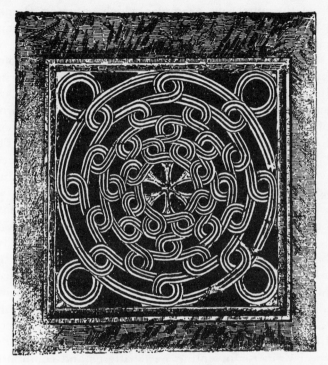

Pierced Marble Screen at Ravenna

foliage, and a slab over the altar of San Giacomo, at
Venice (A.D. 829), with circular knotwork.[1]

A careful examination of these specimens shows that

[1] Slabs of circular knotwork are also to be seen in the church of
Sta. Sabina, Rome.

the plait was the first kind of interlaced-work employed for decorative purposes, and that it was of Classical origin. The plait as a decorative motive must have been well known to the inhabitants of this country during the Roman occupation and immediately after, from the numerous examples which occur on Roman pavements, as at Lydney Park, Gloucestershire, and elsewhere.

Knotwork was gradually evolved from the plait by introducing breaks at regular intervals during the Bizantino-Barbaro period (A.D. 600 to 800); and subsequent to this we find still more complicated forms of interlaced patterns were introduced, which I propose to call circular knotwork and triangular knotwork. The evidence gathered from dated examples of interlaced-work in Italy tends to show that there was a gradual advance in the elaboration of the patterns as time went on. Consequently the style could not have been borrowed *en bloc* by Ireland from Italy, or *vice versâ*, at one time; but interlaced ornament must have been a prevalent form of decoration throughout the whole of the West of Europe, and the style advanced in all the different countries simultaneously, there being always a constant communication between Rome and the centres of religious activity abroad. Some races, like those in Great Britain, who appear to have had a special gift for inventing new patterns and combining them with a sense of artistic fitness, may have made more rapid strides than their neighbours and have influenced the development of the style in consequence, but that is all that can be said.

Two special peculiarities of the Italian interlaced-work, as compared with that in Great Britain, are the ornamenting of the interlaced bands with two incised

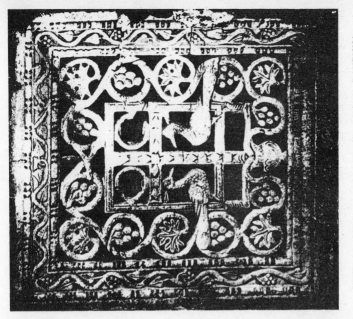

VINE SCROLLS, S. APOLLINARE NUOVO, RAVENNA

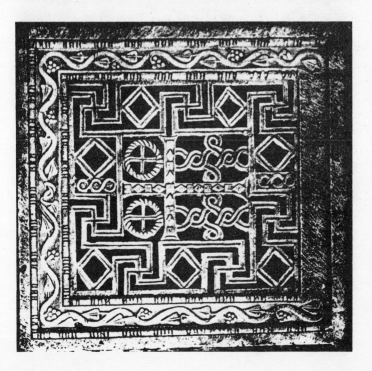

KEY PATTERN, S. APOLLINARE NUOVO, RAVENNA

lines instead of one, and the twisting together two
bands at frequent intervals, thus—

The latter feature, which is clearly Classical, occurs
frequently in circular knotwork in this country, showing
that circular knotwork is of Italian origin.

The reason why interlaced-work is characteristic of
early Christian decoration almost throughout the whole
of Europe, whilst spirals, key-patterns, foliage, etc.,
are confined to particular limited areas, I believe to be
partly because the number of distinct patterns that can
be produced from interlaced-work is far greater than
those which can be got from any other class of
ornament.

It is hardly necessary, perhaps, to enlarge much
upon the subject of the foliage of the early Christian
period in Great Britain. The scrolls with conventional-
ised bunches of grapes are no doubt descendants of the
Classical vine; the involved birds, beasts, etc., being
a later addition[1] of the Bizantino-Barbaro, or Italo-
Bizantino periods. Foliage is unknown in the Pagan
Saxon, Scandinavian, or Late-Celtic art, and the only
other source it could have been derived from is Italian
art.

We lastly have to consider the parts played in the
development of early Christian art in Great Britain by
the Anglo-Saxon and the Scandinavian invaders.
There does not seem to be much evidence to show that

[1] Or a substitution of later forms for the Cupids, etc., of the Classical
style.

the Saxons were ever gifted with any great capacity
for ornamental design, although their workmanship
often reached a high pitch of excellence. In looking
through the plates of the most recent work on *The In-
dustrial Arts of the Anglo-Saxons*, by the Baron J. de
Baye, one is struck with the extremely limited range of
imagination displayed in the design of the patterns.
Interlaced-work (but of a debased kind) occurs on some
of the sword-hilts and buckles, the latter evidently bear-
ing a remarkable affinity to the Merovingian buckles.
A radiated fibula found at Searby, in Lincolnshire,
exhibits a diagonal key-pattern similar to that found
in the Irish MSS. Far the most beautiful specimens
of Saxon jewellery, however, are the circular brooches
with *cloisonné* ornament. The disc-shaped surface of
these brooches is broken up into little compartments,
which are filled in with thin slabs of coloured glass,
garnets, etc. The narrow bands of gold which sepa-
rate the compartments from each other are zigzagged
at right angles, or stepped, and it is quite possible that
the idea of the stepped patterns within circles, which
occur in the decoration of the Irish MSS. and on the
circular enamelled bosses on the Irish ecclesiastical
metalwork, may have been taken from the circular
cloisonné Saxon brooch. It is only fair, however, to
mention that circular ornaments of *cloisonné* enamel,
with an approximation to a stepped-pattern, are used
in the decoration of the magnificent Late-Celtic shield
found in the Thames at Battersea, and now in the
British Museum.

It has been suggested that Irish interlaced-work was
derived from the rude interlaced patterns on the Saxon
and Merovingian buckles, but this appears to me most
unlikely.

M. Paul du Chaillu, in his *Viking Age*, has endeavoured to show that the Anglo-Saxons derived their art such as it is from Northern rather than from Central or from Western Europe; but his views will not receive favour at the hands of the scientific archæologist who relies on hard facts to make good his contentions. The forms and ornamental details of the buckles and other objects found with Saxon burials in the south of England undoubtedly show more affinity with Merovingian grave-goods than with anything emanating from Norway, Sweden, or Denmark.

Although no trace of Scandinavian influence can be detected in the ornamental patterns of the Anglo-Saxons—at all events, in the period preceding the Viking conquests in the ninth and tenth centuries—I am not quite so sure that one of the elements of early Christian decorative art in Great Britain may not possibly be of Northern origin, namely, the zoömorphic element. I put forward this suggestion with the greatest diffidence, and merely as a tentative theory until something better can be found to take its place.

Zoömorphism is not a marked characteristic of Pagan Saxon decorative art, and therefore, in order to account for the predominance of so-called dragonesque designs in the early Irish illuminated MSS., we must fall back on one of the following alternatives: (1) that these patterns are of native origin, and were invented by the Irish; (2) that like the spirals, they are of Late-Celtic origin; and (3) that they are of Italo-Byzantine derivation.

General Pitt-Rivers and Mr. Henry Balfour have given us an insight of the manner in which animal forms, by repeated copying, may degenerate into mere ornament; and at one time I thought that early Chris-

tian zoömorphism might have been the result of a
process of a reverse nature. It is possible to "see
snakes." when looking at a piece of interlaced-work
without necessarily suffering from excess of alcoholism.
Thus zoömorphic designs might have been evolved
from interlaced-work by making the bands terminate
in heads and tails, the limbs following in due course
later on. Such may have been the process by which
the Irish illuminator arrived at his zoömorphism, unless
it can be shown that he got it in some other way.

Animal forms are comparatively rare in Late-Celtic
art, and they are not interlaced, so that it is almost
useless to seek for the original inspiring idea in this
direction.

Birds, beasts, reptiles, and other creatures—often
used symbolically—are frequently seen in Byzantine
art, both in the decorative features of churches and in
the borders of the MSS. If it was thence that the
early Christian zoömorphs in this country took their
origin, I fancy the interlacements must have been
arrived at either by placing the creatures in pairs
symmetrically facing each other, or by contorting their
bodies into unnatural attitudes. In the case of beasts
arranged in pairs, the first step towards interlacement
is to raise their paws and then to make them cross.
The beasts may also be placed with their necks crossed;
their tails may gradually curl round until they pass
over the body, and may be looped or knotted to fill in
a blank space; and in endless other ways the most
complicated forms of zoömorphic interlaced-work may
be evolved from simple beginnings.

Dr. Hans Hildebrand, in his *Industrial Arts of
Scandinavia* (p. 50), explains in a most ingenious
manner how the lion *couchant,* which so often appears

in Roman art, forms the basis of the earlier kinds of zoömorphic ornament in Scandinavia. The question is, did the Irish evolve their zoömorphs independently in a similar way from a Classical or Byzantine lion, or did they get the idea from the Scandinavians after they had so transformed the Roman lion *couchant* that all resemblance to the original had disappeared? The difficulty in settling this point is the absence of accurately dated specimens of Scandinavian art workmanship. The panels of zoömorphic ornament on some of the fibulæ of the Later Iron Age, illustrated in Dr. Hans Hildebrand's work already referred to (pp. 58–65), bear a very considerable general resemblance to the panels of interlaced beasts in the Irish MSS., although the details are worked out differently. The whole question turns on the exact date of the Gotland brooches. If they can be proved to be earlier than the time when zoömorphism first appears in the Irish MSS., and if it is possible that the communication between Ireland and Gotland can be accounted for by the trade in silver objects and bullion existing between this country and the East, then there is something to be said for the Scandinavian origin of zoömorphism in Ireland. I believe, however, that from the evidence of the coins found with hoards of silver objects, this trade did not begin until about A.D. 800.

Attention must here be called to two points which are common to the zoömorphic and anthropomorphic designs of Scandinavia and of Great Britain, namely, (1) the introduction of spiral curves to represent conventionally the folds of the skin where a limb joins the body; and (2) the introduction of figures of men grasping birds and beasts, or arranged swastica-wise grasping each other's limbs. Here, again, it is not

easy to decide whether these features were invented independently, or whether they were borrowed by the Irish from Scandinavia, or by the Scandinavians from Ireland.

Whatever may be thought of the possibility of the existence of Scandinavian influence on Christian art in this country in its earlier phases, there is plenty of evidence of the development of an Anglo-Scandinavian style in particular districts where the Norse element was strong, as in the Isle of Man, and the adjoining coasts of Cumberland, Lancashire, and North Wales, and in Orkney and Shetland.

The specially Scandinavian characteristics of the sculptured monuments in the districts specified are as follows :—

(1) There is a predominance of patterns formed of chains of rings.

(2) The bands of the interlaced-work have a tendency to bifurcate and break off into scroll-like terminations.

(3) The beasts in the zoömorphic designs have two toes, instead of three ; the bodies are covered with scales ; the attitude is peculiar, the head being bent back and a crest issuing from it with fin-like appendages in places ; and the junction of the limbs with the body is conventionally indicated by spirals.

(4) Amongst the figure-subjects scenes from the mythic-heroic Eddaic poems, such as Sigurd Fafni's bane, Thor fishing for the Midgard-worm, Weyland Smith, etc.

Even in Norman times Scandinavian influence is exhibited in the details of the tympana at Hovering-ham, and Southwell Minster, Notts, and St. Nicholas, Ipswich.

The only element in early Christian decorative art the origin of which we have not succeeded in running

to earth in the preceding investigation is the key-pattern. I venture to think that this may have been suggested by the Greek or Roman fret, and that the essentially Celtic character imparted to it was the placing of the guiding lines in a diagonal direction with regard to the margin, instead of parallel to it. I believe the reason for this to be that exactly the same setting-out diagram was used both for the interlaced-work and the key-pattern. It is often possible to trace the origin of key-patterns to the necessities of the methods of weaving textile fabrics; but with regard to the ones we are now considering I am inclined to think that their beginnings are due to the geometrical conditions imposed by the arrangement of the setting-out lines.

In conclusion, I wish to emphasise the fact that the beauty and individuality of the ornamental designs found in early Christian art in Great Britain are due chiefly to the great taste with which the different elements are combined and the exquisite finish lavished upon them. I cannot see that it in the least detracts from the praise due to the orignators of the style if it can be shown that the ideas underlying many of the patterns were suggested by a pre-existing native style or adapted from a foreign one. Interlaced-work, key-patterns, spirals, and zoömorphs are to be found separately in the decorative art of many races and many periods, but nowhere and at no time have these different elements been used in combination with such consummate skill, as in the early Christian period in Great Britain and Ireland.

CHAPTER VIII

CELTIC ART OF THE CHRISTIAN PERIOD

THE LEADING CHARACTERISTICS OF CELTIC ART OF THE CHRISTIAN PERIOD IN GREAT BRITAIN, AND THE GENERAL NATURE OF ITS DECORATIVE AND SYMBOLIC ELEMENTS

THE leading characteristics of Celtic art of the Christian period are as follows :—

(1) The prominence given to the margin or frame within which the whole design is enclosed.

(2) The arrangement of the design within the margin in panels, each containing a complete piece of ornament.

(3) The use of setting-out lines for the ornament, placed diagonally with regard to the margin.

(4) The use of interlaced-work, step-patterns, key-patterns, spirals, and zoömorphs in combination.

(5) The geometrical perfection of all the ornament.

(6) The superiority of the decorative designs to the figure-drawing.

There are in the world two distinct schools of decorative art, one which entirely ignores the shape of the surface to be ornamented, and the other which allows the contour of the margin to influence the whole design. Japanese art belongs to the first of these, and Celtic art to the second. In the Irish illuminated

254

MSS. the rectangular shape of the page determines the setting out of the design, which is universally enclosed within a rectangular margin composed of lines of various thicknesses, or within an ornamental panelled frame. The only exception is in the case of the initial pages of the Four Gospels, where the margin is incomplete, so as to allow the extremities of the letters to project more nearly to the edge of the page. This prominence given to the margin often greatly influences the designs within it, more especially the key-patterns with diagonal setting-out lines. In sculptured stonework either roll-mouldings or flat bands form the margin, and in metalwork the margins are raised and the panels sunk.

The panels within the margin are generally rectangular, but sometimes they are circular, annular, segmental, triangular, etc. The ornament in adjoining panels is seldom of a similar kind, and the patterns are often arranged on the principle of chequerwork, so that if there is a panel of interlaced-work at the left-hand upper corner of the page of a MS., and a panel of key-pattern at the left-hand lower corner, the order will be reversed on the opposite side of the page, and the key-pattern will be at the right-hand upper corner and the interlaced-work at the right-hand lower corner.

The diagonal setting-out lines are chiefly confined to the key-patterns, and, as we shall see subsequently, are the origin of the peculiar form of Celtic key-pattern which was developed from the Greek fret.

The various motives that have been specified—namely, interlaced-work, step-patterns, key-patterns, spirals, and zoömorphs—are not always found in combination, except in the MSS., sculptured stones, and

metalwork of the best period. The step-patterns are, as a rule, only found in the early MSS. and on the enamelled settings of metalwork. Foliage is a distinctly non-Celtic element, and wherever it occurs it is a proof of Anglian influence from Northumbria. As the decadence of Celtic art set in the spirals disappeared first, and then the key-patterns, leaving only interlaced-work and zoömorphs, which survived even after the Norman conquest. Key-patterns survived in a debased form in the architectual details of the churches of the twelfth century in Ireland, but not in Scotland or Wales.

By the geometrical perfection of the Celtic ornament is meant that there are hardly ever any mistakes in the setting-out and complete execution of the designs. Thus in the interlaced-work every cord laps under and over with unfailing regularity (never over two or under two), and all the cords are joined up so as not to leave any loose ends. All the details of the spiral-work are executed with the minutest care, and there is never a broken line or pseudo-spiral. In the zoömorphic designs the beasts are all provided with the proper number of limbs and are complete in every respect down to the smallest detail.

The inferiority of the figure drawing in Christian Celtic art to the ornament will be dealt with subsequently in its proper place.

We will now proceed to examine in detail the different motives made use of in the Celtic art of the Christian period in Great Britain.

PLAITWORK ON CIBORIUM IN THE CHURCH OF
SAN CLEMENTE, ROME
(SIXTH CENTURY)

PLAITWORK ON ROMANO-BRITISH PAVEMENT AT LYDNEY PARK,
GLOUCESTERSHIRE

INTERLACED-WORK

The interlaced ornament used in Celtic art may be divided into the following classes :—

(1) Regular plaitwork, without any breaks.
(2) Broken plaitwork, with breaks made in an irregular way.
(3) Knotwork.
(4) Circular knotwork.
(5) Triangular knotwork.
(6) Ringwork or chainwork.

Interlaced-work is the predominant motive of the Celtic style of the Christian period. It lasted longer in time than any other motive, and its geographical distribution extends over a larger area. It is very seldom that one motive is used by itself for the decoration of a stone monument, metal object, or page of a MS.; but where this is the case the motive chosen is invariably interlaced-work, and not a key-pattern, spiral, or zoömorph. As instances of sculptured monuments decorated entirely with interlaced-work we have the cross at Neuadd Siarman, Brecknockshire, and the cross-shaft at St. Neot, Cornwall.

The evolution of knotwork from plaitwork cannot better be studied anywhere than in the decoration of the Welsh crosses. Let us now endeavour to trace the various stages in the process by which the higher forms of Celtic interlaced work were arrived at.

In Egyptian, Greek, and Roman decorative art the only kind of interlaced-work is the plait, without any modification whatever; and the man who discovered how to devise new patterns from a simple plait by making what I term *breaks* laid the foundation of all the wonderfully complicated and truly bewildering

forms of interlaced ornament found in such a master-piece of the art of illumination as the Book of Kells in the library of Trinity College, Dublin. Although we do not know *who* made this discovery of how to make breaks in a plait, we know pretty nearly *when* it was made. In the decoration of the mosaic pavements in Great Britain belonging to the period of the Roman occupation, no instance, as far as I can ascertain, exists of the introduction of a break in a plait; nor is there any break in the plaitwork on the marble screen and the capitals of the columns of the ciborium in the Church of San Clemente at Rome (which are dated by R. Cattaneo[1] between A.D. 514 and 523). In the eighth century, however, there are several examples with well-authenticated dates of the use of true knot-work (as distinguished from plaitwork) in the decoration of churches in Italy; namely, on the ciborium of San Giorgio at Valpolicella[2] (A.D. 712); on the Baptistery of Calistus at Cividale[3] (A.D. 737); and on the jambs of the doorway of the Chapel of San Zeno in the Church of San Prassede at Rome[4] (A.D. 772–795).

It would appear, then, that the transition from plait-work to knotwork took place between the Lombard conquest of Italy under Alboin in A.D. 563, and the extinction of the Lombard monarchy by Charlemagne in A.D. 774; possibly during the reigns of Luitprand (A.D. 712–736) and Rachis (A.D. 744): for the name of the former king is mentioned in the inscriptions on the Baptistery at Cividale and the ciborium of San Giorgio at Valpolicella, and the latter on the altar at Cividale.

[1] *L'Architettura in Italia*, pp. 29 and 31.
[2] *Ibid.*, p. 80. [3] *Ibid.*, p. 87.
[4] *Archæologia*, vol. xl., p. 191.

I now propose to explain how plaitwork is set out, and the method of making breaks in it. When it is required to fill in a rectangular panel with a plait the four sides of the panel are divided up into equal parts (except at the ends, where half a division is left), and the points thus found are joined, so as to form a network of diagonal lines. The plait is then drawn over these lines, in the manner shown on the accompanying diagram. The setting-out lines ought really to be double so as to define the width of the band composing the plait, but they are drawn single on the diagram in order to simplify the explanation.

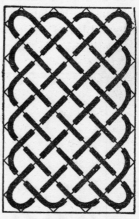

Regular plaitwork without any break

If now we desire to make a break in the plait any two of the cords are cut asunder at the point where they cross each other, leaving four loose ends A, B, C, D. To make a break the loose ends are joined together in pairs. This can be done in two ways only: (1) A can be joined to C and D to B, forming a vertical

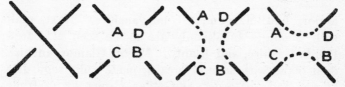

Method of making breaks in plaitwork

break; or (2) A can be joined to D and C to B, forming a horizontal break. The decorative effect of the plait is thus entirely altered by running two of the meshes

between the cords into one. By continuing the process
all the knots most commonly used in Celtic decorative
art may be derived from a simple plait.

Let us proceed to trace the process of the evolution
of knotwork out of plaitwork by actual instances taken
from the Welsh crosses. We have, to start with, good
examples of plaits of four, six, and ten cords[1] without
any breaks at Nevern, Pembrokeshire ; and Llantwit

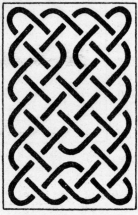

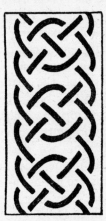

Regular plaitwork, with one
vertical break and one
horizontal break

Six-cord plait, with
horizontal breaks at
regular intervals[2]

Major, and Margam, Glamorganshire. Next, plaits
with a single break only are to be seen at Carew,
Pembrokeshire, and Llantwit Major, Glamorganshire ;
then plaits with several breaks, made quite regardless
of symmetry or order, at Golden Grove, Carmarthen-
shire ; and, lastly, breaks made at regular intervals,

[1] Plaits of an uneven number of cords are seldom used, because they
produce lopsided patterns.
[2] This occurs on the second panel of the cross at Llanbadarn Fawr.

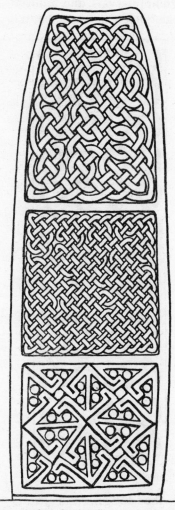

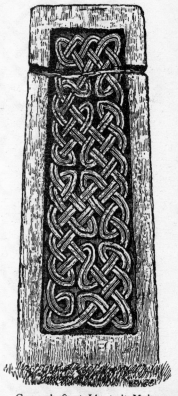

Cross-shaft at Llantwit Major
(No. 5), Glamorganshire.
Eight-cord plait, with cruciform
breaks

Scale $\frac{1}{12}$ linear

Cross-shaft at Golden Grove, with panels
of irregular broken plaitwork

Scale $\frac{1}{18}$ linear

at Neuadd Siarman, Brecknockshire. When the breaks are made symmetrically at regular intervals, and brought sufficiently near together, the plait ceases to be the

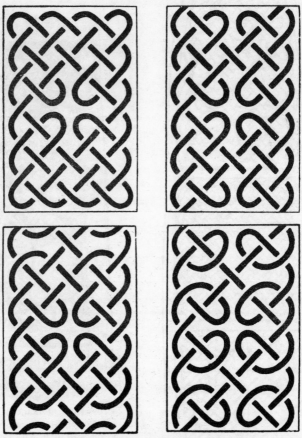

Eight-cord plaits, with cruciform breaks

most prominent feature in the design, and in its place we get a pattern composed entirely of what (for want of a better name) are called knots. On

some of the Welsh crosses (as at Carew and Nevern, Pembrokeshire), however, the breaks are made with sufficient regularity and proximity to produce knots,

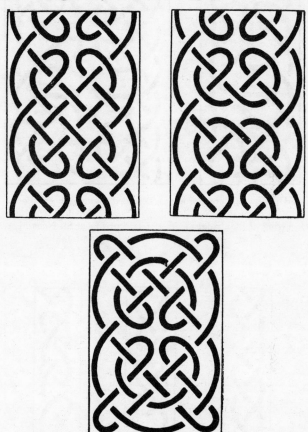

Eight-cord plaits, with cruciform breaks

and yet the knots themselves are not symmetrically placed. The result is a class of interlaced-work, intermediate between plaitwork with irregular breaks and

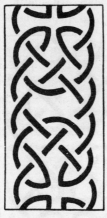

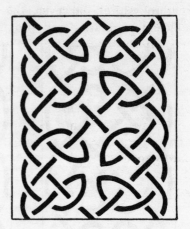

Six-cord plait, with cruciform
breaks
(Occurring at Llanbadarn
Fawr)

Ten-cord plait, with cruciform
breaks
(Occurring at St. Neuadd
(Siarman)

Knots derived from a three-cord plait

knotwork. The same kind of thing is to be seen on the crosses at Coppleston, Devonshire; and St. Neot, Cornwall.

If two horizontal breaks and two vertical breaks are made next to each other in a plait, a space in the shape of a cross is produced. A large number of the inter-laced patterns used in Celtic decorative art are derived from a plait by making cruciform breaks at regular intervals. There are examples of this in Wales, at Neuadd Siarman, Brecknockshire; Llanbadarn Fawr, Cardiganshire; and Llantwit Major, Glamorganshire. It is not unlikely that symbolism had something to do with the frequent use of the cruciform break.

There are eight elementary knots which form the basis of nearly all the interlaced patterns in Celtic decorative art, with the exception of those already described. Two of the elementary knots are derived from a three-cord plait, and the remaining six from a four-cord plait.

Knot No. 1 Knot No. 2

Knot No. 1 is derived from a three-cord plait by making horizontal breaks on one side of the plait only, and **No. 2** by making horizontal breaks alternately on one side and the other.

Knot No. 3 is derived from a four-cord plait by making horizontal breaks in the middle of the plait.

Knot No. 4 is derived from No. 3 by making a horizontal break at A; and **No.** 5 from No. 4 by making a vertical break at B and C.

Knot No. 6 is derived from a four-cord plait by making horizontal breaks in the middle of the plait, in the same way as in the case of knot No. 3, but closer together.

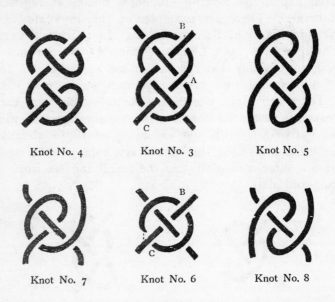

Knot No. 4 Knot No. 3 Knot No. 5

Knot No. 7 Knot No. 6 Knot No. 8

Knot No. 7 is derived from No. 6 by making a vertical break at B; and **No. 8** from No. 6 by making vertical breaks at B and C.

If a series of knots repeated in a single row can be derived from a plait of n bands, a series of the same knots repeated in a double row can be derived from a plait of $2n$ bands. Thus a pattern composed of knot

No. 1 arranged in a double row would be derived from a plait of six cords.

Knots like Nos. 3 and 4, which are longer than they are broad, can be placed either horizontally or vertically. Thus No. 3 placed with its longer axis vertical can be derived from a four-cord plait, but if placed horizontally it would be derived from a six-cord plait.

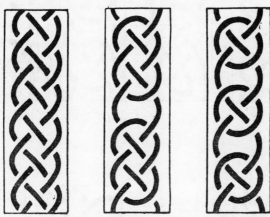

Method of deriving Knots Nos. 3 and 6 from a four-cord plait

Knot No. 2 does not occur on the Welsh crosses, and No. 1 only in a double row, as at Neuadd Siarman, Brecknockshire. This pattern is derived from a six-cord plait by making horizontal breaks in the two edges of the plait, and vertical breaks in the middle, the stages being shown on the annexed diagram.

Knot No. 3, in a single row placed with its longer axis vertical, occurs at Llandough, Glamorganshire, and, in a single row placed the other way, at Margam, Glamorganshire.

Examples of the two knots, Nos. 4 and 5, which are

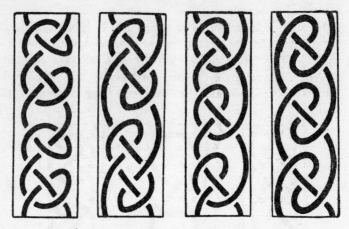

Knots Nos. 4, 5, 7, and 8, derived from a four-cord plait

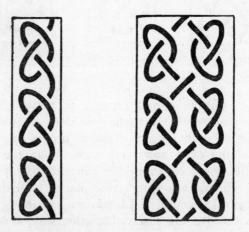

Knot No. 1, derived from either a three-cord or a six-cord plait

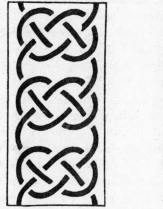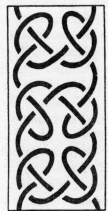

Knots 3 and 4, derived from a six-cord plait

Evolution of Knot No. 1 from a six-cord plait

derived from No. 3, are to be seen at Baglan, Glamorganshire, and Penally, Pembrokeshire.

Knot No. 6, in a single row, occurs at Llantwit Major, Glamorganshire, and its second derivative, No. 8, at Llantwit Major, and also at Neuadd Siarman, Brecknockshire. Its first derivative, No. 7, is only used in a double row on the Welsh crosses, as at Silian and Maes Mynach, Cardiganshire, and at Penally, Pembrokeshire, where the knots have an extra spiral twist. The direction of the twist of the spirally bent cord is the same in both the right-hand and left-hand vertical row of knots, although the positions of the knots are different. The more usual arrangement is to make the cords twist in opposite directions, as on the annexed diagram, in which the evolution of the pattern is shown. (Page 271.)

The clearest proof that the spiral knot No. 7 was developed from plaitwork in the manner explained is that on stones at Llangenydd, Glamorganshire; Whithorn, Wigtownshire; Abercorn, Linlithgowshire; and Aycliffe, Co. Durham; the successive stages of development can be easily traced.

I have coined the term *circular knotwork* to describe a particular class of interlaced-work, in which the circular curves made by the cords give the pattern its distinctive appearance. The best example of circular knotwork in any of the Hiberno-Saxon MSS. occurs on one of the ornamental cross-pages of the Book of Durrow.[1] Circular knotwork is not used in the decoration of the Irish ecclesiastical metalwork, probably because it is only suitable for application to larger

[1] J. R. Allen and J. Anderson's *Early Christian Monuments of Scotland*, p. lxxviii.; J. A. Bruun's *Illuminated Manuscripts of the Middle Ages*, pt. 1, "Celtic MSS.," p. 8.

surfaces than are to be found on comparatively small metal objects. Circular knotwork is characteristic of

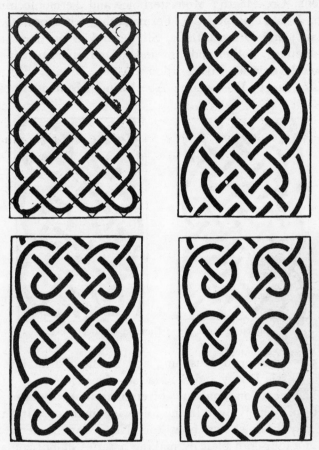

Evolution of Knot No. 7 from an eight-cord plait

the Irish and Scottish sculptured monuments of the best period; it is unknown in Cornwall and the Isle of Man and there is only one instance of its occurrence in

Wales. Very good examples of circular knotwork
may be seen on sculptured monuments in Ireland[1] at
Kells, Co. Meath; Monasterboice and Termonfechin,
Co. Louth; Boho, Co. Fermanagh; Kilfenora, Co.
Clare; and Drumcliff, Co. Sligo; and in Scotland[2] at
Collieburn, Sutherland (now in the Dunrobin Museum);
Tarbet (now at Invergordon Castle), Brodie, Elgin-
shire; Nigg, Ross-shire; Aberlemno, Monifieth (now

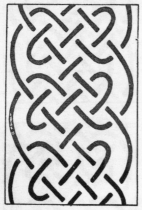 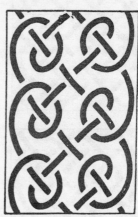

Evolution of Knot No. 7 from an eight-cord plait

in the Edinburgh Museum), and Eassie, Forfarshire;
and Rossie Priory and St. Madoes, Perthshire.

The most common kinds of circular knotwork appear
to have been evolved in the following manner. It has
already been shown how knot No. 3 can be derived
from a four-cord plait by making a series of horizontal
breaks at regular intervals, leaving two crossing-points
of the cords between each break; and how knot No. 4

[1] H. O'Neill's *Crosses of Ancient Ireland*.
[2] Allen and Anderson's *Early Christian Monuments of Scotland*.

can again be derived from knot No. 3 by making a horizontal break at the point A.

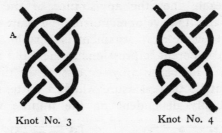

A

Knot No. 3 Knot No. 4

Now if a pair of knots like No. 4 be placed opposite each other thus—

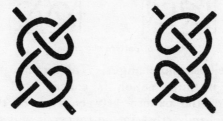

and repeated in a vertical row, we get the pattern shown below.

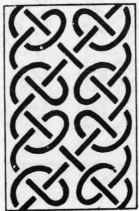

By making pointed ends to the loops forming the knots and "sweetening" the curves of the bands between each knot the appearance of the whole is changed, and its development from the plait disguised. Almost all geometrical ornament is capable of conveying several different impressions to the mind according to the way it is observed by the eye for the time being, and the intellectual pleasure which a pattern gives is most probably dependent on the infinite variety of

Sections of pattern shown on p. 273

these kaleidoscopic changes. Taking this pattern for example, if the attention is concentrated upon the portions of the pattern between each of the points where the bands cross in the centre, it will seem as if

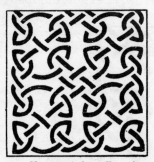 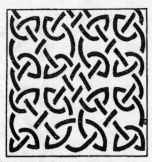

Knotwork from Ramsbury, Wilts, and Nigg, Ross-shire

the whole was formed of repetitions of knot No. 4; but if the attention be now directed towards the portions lying between the middle points of each of the

knots, the pattern will appear to consist entirely of circular curves with two diameters crossing each other diagonally.

When the circular knot thus obtained is repeated in a double row we get a comparatively simple pattern, in which the circular curves assume much greater prominence.

More complicated forms of circular knots can be derived from the elementary circular knot by combining it with a circular ring, either a larger one enclosing the four loops in the middle entirely, or a smaller one interlaced through the loops thus :—

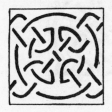 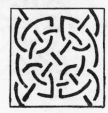

Further variations can again be produced from these by severing the bands in places, and joining parts of the loops to the rings on the same principle that breaks can be made in a plait.

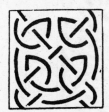

The connection between the different knots will at once become clear if they are drawn on separate pieces of tracing paper and placed one over the other.

Another kind of circular knotwork is formed by enclosing the simpler sort of knots derived directly from plaitwork within a circular band, which crosses over in one or two places and turns inwards to form the enclosed knots.

Circular knotwork from Tarbet, Ross-shire

The illustrations of the different kinds of circular knotwork from actual examples show the process of development.

Circular knotwork from Monasterboice, Co. Louth

By the term *triangular knotwork* is meant interlaced patterns, the setting-out lines of which form triangles only or triangles and lozenges. The patterns are made by distorting the simple knots derived from plaitwork, so as to adapt them to the triangular shape. This species of knotwork is very seldom seen except in a few of the Hiberno-Saxon MSS. and on some of the sculptured stones of Ireland and Scotland. The best

Triangular knotwork from Ulbster, Caithness

examples are at Kilfenora, Co. Clare ; Ulbster (now at Thurso Castle), Sutherlandshire ; and Dunfallandy, Perthshire.

Under the head of ringwork and chainwork are included all patterns composed of circular, oval, and looped rings interlaced symmetrically round a centre, or arranged so as to form a long chain. Patterns of this kind are not found in the best Celtic work, and when they occur it is generally an indication either of Scandinavian influence or of the style being debased.

A certain number of modifications of the interlaced-work already described are produced by adapting the patterns so that they will fit into circular or annular spaces. Instances of this may be seen on the erect

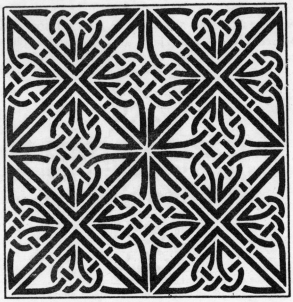

Triangular knotwork from Dunfallandy, Perthshire

cross-slabs at Hilton of Cadboll (now at Invergordon Castle) and Nigg, Ross-shire; Glamis, Forfarshire; and Rossie Priory, Perthshire; and on the Lough Erne and Monymusk Reliquaries.

STEP-PATTERNS

A step-pattern is one which is formed of straight lines bent backwards and forwards at right angles so as to resemble a flight of steps. The lines are often

arranged symmetrically round a centre, so as to make cruciform and swastika designs, and the different parts are also generally shaded alternately black and white on the principle of chequerwork. Step-patterns hardly ever occur in Christian Celtic art except on the enamelled bosses of metalwork and in a few of the illuminated MSS., such as the Lindisfarne Gospels, the St. Gall Gospels (Codex No. 51), the Gospels of Mac Regol, the Book of Kells, and the Book of Durrow. The step-patterns in the MSS. so nearly resemble those on the enamelled bosses on the Ardagh Chalice, the Tara Brooch, and the Cross of Cong, that there can be but little doubt the illuminators copied their designs from the enamels. In the Pagan Celtic enamels the ornament is nearly always curvilinear; but in the Christian Celtic enamels it is rectilinear, the arrangement of the *cloisons* being very similar to that on the Anglo-Saxon disc brooches incrusted with small slabs of garnet, glass, etc. Instances have already been given in a previous chapter of the use of step-patterns by the Pagan Celts on the engraved woodwork from the Glastonbury Marsh Village (p. 161). The only instances I have met with of step-patterns on the sculptured stones of the early Christian period in this country are at Bradford-on-Avon, Wilts; and Dysert O'Dea, Co. Clare.

KEY-PATTERNS

The term *key-pattern* is used to describe a particular kind of rectilinear ornament which bears a certain amount of resemblance to the perforations in a key to allow it to pass the wards of a lock. The best-known key-pattern is the Greek fret. This is composed of what may be appropriately called straight-line spirals;

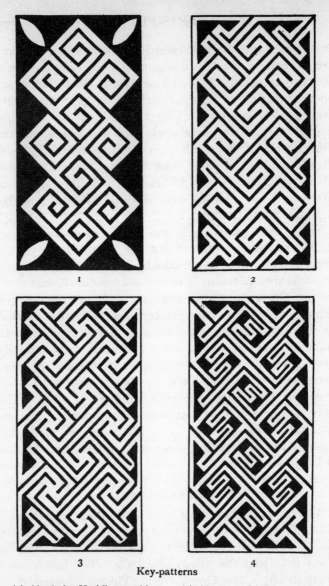

Key-patterns

(1) Aberlady, Haddingtonshire (2) Abercorn, Linlithgowshire
(3) St. Andrews, Fifeshire (4) Collieburn, Sutherlandshire

that is to say, straight lines (or, to speak more accurately, narrow straight bars) bent round into a series of right angles in the same direction. The space between the lines (or narrow bars) is generally about the same width as that of the line itself.

The key-patterns used in Christian Celtic art may be classified as follows :—

(1) *Square key-patterns*, in which the lines run horizontally and vertically parallel to the margins.

(2) *Diagonal key-patterns*, in which the lines run vertically parallel to the right and left margins, and diagonally in two directions at an angle of 45° to the margins.

(3) *Diaper key-patterns*, in which the lines run horizontally and vertically parallel to the margins, and diagonally in two directions at an angle of 45° to the margins.

The essential difference between the key-patterns used by the Egyptians, Greeks, and Romans and those used by the Christian Celts consists in the introduction of diagonal lines by the latter. Square key-patterns (*i.e.* those of the Greek fret type) were very seldom used in Christian Celtic art. There is, however, a very good example on one of the crosses at Penmon, Anglesey. The first step in the evolution of the Celtic key-pattern was to turn the Greek fret round through an angle of 45° so as to make the lines run diagonally with regard to the margins instead of parallel to them. Key-patterns in this stage of development are to be seen in the Lindisfarne Gospels, the St. Gall Gospels (Codex No. 51), and an Anglian cross-shaft from Aberlady, Haddingtonshire, now at Carlowrie Castle, near Kirkliston, Midlothian. It will be observed, however, that the result of changing a square key-pattern into a diagonal one is to leave a series of unornamented

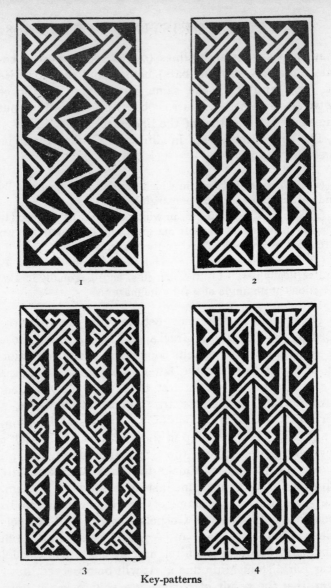

Key-patterns

(1) Rosemarkie, Ross-shire (2) Farr, Sutherlandshire
(3) Gattonside, Roxburghshire (4) Nigg, Ross-shire

triangles all round the edge (p. 280). When these tri-
angles are filled in by bending the ends of the diagonal
lines round through an
angle of 45°, so as to run
parallel to the margins,
we get such a character-
istically Celtic key-pattern
as the one on the great
cross-shaft at St. Andrews,
Fifeshire. Lastly, when
the opposite ends of the
diagonal lines in the mid-
dle of the panel are bent
round in a similar manner,
the most typical of all the
Celtic key - patterns is
arrived at, of which there
is a very good example
on the erect cross-slab at
Farr, Sutherlandshire.

The filling in of the
sharp corners made by
the lines inclined to each
other at an angle of 45°,
with small black triangles
(if in a MS.) or with
sunk triangles (if on a
sculptured stone) gives a
decorative finish to the
pattern, and still further
adds to its distinctively
Celtic character.

Next to interlaced-work
the key - pattern is the

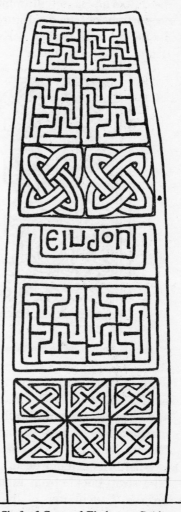

Shaft of Cross of Eiudon, at Golden
Grove, Carmarthenshire

most common motive made use of in the decorative art of the Christian Celtic period. It occurs in nearly all the Hiberno-Saxon illuminated MSS. and on a large proportion of the sculptured monuments in Ireland, Scotland, and Wales. Key-patterns and interlaced-

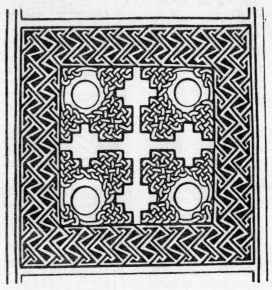

Detail of ornament on erect cross-slab at Rosemarkie, Ross-shire

work in combination, but without any other decorative motive, may be seen on the Welsh crosses at Carew and Nevern, Pembrokeshire; Golden Grove, Carmarthenshire; and Llantwit Major and Margam, Glamorganshire. On the metalwork of the period key-patterns seldom occur, except on the bronze bells, on a strap-buckle from Islandbridge, near Dublin, and on the Crucifixion plaque of repoussé bronze from Athlone, now in the Dublin Museum.

SPIRAL ORNAMENT

The spiral is the only decorative motive used in
Christian Celtic art that can be proved to have been
borrowed from the Pagan Celtic art of the preceding
period. Although spiral ornament appears to be so
complicated when it is completed, the geometrical pro-
cess of setting it out is simplicity itself. All that it is
necessary to do is to fill in the surface to be decorated

Methods of connecting spirals

with circles of any size, leaving about the same distance
between each; then connect the circle with S- or C-
shaped curves; and, lastly, fill in the circles with
spirals working from the tangent points, where the
S or C curves touch the circles, inwards to the centre.
As the size of the circles is a matter of no importance,
a surface of irregular shape may be covered with spiral
ornament just as easily as one of symmetrical shape.
In the flamboyant ornament of the Pagan Celtic period
we have the same S- and C-shaped curves, but the
circles were occupied either by a disc of enamel (as on

the bronze shield from the Thames), or by raised
conchoids (as on the gold necklet from Limavady, Co.
Londonderry). In the spiral ornament of the Christian
Celtic period closely coiled spirals like those of the
Bronze Age were substituted for the discs of enamel
or raised conchoids. The background of the spirals,
however, retained several of the prominent features of
the repoussé metalwork, the effect of the light shining

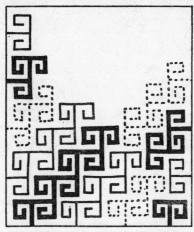

Tree key-pattern, Meigle, Perthshire

on the raised trumpet-shaped expansions of the **S** and
C curves being imitated in black and white or coloured
by almond-like dots. In the later and less refined
spiral ornament of the Christian period this back-
ground disappears altogether, and the spirals are made
all the same size and placed close together.

As the spiral was the earliest decorative motive in
Christian Celtic art, so it was also the first to disappear,
and its disappearance marks the decadence of the style.
We have in a previous chapter traced the spiral motive

from the Pagan metalwork through the enamelled disc ornaments of the bronze bowls of the Transition period to the illuminated MSS. of Christian times.

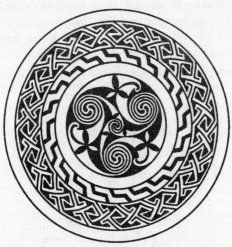

Spiral ornament, with key-pattern border, from the Book of Kells

Spiral ornament in its best form is to be found in the following MSS. :—

The Lindisfarne Gospels .	. A.D. 720.
The Book of Kells . .	. 8th century.
The Gospels of St. Chad .	. ,, ,,
The Book of Durrow .	. ,, ,,
The Book of Armagh .	. A.D. 750–808.
The Gospels of Willibrod .	. A.D. 739.
The Gospels of St. Gall .	. 8th or 9th century.
The Gospels of MacRegol .	. A.D. 820.
The Gospels of Stockholm .	. A.D. 871.
The Vespasian A. i. Psalter	. 8th century.

In metalwork spiral ornament is less common than in the MSS., there being good examples on the Ardagh

Chalice, the Tara Brooch, the Hunterston Brooch, the Monymusk Reliquary, and the Athlone Crucifixion Plaque.

Spiral ornament of the best kind is found on the sculptured stone monuments only in Ireland and Scotland.[1] In Wales, Cornwall, and the Isle of Man spiral ornament is extremely rare, and when it does occur it is of debased character. Typical examples of spiral ornament may be seen on the sculptured

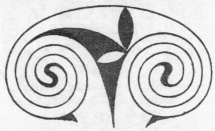

Method of connecting spirals

monuments in Ireland at Kells, Co. Meath; Monaster-boice, Co. Louth; Clonmacnois, King's Co.; and Kilklispeen, Co. Kilkenny; and in Scotland at Nigg, Shandwick, Hilton of Cadboll (now at Invergordon Castle), all in Ross-shire; the Maiden Stone, Aberdeenshire; St. Vigeans, Forfarshire; Meigle and Dunfallandy, Perthshire; and Ardchattan, Argyllshire.

Judging from the evidence afforded by the dated specimens, the best kind of spiral ornament seems to have disappeared entirely from Christian Celtic art after the first quarter of the tenth century.

ZOÖMORPHIC DESIGNS

Animal forms are used in Celtic art of the Christian period in three different ways, namely, (1) pictorially,

[1] Chiefly in the Pictish districts of the north-east of Scotland.

(2) symbolically, and (3) decoratively. As cases of the
first kind of treatment we have the hunting scenes,[1]
battle scenes,[2] men driving in chariots[3] drawn by
horses, groups of animals,[4] etc., on the erect cross-
slabs of Scotland and on the bases of some of the
Irish and Welsh crosses. Although these subjects
may have some symbolism behind them, yet all the
living creatures represented are treated realistically,
and not conventionally. As cases of the second kind
of treatment we have the Symbols of the Four Evan-
gelists, which, although consisting of the figures of
a man, a lion, a bull, and an eagle, are generally
highly conventionalised. Lastly, we have the decora-
tive use of animal forms, where the zoölogical species
of the creatures represented becomes of so little im-
portance that it is altogether ignored. The creatures
can certainly be divided into beasts, birds, fishes, and
reptiles ; but the artist has taken such liberties with
the shapes of their bodies, limbs, heads, tails, and
other details, that he would be a bold man who would
say of any one of the beasts whether it was intended
for a lion, a tiger, a dog, a wolf, or a bear. The
quadruped most in favour with the Christian Celtic
artist may, as has been already suggested, have been
degraded by successive copying from the Classical lion.
Anyway, it has a head something like that of a dog,
with pointed ears, an attenuated body, four legs termi-
nating in paws with claws, and a long tail. The head

[1] As on the erect cross-slab at Hilton of Cadboll (now at Invergordon
Castle), Ross-shire.
[2] As on the erect cross-slab at Aberlemno, Forfarshire.
[3] As on the base of the cross in the churchyard of Kells, Co. Meath.
[4] As on the erect cross-slabs at Shandwick, Ross-shire ; and St.
Vigeans, Forfarshire ; and on the base of the cross at Castledermot,
Co. Kildare.

and the paws are never misrepresented for decorative purposes, but the body, limbs, ears, and tail may be extended to any given length or bent in any desired direction. The beasts and other creatures are generally shown in profile, and only rarely in plan.

In the simplest kind of zoömorphic ornament a single beast is used to fill a panel, the different attitudes being as follows :—

(1) With the head looking forwards.
(2) With the head bent backwards.
(3) With the head bent backwards, biting the middle of the body.
(4) With the head bent backwards, biting the end of the tail.
(5) With the tail curled up over the back.
(6) With the tail curled up under the belly.

If the beasts are in pairs, they may be placed in the following positions :—

(1) Symmetrically facing towards each other, or face to face.
(2) Symmetrically facing away from each other.
(3) In a horizontal row one in front of the other.
(4) In a vertical row one below the other.

When there are three or four beasts, besides being arranged in rows, they may be placed after the fashion of the triskele or the swastika round a centre.

Interlaced zoömorphic ornament can be made with a single beast by extending the length of its tail and ear, and forming them into knots at intervals, crossing over the body and limbs where necessary. Sometimes the tail alone is knotted. In this sort of ornament the shape of the beast is seen distinctly and the knots occupy the background. A more complicated design

can be made from a single beast by twisting its body and limbs into knots as well as the ears and tail.

The panels of zoömorphic ornament in Christian Celtic art are, however, usually composed of two or more beasts placed symmetrically with regard to each other and having their bodies and limbs crossed over and interlaced. The ears and tails may also be extended and formed into knots in combination with the bodies and limbs. The designs thus produced will be seen to consist apparently of two sets of bands crossing each other diagonally, the wide bands being the bodies of the beasts and the narrow bands, the limbs, tails, and ears. The bands are nearly straight, or if bent at all only gently curved.

When the beasts are not placed in opposite symmetrical positions, but in horizontal rows one in front of the other, or in vertical rows one below the other, the bodies are often bent round spirally in one direction or twisted into S-shaped spirals in two directions. A favourite device with the Celtic artist was to make the beasts bite their own bodies, limbs, or tails, or the body, limbs, or tail of the beast immediately in front of it.

The zoömorphic designs composed of birds were arranged on the same principles as those composed of beasts.

Reptiles or serpentine creatures with bodies of nearly the same width throughout were converted into interlaced zoömorphic ornament by twisting, plaiting, looping, or knotting the bodies together. This class of ornament is, in fact, the ordinary interlaced patterns derived from the plait, with heads added at one end and tails at the other.

A very ingenious zoömorphic design is made by filling in a long narrow panel with the body of a

serpentine creature undulating from side to side. The head of the creature is at the top of the panel, and the body remains about the same width until it reaches the bottom of the panel, where its width is greatly reduced and its direction reversed. On its return journey it makes a series of Stafford knots, which fill in the spaces between the undulations of the body and the sides of the panel, and the end of the tail is finally received into the mouth of the reptile.[1]

There are two kinds of zoömorphic designs which are peculiar to the MSS. of the period, namely, initial letters made in the form of a bird or beast, and the incomplete frames round the initial pages of the Gospels terminating in a beast's head at one end and a fish-like tail at the other. The only thing of a similar kind which occurs on the sculptured monuments is the zoömorphic margin round some of the erect cross-slabs of the east of Scotland.[2] The margin is formed by two beasts, the heads of which appear at the top facing each other and the tails at the bottom.

Zoömorphs are found throughout the whole range of Christian Celtic art; they form an important feature in the decoration of nearly all the Hiberno - Saxon illuminated MSS.; they are particularly characteristic of the Irish ecclesiastical metalwork; and they are of frequent occurrence on the sculptured monuments of Ireland and Scotland. On the crosses of Wales and Cornwall zoömorphs are comparatively rare. Some of

[1] Instances of this occur at Lanherne and Sancreed, Cornwall.

[2] At Cossins and Monifieth, Forfarshire; and Meigle, Dunfallandy; and St. Madoes, Perthshire. The arched top of the frame round the miniature of Christ seized by the Jews, in the Book of Kells, is treated in exactly the same way as the pedimented tops of the erect cross-slabs. In the second table of Eusebian Canons, in the Book of Kells, the head and arms of Christ are placed between the two beasts' heads.

the best instances of zoömorphic designs in the MSS.
are to be seen in the cross-pages of the Book of Durrow,
the Gospels of Lindisfarne, the Book of Kells, the
Gospels of St. Chad, and the St. Gall Gospels (Codex
No. 51); in metalwork on the Ardagh Chalice, the
Tara Brooch, the Hunterston Brooch, the Shrine of
the Bell of St. Patrick's Will, the Cross of Cong, and
the Shrine of St. Manchan; and on sculptured monu-
ments at Termonfechin, Co. Louth; Kells, Co. Meath;
Tihilly, King's Co.; Dysert O'Dea, Co. Clare; Nigg,
Ross-shire; Aberlemno and Invergowrie, Forfarshire;
St. Madoes, Perthshire; Penally, Pembrokeshire; and
Sancreed and Lanherne, Cornwall.

Sometimes key-patterns and spirals are converted
into zoömorphic designs by the addition of animals'
heads, as at Penmon, Anglesey; and Termonfechin,
Co. Louth. The centres of spirals are also often made
zoömorphic, as in the Gospels of Lindisfarne, on the
cross at Kilklispeen, Co. Kilkenny, and on an erect
cross-slab at St. Vigeans, Forfarshire.

Probably the most wonderful *tour de force* in the way
of zoömorphic sculpture is a pair of panels on the
erect cross-slab at Nigg, Ross-shire. Each panel is
ornamented with a series of raised bosses arranged
symmetrically. The whole of the convex surfaces of
the bosses is covered with intricate knotwork, and the
background is composed of serpents, the tails of which
coil spirally round the bases of the bosses, and in each
case enter the circumference at three points to form the
interlaced-work on the boss. After innumerable cross-
ings under and over, the tails again diverge at three
other points round the base of the boss, and finally
terminate in small spirals in different parts of the back-
ground.

ANTHROPOMORPHIC DESIGNS

Under the above heading are classed all designs in which the complete figure of a man, or portions of a man are used for purposes of decoration. Human heads occur in metalwork in the decoration of the Tara Brooch[1] and in sculptured stonework on the cross of Muiredach, at Monasterboice, Co. Louth, and on a cross-head from the crannog at Drumgay Loch.

The most remarkable instances of the decorative use of the complete figures of men in the illuminated MSS. are to be found in the Book of Kells. The figures are generally arranged in pairs facing each other, in groups of three triskele fashion, and in nearly all cases the attitudes are extremely uncomfortable with the knees drawn up close against the stomach. The limbs of the different figures are crossed over and interlaced, as in zoömorphic ornament, and the hands are shown grasping either the limbs, hair, or beard of one of the other figures. Sometimes the human figures are combined with figures of birds or beasts.

We have already referred to the incomplete frames of the initial pages of the Gospels with zoömorphic terminations. In the " Nativitas $\overline{\text{XPI}}$ " initial page in the Book of Kells the incomplete frame terminates in a human head at one end and two legs at the other. Another initial page in the same MS.—that of St. Mark's Gospel—has a zoömorphic frame, but the beast's head is holding a man between its jaws, whilst the man is tugging at the beast's tongue with his hand.

Groups of four human figures arranged swastika fashion, interlaced and each grasping the limbs, wrists,

[1] A pin brooch ornamented with a human head, from Woodford River, Co. Cavan, is illustrated in Sir W. Wilde's *Catal. of the Mus. R.I.A.*, p. 565.

hair, or beard of one of the other figures, occur on crosses in Ireland at Kilkispeen, Co. Kilkenny; Monasterboice, Co. Louth; and Kells, Co. Meath; and in Scotland on a recumbent monument at Meigle, Perthshire. A human figure interlaced with a bird occurs in two instances on sculptured stones in Scotland, namely, at Monifieth, Forfarshire (now in the Edinburgh Museum of Antiquities); and at Meigle, Perthshire.

FOLIAGE

Leaf and plant motive decoration is entirely foreign to the spirit of purely Celtic Christian art, and whenever it occurs it is generally to be traced to Northumbrian influence. The Book of Kells and the Stockholm Gospels are the only Hiberno-Saxon illuminated MSS. in which any trace of foliage can be detected. There are panels of foliage on the Irish crosses at Kells, Co. Meath; Monasterboice, Co. Louth; and Clonmacnois, King's Co. In Wales there is an instance of foliage on the crosses at Penally, Pembrokeshire. In Scotland the only sculptured monuments with foliage upon them (excluding, of course, those in the Northumbrian districts of the south) are the erect cross-slabs at Hilton of Cadboll and Tarbet, Ross-shire (both now at Invergordon Castle); St. Vigeans, Forfarshire; and Crieff, Perthshire; on crosses at Camuston, Forfarshire; Dupplin, Perthshire; and on a cross-shaft at St. Andrews, Fifeshire.

The foliage may in all cases be traced back to the Classical vine, the well-known symbol of Christ. It is often much degraded by successive copying, and although the forms of the leaves are often altered beyond recognition the bunches of grapes can always be made out.

SYMBOLICAL FIGURE-SUBJECTS

We have already mentioned most of the figure-subjects to be found in the Hiberno-Saxon illuminated MSS., and on the Irish ecclesiastical metalwork. It remains therefore only now to take the sculptured monuments into consideration.

It was in Ireland alone that a recognised cycle of scriptural figure-subjects was adopted for the decoration of the crosses and that in nearly all cases the ornament was relegated to a subordinate position. In Scotland and Wales, on the contrary, Scripture scenes are seldom represented on the sculptured monuments; in Cornwall the only figure-subject which occurs on the crosses is the Crucifixion; and in the Isle of Man the figure-subjects are mostly taken from the Pagan Norse mythology.

The following table shows the Scriptural subjects on the sculptured monuments of Ireland, Scotland, Wales, and Cornwall, and the frequency with which they occur :—

	Ireland.	Scotland.	Wales.	Cornwall.
Old Testament—				
Adam and Eve . . .	15	2	—	—
Noah in the Ark . .	2	1	—	—
Sacrifice of Isaac . .	9	1	—	—
Three Children in Furnace .	4	—	—	—
Daniel in Den of Lions .	8	9	—	—
David and Harp . .	6	2	—	—
David and Lion . .	6	2	—	—
David and Goliath . .	3	—	—	—
Jonah and Whale . .	—	3	—	—
Ascent of Elijah . .	—	1	—	—

	Ireland.	Scotland.	Wales.	Cornwall.
New Testament—				
Virgin and Child . . .	—	5	—	—
Adoration of Magi . .	2	1	—	—
Flight into Egypt . . .	1	—	—	—
Baptism of Christ . . .	2	—	—	—
Miracle of Loaves and Fishes	4	1	—	—
Raising of Lazarus . .	—	1	—	—
Crucifixion	16	5	3	40
Christ in Glory . . .	5	1	—	—
Last Judgment . . .	1	—	—	—
Annunciation	—	—	1	—
Christ seized by the Jews .	2	—	1	—
Twelve Apostles . . .	1	—	—	—
Agnus Dei	2	—	—	—
Dextera Dei	2	—	—	—

In addition to the above there are the following, which are sacred or ecclesiastical, but not, strictly speaking, Scriptural :—

	Ireland.	Scotland.	Wales.	Cornwall.
Symbols of Four Evangelists .	—	4	—	—
Cherubim	—	—	1	—
Angels	—	22	—	—
Saints	—	—	—	—
Oranti	—	1	3	—

It appears, then, that the Scriptural subjects of most frequent occurrence in Ireland are the Crucifixion, Adam and Eve, the Sacrifice of Isaac, Daniel in the Lions' Den, and the scenes from the Life of David; and in Scotland, the Crucifixion, Daniel in the Lions' Den, the Virgin and Child, and the symbols of the four Evangelists.

The subjects common to both Ireland and Scotland are Adam and Eve, Noah (?), Sacrifice of Isaac, Daniel in the Lions' Den, David and the Harp, David and the Lion, Adoration of the Magi, Flight into Egypt, Miracle of Loaves and Fishes, Crucifixion, Christ in Glory, Agnus Dei, Angels.

The subjects which occur in Ireland, but not in Scotland, are the Three Children in the Furnace, David and Goliath, Baptism of Christ, Resurrection, Last Judgment, Dextera Dei, Twelve Apostles. And those which occur in Scotland, but not in Ireland, are Ascent of Elijah, Raising of Lazarus, Jonah and the Whale, Annunciation, Salutation, Miracle of Healing the Blind, Christ and Mary Magdalene, Lazarus.

Of the subjects on the early sculptured stones of Ireland and Scotland the following belong to the cycle of subjects found on the paintings in the Catacombs and the Sculptured Sarcophagi (A.D. 50 to 450):—

Adam and Eve.	Daniel in the Lions' Den.
Noah.	Jonah and the Whale.
Sacrifice of Isaac.	Adoration of Magi.
Three Children in the Fur-	Miracle of Loaves and Fishes.
nace.	Miracle of Healing the
Ascent of Elijah.	Blind.

The following subjects belong to the Lombardo-Byzantine period (A.D. 700–1100):—

David.	Christ in Glory.
Baptism of Christ.	Last Judgment.
Crucifixion.	Agnus Dei.
Resurrection.	Dextera Dei.
Flight into Egypt.	Twelve Apostles.
Virgin and Child (apart from	Symbols of the Four Evan-
Magi).	gelists.
Christ and Mary Magdalene.	Angels.

Thus the early Sculptured Stones and the Hiberno-Saxon MSS. of Great Britain, and the Carlovingian Ivories afford a connecting link between the older symbolism of the primitive Christianity of the Catacomb period and the more strictly ecclesiastical art of mediæval times.

Quite apart from the fact that King David was a type of Christ, and that his pictures formed the illustrations of the Psalter, it is not surprising that he should have been an object of popular worship amongst the warlike and musical Celts, to one side of whose character his heroic deeds in rending the jaws of the lion and slaying the giant Goliath, would appeal as strongly as his talent as a harper would to the other.

A small MS. Irish Psalter in the British Museum (Vit. F. i.)[1] contains two very curious miniatures, one of David Playing the Harp and the other of David and Goliath.[2] The former is interesting, because I think it helps to explain the meaning of a figure sitting on the back of a beast and playing a harp,[3] sculptured on one of the panels of the cross at Clonmacnoise. As I hold, this is intended for David; and my reason for supposing this is, because the throne on which David is seated in the miniature in the Psalter is conventionally treated as a beast.

I am not quite sure whether the boat with men in it, on the stone at Cossins, is intended for Noah's Ark or not, but a boat of just the same kind is represented on

[1] Westwood's *Miniatures*, pl. 5.

[2] In the miniature of David and Goliath in the Psalter David holds a sling in one hand and a beast-headed club in the other. The resemblance between this club and the beast's-head symbol, which occurs on the Norrie's Law silver ornaments and on several of the early incised slabs in Scotland, may be only accidental, but it is worth noting as a possible clue to the scriptural interpretation of the symbol.

[3] O'Neii, pl. 24A.

a carved wooden pillar at Olaf's Church,[1] Nesland, where it is associated with other Scriptural subjects, amongst others the creation of Eve, Samson and Delilah, and David and Goliath. In this case there can be little doubt but that the boat is intended for Noah's Ark, so that probably the boat at Cossins has the same meaning.

The angels are cherubim, with four wings, and spirals where the wings join on to the body, representations of which are to be seen on the stones at Eassie, Glamis, and elsewhere in Scotland. They do not occur on any of the sculptured crosses in Ireland; but there are instances of angels or the symbols of the four evangelists treated in the same fashion in the St. Gall Gospels, Codex. No. 51,[2] and on the Book Shrine of St. Molaise's Gospels,[3] in the Museum of the Royal Irish Academy in Dublin, and also on a bronze plaque[4] of the Crucifixion, in the same collection. I have recently discovered a very curious instance of an angel of this kind, with three wings on a cross-slab, with interlaced-work, in St. David's Cathedral, given in Westwood's *Lapidarium Walliæ* (pl. 63, fig. 4), but the wings and spirals only shown, and the head of the angel omitted.

The pair of ecclesiastics, sometimes standing, sometimes enthroned, sometimes kneeling, with a bird holding a circular disc in its mouth between them, is a subject common to the early sculptured stones of both Scotland[5] and Ireland,[6] but the exact meaning of it

[1] L. H. S. Dietrichsen, *De Norske Stavkirker*, p. 362.
[2] C. Purton Cooper's "Appendix A to Report on Rymer's Fœdera," pl. 5.
[3] *Archæologia*, vol. xliii., p. 131.
[4] Westwood's *Miniatures*, pl. 51.
[5] As at Nigg and St. Vigeans. Dr. J. Anderson regards the Nigg example as being intended for St. Paul and St. Anthony.
[6] As at Kells, Moone Abbey, Clonca.

has yet to be ascertained if we are not to take the instance on the Ruthwell cross as an authoritative explanation of the whole.

As I have already pointed out in my Rhind Lectures on *Christian Symbolism*, there is a nearer affinity between the subjects chosen to decorate the bases of the Irish crosses and the representations of hunting scenes, horsemen, chariots, etc., on the upright cross-slabs of the north-east of Scotland, than the more strictly Scriptural scenes on the shafts of the Irish crosses. The best examples illustrating this are to be seen on the bases of the crosses at Kells (Figs. 5 and 6), Monasterboice, Clonmacnois, Castle Dermot (Fig. 7), and Kilklispeen.

The chariot on the Meigle slab, now lost, may be compared with the chariots to be seen on the shaft of the cross at Killamery, and on the bases of the crosses at Monasterboice, Kilklispeen, and in Kells churchyard; on the base of the cross in the street at Kells we have the eagle and fish, as on the "Drosten" stone at St. Vigeans,[1] and as in the Book of Armagh ; and on the base of this same cross, and on the cross of Muredach at Monasterboice, centaurs occur, in some respects like those on the slabs at Aberlemno, Meigle, and Glamis.

On the base of the Kilklispeen cross is portrayed a procession of ecclesiastics taking part in a most remarkable ceremony. On the south side of the base is to be seen a priest carrying a processional cross, and followed by a man leading a horse, on the back of which is laid the headless trunk of a man, with

[1] Another remarkable instance of the eagle and fish has recently been found on a stone with an Ogam inscription, at Latheron, near Keiss, Caithness.

two birds of prey, or carrion crows, perched on the top.

On the north side of the base are two ecclesiastics on horseback, followed by two more in a chariot drawn by a pair of horses.

On the east side are several beasts, birds, and a man.

On the west side is a central figure, perhaps a bishop, with three ecclesiastics holding croziers on each side of him.

These scenes can hardly be Scriptural; and if they are not taken from the life of some saint, it is difficult to see what explanation remains to be suggested, except that an event of local importance is here commemorated. The bases of the pillar-cross at Llandough and of the great wheel-cross at Margam, both in Glamorganshire, are the only ones with figures of horsemen upon them in Wales.

The symbolism of the shafts of the Irish crosses is so strictly biblical that secular subjects may have been placed on the bases by way of contrast, to indicate the actual world or earth on which the cross stood representing the spiritual world. The eagle and fish may personify the ocean, and the centaur the desert, for which we have the authority of the bestiaries and the legendary life of St. Anthony.

The points of similarity between the ornamental patterns on the stones of Ireland and Scotland raise questions of too much intricacy to be dealt with here; but it may be remarked that figure-sculpture forms the chief feature of the Irish crosses—geometrical, zoömorphic, and foliageous designs being only as a rule applied to the decoration of the smaller panels on the sides of the shafts and to the rings connecting the

arms. The upright cross-slabs of Scotland, more particularly those in Ross-shire, approach much more nearly in style—and therefore probably in age—to the illuminated pages of the Hiberno-Saxon MSS. of the best period, than do any of the Irish crosses.

In conclusion, I consider the so-called Celtic style to be a local variety of the Lombardo-Byzantine style, from which the figure-subjects, the interlaced-work, the scrolls of foliage, and many of the strange real and fabulous creatures were apparently borrowed. The Lombardo-Byzantine style was introduced into this country after the Saxons had become Christians; and being grafted upon the Pagan art of the Late-Celtic period, was developed in different ways in different parts of Great Britain. However, it in no way detracts from the artistic capacity of the Celt that he should have adapted certain decorative motives belonging to a foreign style instead of evolving them out of his own inner consciousness. Although his materials may not all have been of native origin, they were so skilfully made use of in combination with native designs, and developed with such exquisite taste, that the result was to produce an entirely original style, the like of which the world had never seen before.

INDEX